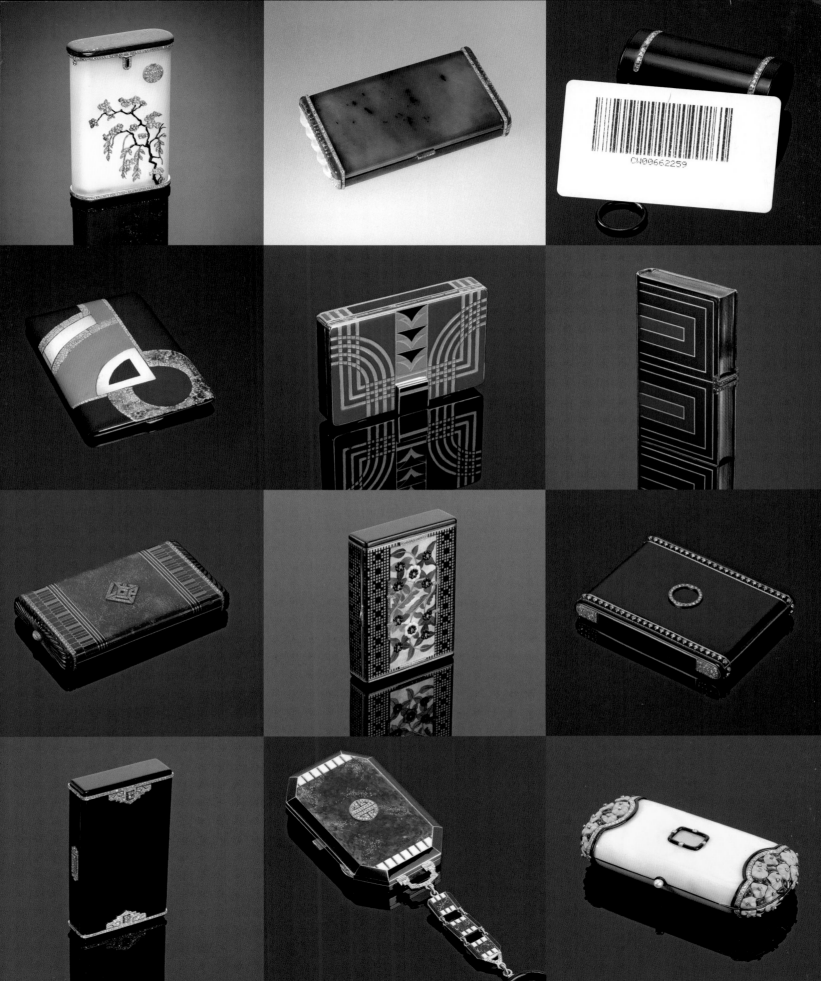

UNICORN PRESS

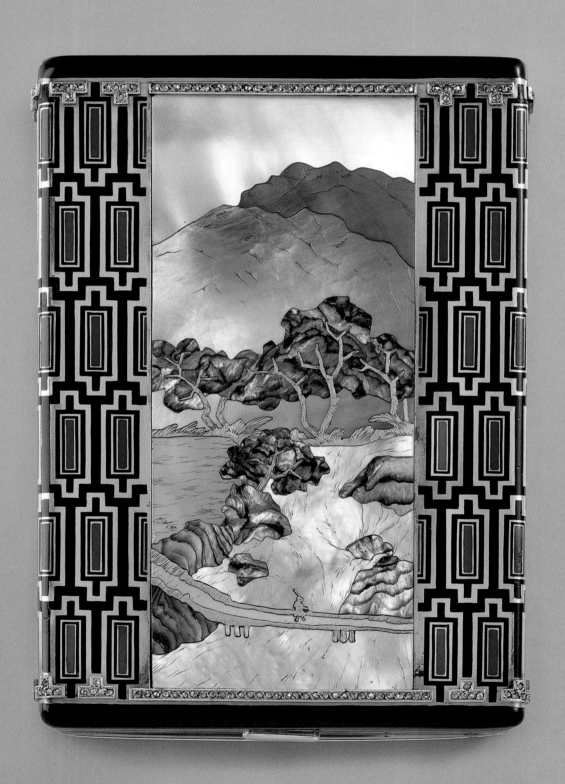

A KIND OF MAGIC

ART DECO VANITY CASES

SARAH HUE-WILLIAMS & PETER EDWARDS

CONTENTS

PAGE 1 Original drawing for the Cartier vanity case on page 124. *PAGE 2* Double-sided vanity case by Ostertag, 1925. LEFT Original drawing for the Van Cleef & Arpels vanity case on pages 162–3.

FOREWORD

'In the lovely gay
Years before the Crash
Mr Cartier
Never asked for cash'

So sang the Children of the Ritz in Noël Coward's *Words and Music* in 1932. Their high-living days were over, but a later generation recognises the brilliance and the virtuosity of the jewellery created in Paris, New York and London for the Children and their contemporaries.

This book celebrates the imagination and surpassing excellence of the great jewellery houses and their designers, goldsmiths, enamellers, engine-turners and lapidaries who made the vanity case the successor of the boxes of earlier ages. The cases of Lacloche, Van Cleef & Arpels and Cartier stand in direct line of descent from the boxes of Jean Ducrollay and Johann Christian Neuber created in eighteenth-century Paris and Dresden. The finest cases are pinnacles of Art Deco design and miracles of precision manufacture.

Yet the book is also a celebration of a personal collection born out of love. As Peter Edwards reveals, the collection brings together a musician of genius and a collector whose mission to honour the memory of her brother has been matched by her keen eye and sure trust in the dealer who shared her vision.

The jewellery collections now displayed at the Victoria and Albert Museum began with purchases from the Great Exhibition of 1851, including Berlin ironwork and a bracelet by Froment-Meurice. Later the V&A bought Art Nouveau direct from Paris. But Art Deco jewellery has mainly been acquired long after its creation. There are some magnificent pieces, but much more is needed to tell the full story.

This superb collection, which has been generously promised to the museum as a gift, will be transformative. It is of international significance, and we hope that its display will bring as much pleasure to its inspirational donor as it will to the V&A's visitors.

Richard Edgcumbe
Senior Curator, Victoria and Albert Museum
London, 2017

A MAGICAL COLLECTION

Vintage photos of 1920s nightlife invite a host of intriguing questions. Who was looking in the mirror of her jewelled *nécessaire* when applying her lipstick? Whose gloved hand took a cigarette from her enamelled case or discreetly handed a visiting card to an admirer? Was she listening to Duke Ellington at the Cotton Club, dancing to Gershwin and Porter at the Embassy or applauding Josephine Baker at the Folies Bergère? And is that Hemingway talking to Scott Fitzgerald?

The small jewelled masterpieces contained in these pages will always conjure up the impossibly glamorous era captured in such images. The cases were essential accoutrements for women of means, and evoke lifestyles that have largely vanished. I have been fascinated by these magical objects for a long time, and decided to include them in my dealing stock some 20 years ago. The timing was fortuitous. It is curious to reflect now that until the late 1960s there was little or no interest in the designs or creations of the era that we have come to know as Art Deco. This began to change with the 1966 exhibition held at the Musée des Arts Décoratifs in Paris entitled *Les Années 25*, which announced the resurgence of this style, while Bevis Hillier's book of 1968 on the subject was the first to use the term 'Art Deco' (derived from the 1925 *Exposition Internationale des Arts Décoratifs et Industriels Modernes*) to identify the style of this era. The Jacques Doucet collection of works by the great designers of the 1920s, sold at the Drouot auction house in Paris in 1972, added further stimulus, gaining worldwide attention and the interest of, amongst others, Andy Warhol and Yves Saint Laurent. This was a benchmark sale. But the luxury objects languished, considered by many to be too frivolous. That is, until the auction at Christie's in London of the H. Robert Greene collection of Art Deco objects in 1978 – a 'white glove' sale in which every lot was successfully sold and which raised awareness of the skills and craftsmanship involved in making the pieces. By the time of my involvement many of the greatest examples were already in private collections or museums, but it was still possible to find fine and occasionally very rare pieces such as that by Jean Fouquet (pages 180-1). Today they have all but disappeared from the marketplace.

Equally fortuitous was a chance conversation with Kashmira, which was the genesis of this book. For this book is a story. It is not an academic treatise or a catalogue with endless references and cross-references and bibliographies and contributions from museum curators. It is a story intended to conjure up the magic of the time and it is the story of the determination of one woman, with no history of collecting, to form a collection of which she felt her brother would have been proud. Her brother was a collector of beautiful things, an accomplished artist with a great aesthetic sense, and a hugely talented musician.

Her brother was Freddie Mercury.

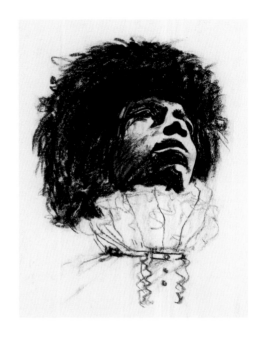

The jewelled and enamelled cases seemed an obvious choice, and given Freddie's fondness for all things Japanese it seemed only natural that Kashmira's first purchase should be the stunning frosted crystal case applied with a diamond and enamel Japanese weeping willow by Lacloche (page 127).

Kashmira's love for her brother is palpable. She speaks of him frequently and her eyes light up when she hears him on the radio. Every time we found a case suitable for inclusion in the collection she would say: 'I think Freddie would have liked this one'. She was thrilled when the Musée des Arts Décoratifs requested the Fouquet case for inclusion in their wonderful exhibition *Bijoux Art Déco et Avant Garde* in 2009. And equally thrilled when Van Cleef & Arpels included her cases in their exhibition in Shanghai in 2012.

The creation of this collection has been an enjoyable journey, and some two years ago I felt that it had the necessary ingredients for a book. Kashmira was all for it, and I knew exactly who I wanted to write it for us. When I suggested my ideas to Sarah she agreed immediately, having long admired the jewellery and accessories of the Art Deco period. 'I'd love to do it!' she said. I gave her the brief and she did the rest, for which I will always be grateful.

Then came the question: what to call the book? I had constantly referred to these magical creations from a magical era, and it seemed logical to use this in the title. What could be more appropriate than 'A Kind of Magic'? I am grateful to Roger Taylor, who wrote the song for Queen, for allowing us to use it.

The journey is now over and the book is done. For my part I intend that all profits from the sale of the book will be donated to the Mercury Phoenix Trust.

Kashmira has promised the entire collection as a gift to the Victoria and Albert Museum in London in memory of her brother.

I think that Freddie would have approved.

Peter Edwards
London, 2017

OPPOSITE Freddie's drawing of Jimi Hendrix, done while he was an art student. LEFT and BELOW Freddie and Kashmira, devoted brother and sister.

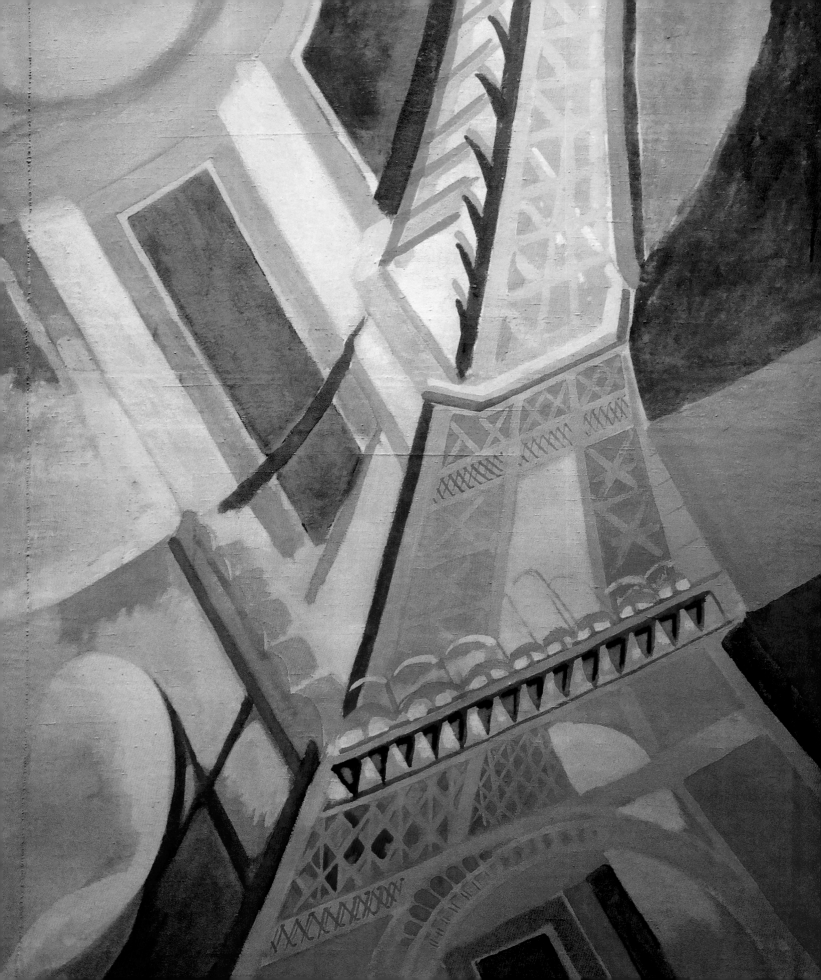

I
....

A BRAVE NEW WORLD

....

A BRAND NEW ERA

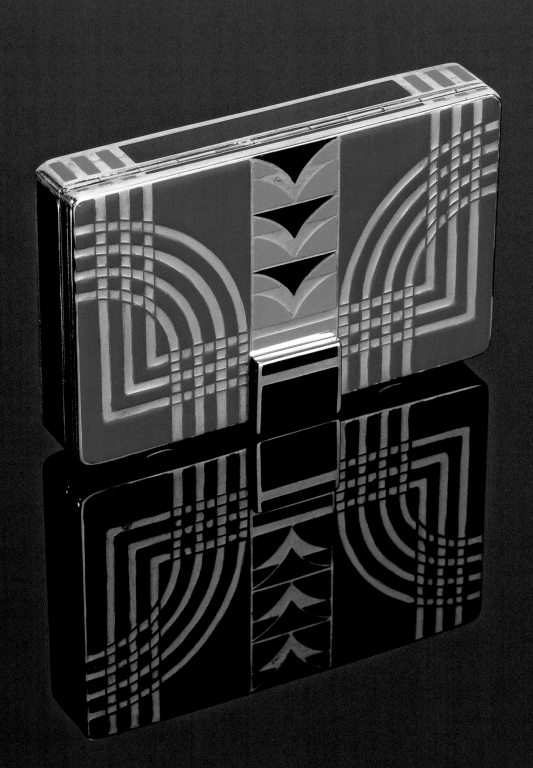

As small but sparkling commentaries on the world around them, precious objects express their era in succinct and dazzling style. They can provide the best backstage passes into history, snapshots of time and place in miniature that reveal the zeitgeist of the day, giving us a glittering lens through which to glimpse something of the lives and times of our ancestors, whose characters live on in their personal possessions.

Jewels have the power to do this: to transport us to another world, another emotion, and the finest jewelled vanity cases – the most astonishing accessories produced in the interwar years – take us back to a very specific time and place: Paris, London and New York in the 1920s. No creation was more quintessentially of its time, and as the ultimate indulgence of the Great Age of Glamour the story of the vanity case is, in effect, the story of the 1920s, the Art Deco era. 'Let us speak first of all of the ideal aesthetic of our age; a powerful and clear aesthetic which guides us purposefully. Let us open our eyes wide to: the cinema, blurred and fleeting images of things seen at high speed, the beauty of precision-made machine parts; the simplicity and grandeur of smooth, plain surfaces, the transatlantic liner, modern painting; aviation, percussive and syncopated music, neon signs, locomotives, the cocktail shaker, the telephone switchboard, polished steel, matt nickel, light and shade, the mechanical and the geometric. We are all of this. We see it, we live it every day. Let us quite simply live our age', suggested the avant-garde jeweller Gérard Sandoz in 1928.

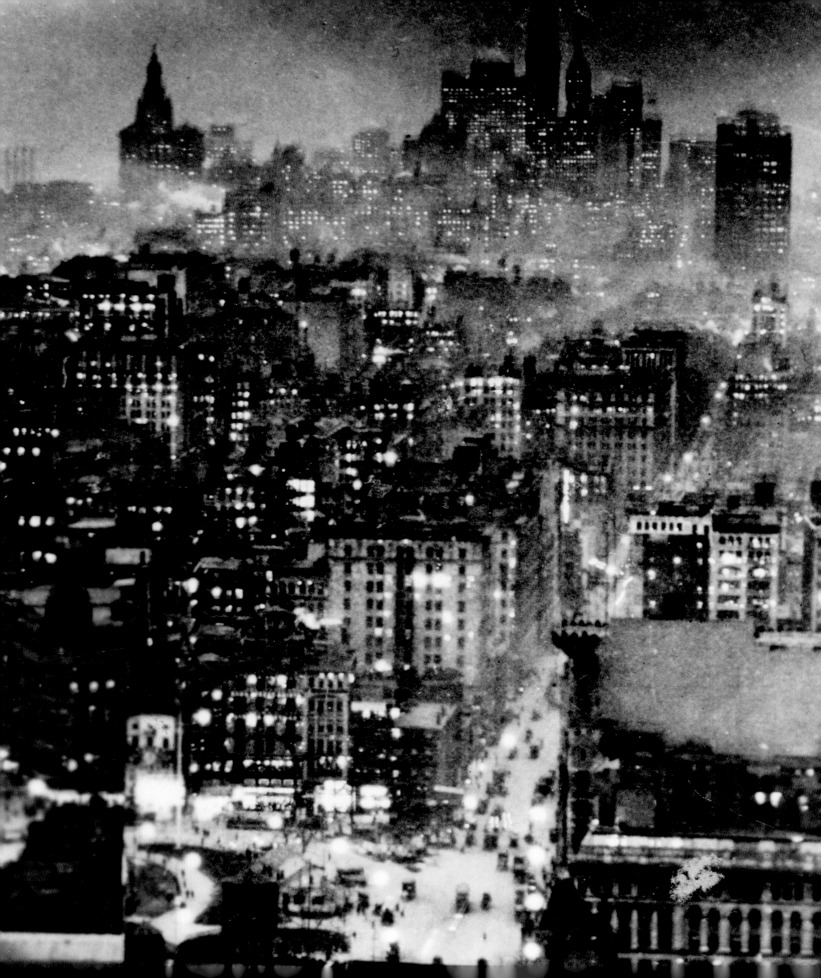

eriods of great privation and hardship have historically been followed by years of their antithesis, and so it proved when the end of the Great War ushered in a new era of euphoria and indulgence across the Western world, a sweeping aside of the old and an urgent quest for the new. Everything was focused on a fresh start, the past ignored in a conscious effort to erase every reminder of recent warfare and its horrors. The sheer pleasure of being alive became a rage to live life to its fullest with absolute abandon, to create a new culture and a new way of living shaped by fresh imagination rather than previous convention. Post-war Europe and America experienced a collective and compelling sense of liberation and a widespread desire to live for the moment. It was frantic, frenetic, and anything seemed possible as the cataclysm of war became a catalyst for fundamental change. Carried along on this wave of exuberance, a magical age burst forth, a radical, new age known as 'Les Années Folles', the 'Jazz Age' and the 'Roaring Twenties' on account its sheer vivacity and joie de vivre.

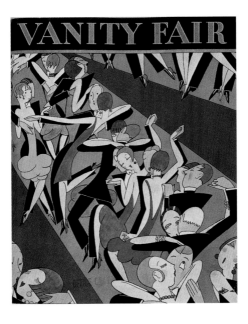

War had undoubtedly changed the men who went to the front and saw things they could never forget. One in 20 soldiers from France, Britain and Germany never came home. But the women they left behind also had their lives turned upside down. They had been asked to embrace new roles and new skills that until the hostilities had been regarded as 'men's work'. Once warfare ceased and everyday living resumed, society found itself fundamentally transformed, the natural order of things irreparably disrupted. It was simply not possible to reinstate the status quo and the way people had previously lived and behaved: four years of war had irreversibly transformed the world, and everyone in it. More innovations, inventions and advances had appeared during that relatively short space of time than in the previous half-century, and people's priorities and values changed as quickly as the technology that was accelerating the pace of life on both sides of the Atlantic. The total wealth of the US more than doubled in the years between 1920 and 1929, and huge economic growth spawned a newly affluent consumer

NEW LIFESTYLES

PAGE 10 Robert Delaunay, *The Eiffel Tower* (detail), 1926. Musée d'Art Moderne de la Ville de Paris. *PAGE 12* Silver vanity case with pale and dark blue enamel decoration, silver gilt interior and slide action lipstick holder. Gérard Sandoz, Paris, c.1925. *PAGE 14* Night view of New York City from the Metropolitan Tower, c.1920. *PAGE 15* Cover of *Vanity Fair* magazine, December 1927.

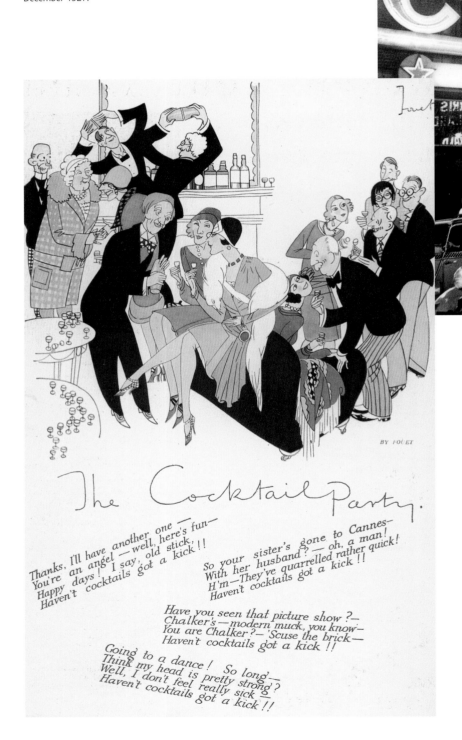

FROM LEFT TO RIGHT Illustration by Fouet in *The Bystander*, 1 May 1929, accompanying a poem on the delights of the cocktail party; The Cotton Club in Harlem, a fashionable venue during the Prohibition era; Pierre Sicard, *Le Pigall's*, 1925. Musée Carnavalet, Paris.

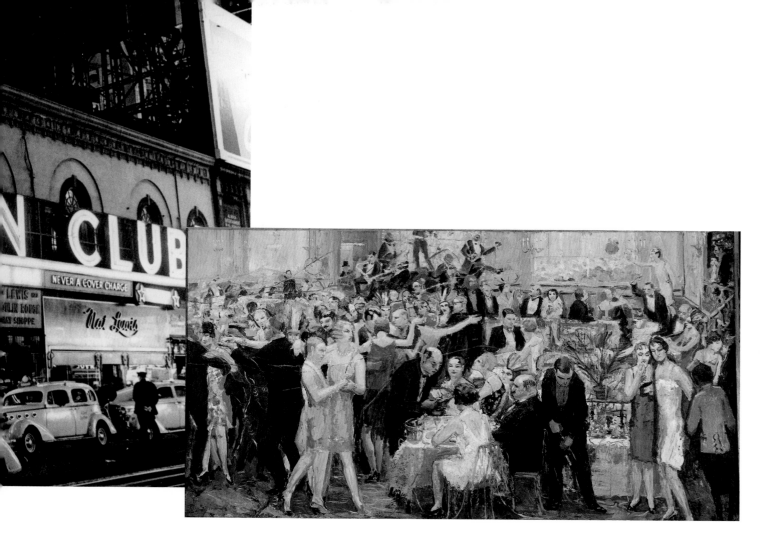

society, hungry for life and all that it offered. The modern world, with its music and movies, motorcars and air travel, had undoubtedly arrived.

The buzz was felt across every Western culture and society. France, impoverished and war-torn but defiant, rose again from the devastation, rallying the cause of progressives intent on building a better existence at furious speed. Paris became a natural focal point, an avant-garde City of Light that everyone gravitated to, with London, New York and Shanghai ('The Paris of the East') carried along on its coat-tails. Aspirations were changing rapidly across all classes of society and it seemed that everyone wanted to join the new order, the avant-garde club.

This golden decade witnessed an exceptional convergence of taste, talent and money, and people knew it even at the time. Epochal turning points are usually only recognised and acknowledged as such in retrospect, but the ferment and fervour of the early twentieth century was an exception. People felt its

revolutionary character even as it was unfolding around them, and the scent of a paradigm shift hung heavily in the air. Something big was afoot, a definite break with the dusty past that was to turn culture, society – life – on its head. Between the two wars the wealthiest indulged themselves to an unprecedented degree: great fortunes were made and people spent with style and without a sense of guilt, freely flaunting the riches they felt they had earned and more than deserved. Yet it was not just what they spent, but how they spent that brought elegance to every aspect of post-war lifestyles. People had thirsted and fought for the good life and were determined to drink their fill. This was pleasure-seeking at its most extreme: cocktails and cruising, dancing and driving, smoking and speakeasies; everything came together in a great alliance, a perfect, swirling storm. For many it felt like a decade-long party, and those who could afford it lived with a vengeance: 'I remember that decade as a perpetual 14th of July,' wrote Maurice Sachs of Paris. 'It was a tricolour age'.

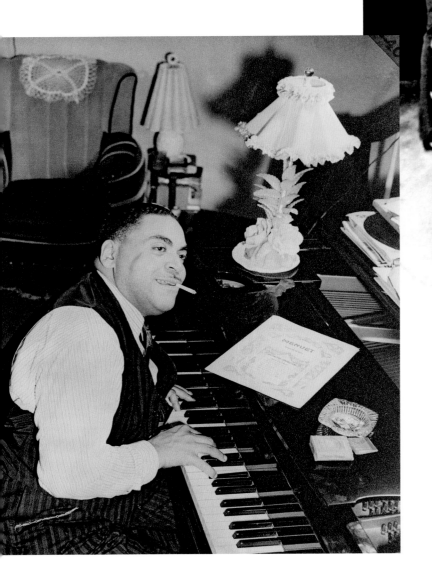

CLOCKWISE FROM BELOW Fats Waller seated at the piano in the 1920s; King Oliver's Creole Jazz Band in the early 1920s, with (L-R) Honore Dutrey, Baby Dodds, King Oliver, Louis Armstrong (kneeling in foreground with trombone), Lil Hardin, Bill Johnson and Johnny Dodds; movie poster advertising *Black and Tan*, starring Duke Ellington and his Cotton Club Orchestra and Fredi Washington, 1929; Fred Astaire with Betty Compton, Adele Astaire and Gertrude McDonald in a scene from the Gershwin musical *Funny Face* at the Alvin Theatre, New York, in 1927.

It was also the age of 'All That Jazz'. Movement, music and the movies provided the backdrop and soundtrack for life. Though Paris undoubtedly led Europe's cultural emergence from the war, across the Atlantic, American patronage helped transform the marketplace at home and abroad. Led by the first generation of industrial magnates, Americans went mad for Ginger Rogers and Fred Astaire and flocked to the Cotton Club in Harlem where the strains of Fats Waller, Duke Elllington, Louis Armstrong and Bix Beiderbecke rang out every night. The Prohibition took socialising underground to the subculture of late-night rendezvous and risqué entertainment. The 'Cakewalk' dance, developed in the

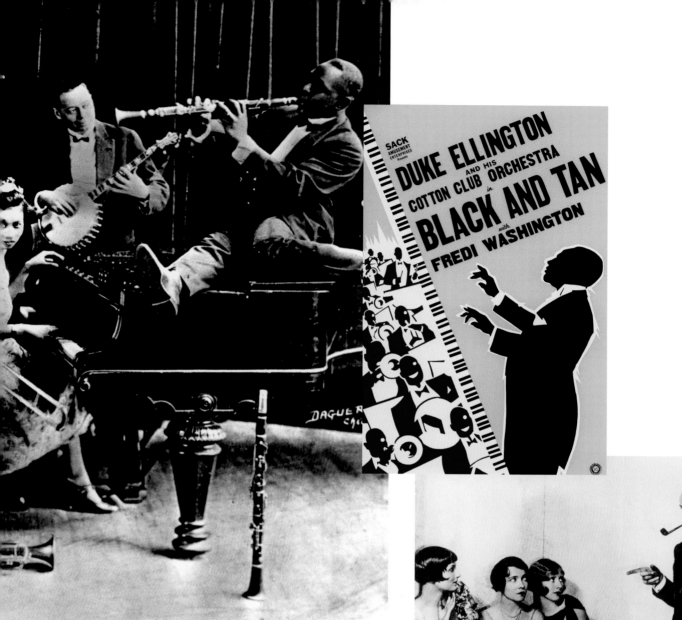

late nineteenth century on black slave plantations in the states of the Deep South, set everything in motion as the evolution of jazz music unfolded apace. After the First World War, many demobbed African American soldiers chose to remain in Paris rather than face continuing segregation at home, and those who were musicians and entertainers by trade were quickly embraced by the cafés, bars, cabarets and music halls of the French capital. Soon all of Paris seemed utterly entranced by the new sound, its rhythms, and its accompanying dances – the Shimmy, the Black Bottom and the Charleston. Jazz clubs sprang up in every arrondissement. The Théâtre des Champs-Élysées cleverly capitalised on the success of

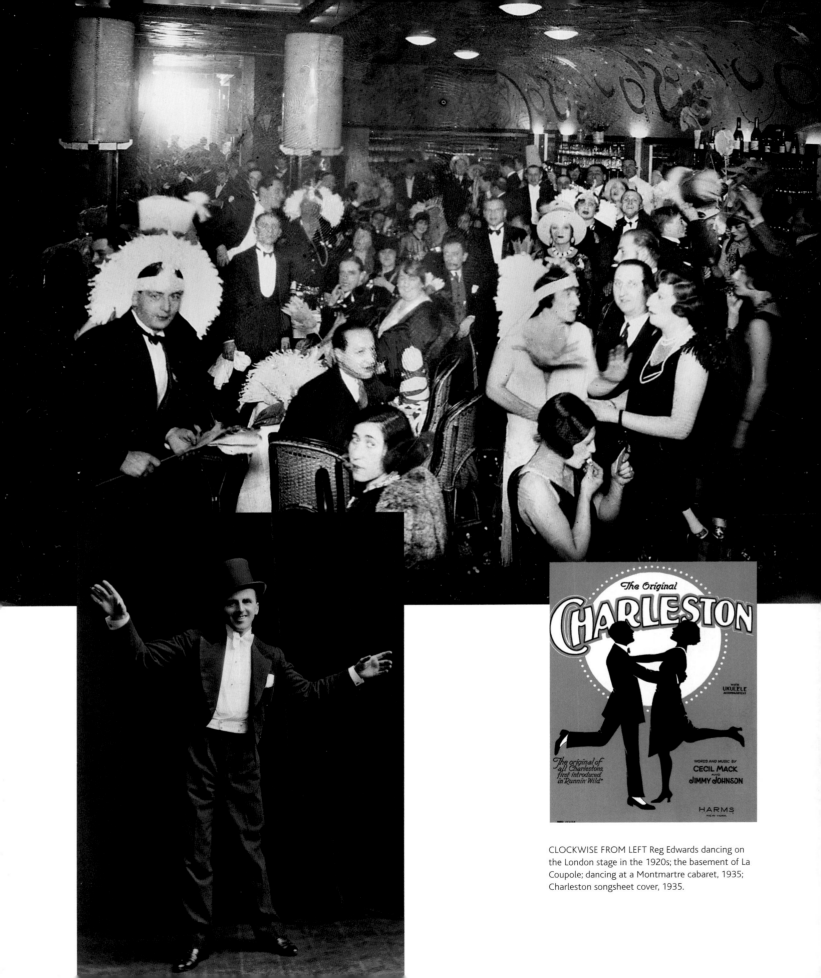

CLOCKWISE FROM LEFT Reg Edwards dancing on the London stage in the 1920s; the basement of La Coupole; dancing at a Montmartre cabaret, 1935; Charleston songsheet cover, 1935.

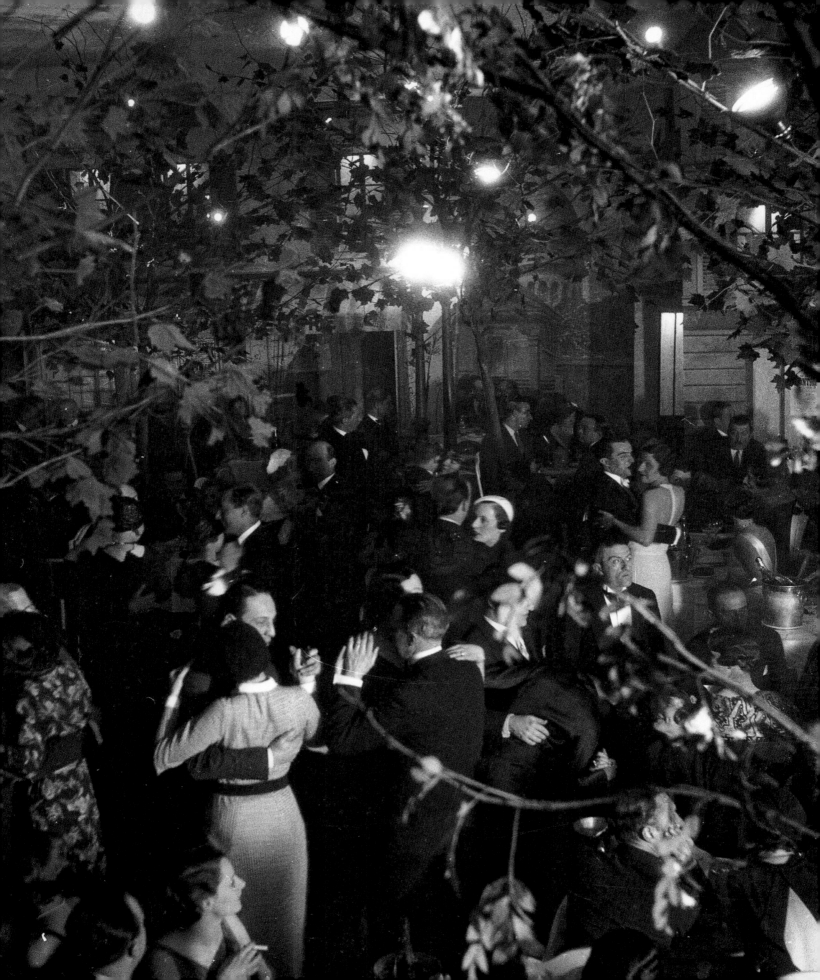

FROM LEFT TO RIGHT Cole Porter photographed in the late 1920s by Nickolas Muray; the Dolly Sisters, Roszika and Yansci, a tandem dance team famous in the 1910s and 1920s, wearing costumes made of pearls; dancers and diners at the Kit Kat Club, London, in 1926; George Gershwin at work on the orchestration of the film *Delicious*, writing notation on sheet music as his brother and partner, lyricist Ira Gershwin, and British dramatist Guy Bolton look on; Alexander Calder, *Josephine Baker (III)*, c.1927. Museum of Modern Art, New York. © 2017 Calder Foundation, New York/DACS London.

an exhibition of 'art nègre' at the Musée des Arts Décoratifs, putting on an exotic, racy show of its own in 1925 named the Revue Nègre, which brought together black musicians and performers from New York with the very best French entertainers. Among them was Josephine Baker, arguably the most acclaimed cabaret artist in Paris during the 1920s, who danced topless to packed audiences in her infamous banana skirt. It was all part of a sudden interest and celebration of African tribal art and jazz music's black roots, and it was alluringly exotic.

Everyone jumped on board and played their part: Jean Dunand designed wide cuff bracelets for Ms Baker, Alexander Calder made a wire kinetic sculpture of her, and posters by 'Cassandre'

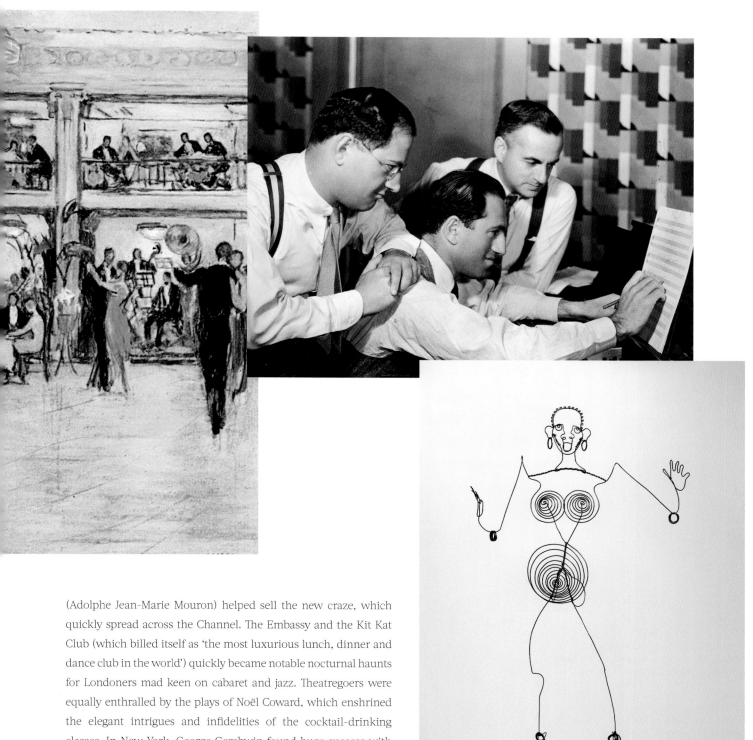

(Adolphe Jean-Marie Mouron) helped sell the new craze, which quickly spread across the Channel. The Embassy and the Kit Kat Club (which billed itself as 'the most luxurious lunch, dinner and dance club in the world') quickly became notable nocturnal haunts for Londoners mad keen on cabaret and jazz. Theatregoers were equally enthralled by the plays of Noël Coward, which enshrined the elegant intrigues and infidelities of the cocktail-drinking classes. In New York, George Gershwin found huge success with his musical compositions in both popular and classical genres, including his orchestral work of 1924, *Rhapsody in Blue*, and a plethora of Broadway theatre numbers such as 'Fascinating Rhythm', which he and his brother Ira wrote that same year. Their

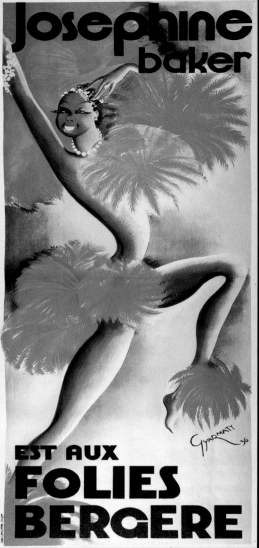

FROM LEFT TO RIGHT Josephine Baker in costume
for her famous 'banana dance'; Folies Bergère poster
from 1936 advertising Josephine Baker; Josephine
Baker in the 1920s – the epitome of glamour.

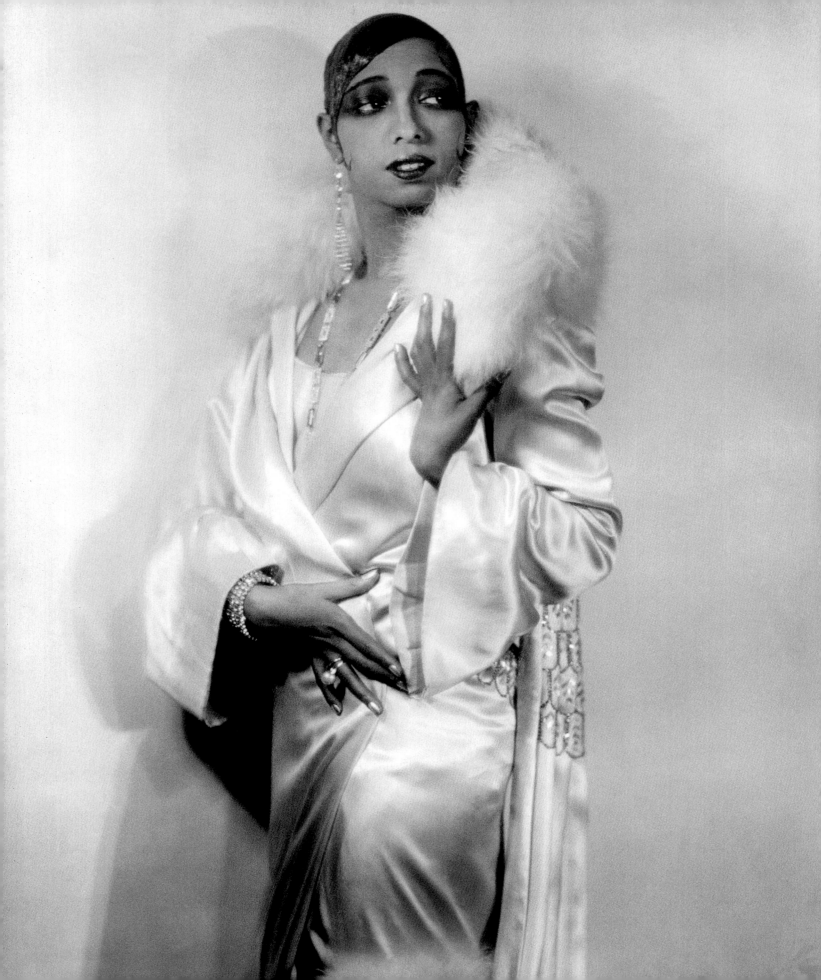

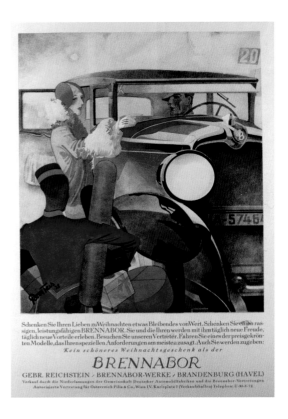

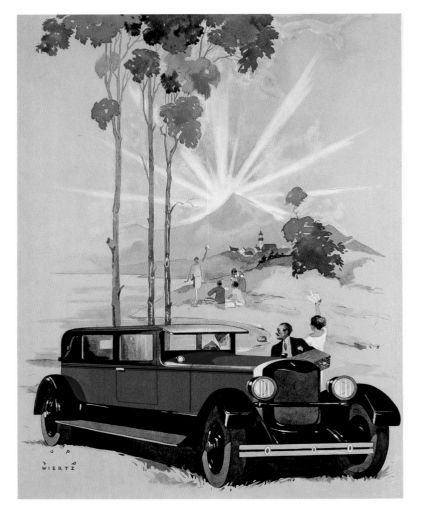

friend, Cole Porter, also composed a hugely successful series of hit musicals and songs distinguished by lyrics every bit as witty as Noël Coward's one-liners. The lyrics to 'Anything Goes', written for Porter's musical of the same name, celebrated the madcap antics exhibited aboard an ocean liner bound for London from New York, epitomising the atmosphere of risqué abandon that characterised the age:

In olden days, a glimpse of stocking
Was looked on as something shocking.
But now, God knows,
Anything goes….
If driving fast cars you like,
If low bars you like,

If old hymns you like,
If bare limbs you like,
If Mae West you like,
Or me undressed you like,
Why, nobody will oppose'.

'Anything Goes' also underlined the importance of travel in this new era of sophistication and speed. By 1925, ten million Model T automobiles had been manufactured on new 'production lines' and sold in the US, and two years later the celebrity aviator Charles Lindbergh made front cover headlines in every newspaper around the world after flying non-stop across the Atlantic from New York to Paris. Everything moved at breakneck pace as the world got smaller, and, as if in recognition of this, the construction of the

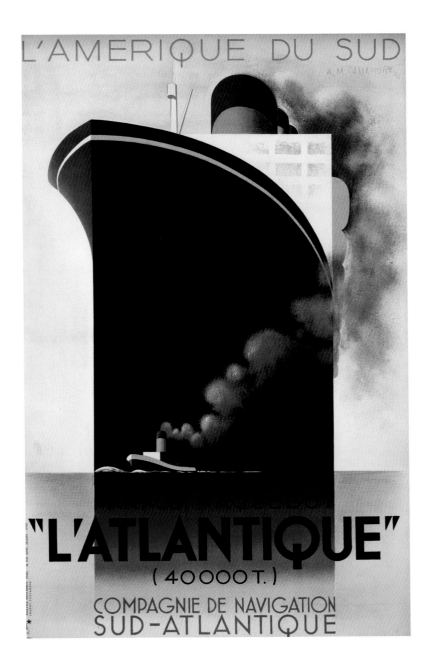

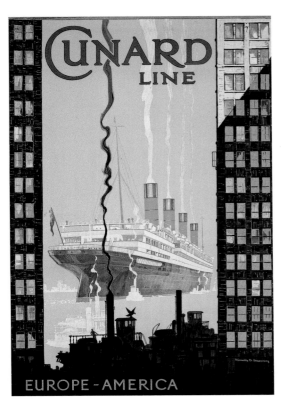

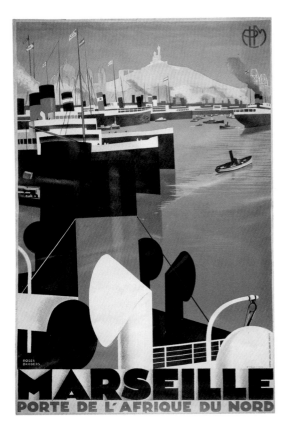

FROM LEFT TO RIGHT Advertisement for a Brennabor motor car from 1928, showing an upper-class woman doing her Christmas shopping; illustration by Jupp Wiertz, c.1920; poster by Cassandre advertising the ocean liner *L'Atlantique*, c.1931; poster by Kenneth Shoesmith advertising travel from Europe to America with the Cunard Line, c.1925; poster by Roger Broders advertising Marseille as a gateway to North Africa, 1930. V&A Museum, London. © ADAGP, Paris and DACS, London.

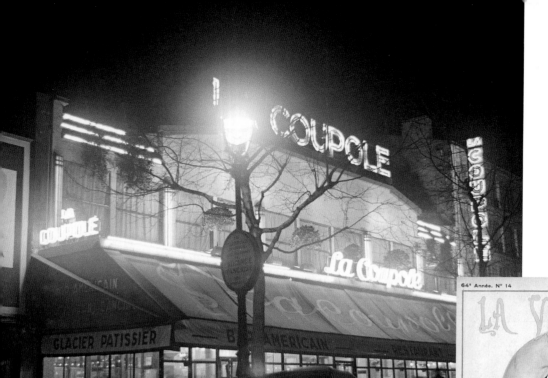

Empire State Building commenced, a project designed to erect the tallest monument on the planet as a potent symbol of man's great advances, its striking Deco lines visible for miles around. Trips on ocean liners, in automobiles and even on airships were thoroughly stylish in every way, and nothing was left to chance: tables in the first-class dining cars aboard trains and ships were set with linen tablecloths, and it was understood that people would 'dress' for dinner even when travelling, just as they would for the theatre and opera. 'Dress' meant white tie and tailcoats for gentlemen and evening gowns for ladies. Porters were available to carry luggage, and cab drivers would naturally open the doors of taxis for their passengers: the experience was truly elegant in every respect.

Commercial radio broadcasting enabled the world to share events almost instantaneously, while in the fledgling film industry, Warner Bros boldly added sound to their motion pictures, releasing the first 'talkie', *The Jazz Singer*, in 1927. It was a storming success and thereafter this age of unabashed glamour

was reinforced and reflected back to the world by Hollywood's royalty, further increasing the momentum of change. This, then, was a thoroughly modern age, an age of the high life: big bands, razzmatazz, bootleggers and Babe Ruth in the ballpark. Above all, it was about life in the fast lane, and immersing oneself in a whole new environment as described in Ernest Hemingway's *A Moveable Feast*. This memoir of expatriate life in Paris in the 1920s depicts a carefree café society and a multitude of establishments such as the Dome, La Rotonde, Le Select and La Coupole, where exiles from

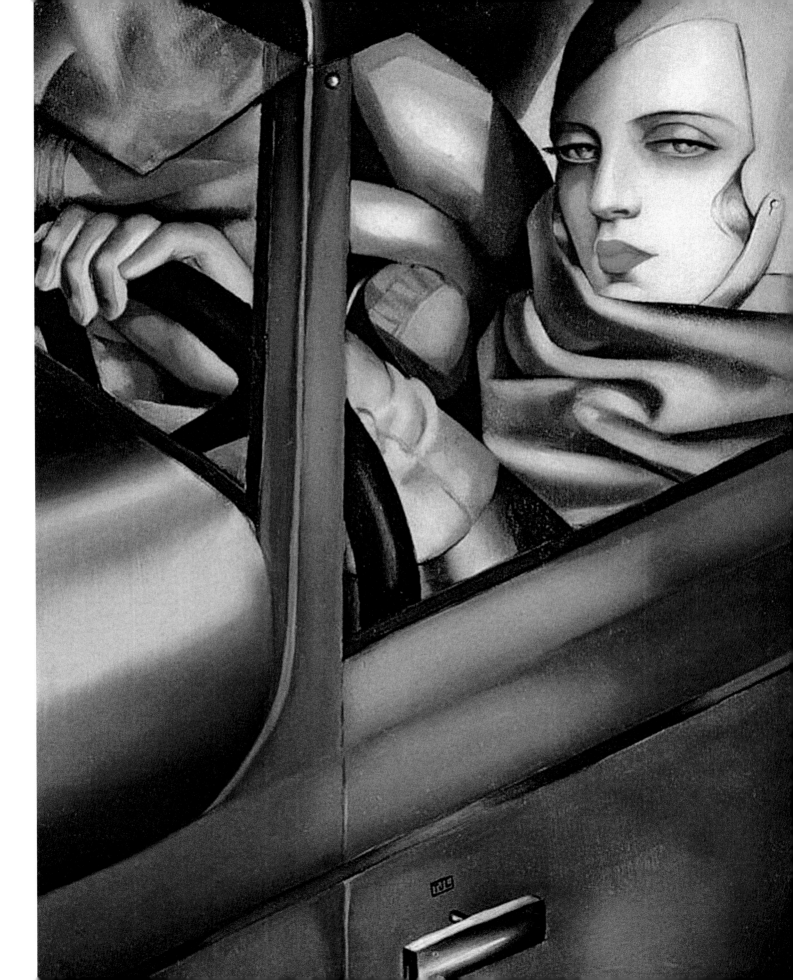

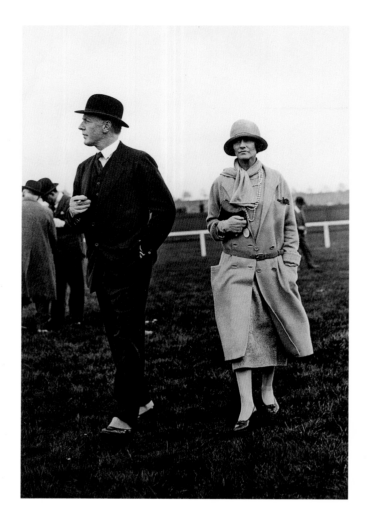

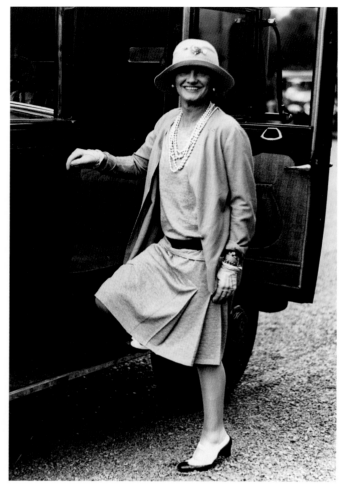

America or Germany would rub shoulders with artists, writers and intellectuals. Hemingway's friend F. Scott Fitzgerald and his flapper wife Zelda led the way as living examples of the hedonism portrayed in *The Great Gatsby*.

Changing lifestyles had a huge effect on women. During the conflict they had worked in munitions factories and fields, operated machinery, worn uniforms and nursed on the front line, gaining their long-awaited freedom in the process. Emancipated, they bravely resolved to remain so when peace returned, hurling themselves wholeheartedly into the unknown world emerging from the embers of combat. Their new post-war status, self-image, roles and enfranchisement all triggered a liberation of behaviour, and the changes were manifold and clear to see. These newly independent women were active and sporty. They embraced the joys of the open air, played tennis and golf and wore bathing suits on holiday in the South of France. They were seen at the

steering wheels of cars and in the pilot seats of aeroplanes; they swept decoratively down the gangways of yachts, posed at stylish motorcar rallies and danced and drank cocktails by night. Many aspired to be *La Garçonne* (The Bachelor Girl), introduced by Victor Margueritte in his novel of 1922, which sold more than 100,000 copies and made the author a fortune (though it was still considered scandalous enough to have him struck off the rolls of the Legion of Honour). This liberated female heroine became a role model for young, emboldened women everywhere.

New habits and hobbies in turn affected fashion, social mores and etiquette. In Europe, women like Coco Chanel were beginning to define the new style rules; descending from her lover the Duke of Westminster's yacht 'as brown as could be', she introduced the appeal of the suntan. Women began to wear makeup more openly and with relish, applying and touching it up in public. Until then, makeup had been worn with reserve and was not

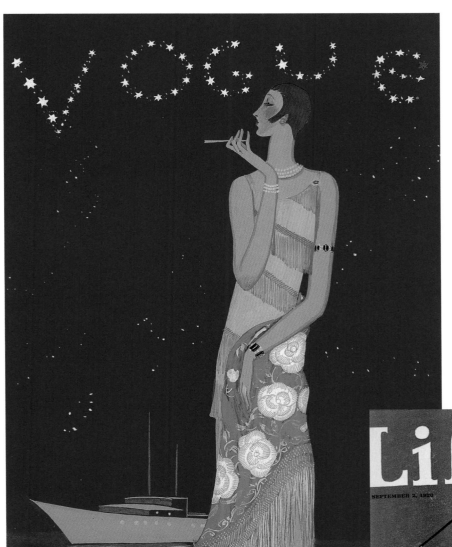

OPPOSITE Coco Chanel at the Chester Races with Hugh Grosvenor, 2nd Duke of Westminster, 1 May 1924; Coco Chanel in Biarritz in 1928. LEFT *Vogue* cover by Eduardo Garcia Benito showing a woman in a flapper dress against a night sky with an ocean liner in the background, 1926. BELOW Cover of *Life* magazine, 5 September 1926.

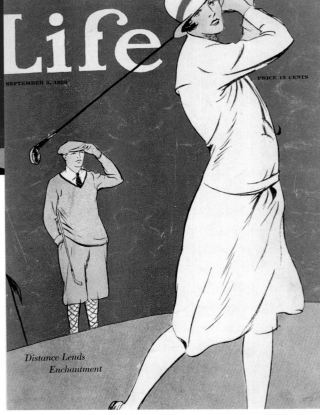

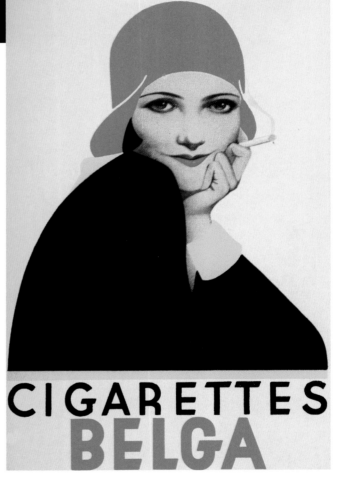

LEFT Russell Patterson, *Where There's Smoke There's Fire*, 1920s. BELOW Vintage postcard illustration advertising Belga cigarettes, c.1925. OPPOSITE, CLOCKWISE FROM TOP Advertising poster for Chesterfield cigarettes, c.1925; advertisement for Lucky Strike cigarettes from *International Studio* magazine, 1926; advertisement for Players cigarettes from *The Sphere*, 28 May 1927.

CIGARETTES BELGA

considered respectable for any lady of good standing, but all this changed as women looked to Hollywood and the idols of the silver screen for inspiration, and movies brought visions of glamour and sophistication to a larger, wider public than ever before.

Increasing numbers of women, wooed by the tobacco industry's cunning marketing campaigns, were also smoking, posing seductively with their stylish cigarette holders. Smoking had already become popular by the middle of the nineteenth century but was a strictly male custom. By 1881 a machine was available for rolling cigarettes, and once smoking became permissible in public establishments during the war, it was clear that the new habit was here to stay. The American Tobacco Company began targeting women with its advertisements for Lucky Strike: they employed prominent celebrities such as Amelia Earhart to feature in their campaigns, further appealing to the vanity of women by promising that the new habit would have a slimming effect. The Phillip Morris Company introduced their Marlboro cigarettes with ivory tips in 1925, advertising them as being 'mild as May', speaking directly to the female consumer. Very soon a woman with a cigarette was branded a woman with appeal, and this acceptance triggered an immediate demand for all the accessories that came with the new practice. Small lighters operable with one hand had been introduced at the turn of the century, but by the 1920s the full gamut of smoking requisites became available and these ceased to be purely functional: they now had strong and sleek designs of their own and were perfectly made to fit easily in a pocket or slip into a purse.

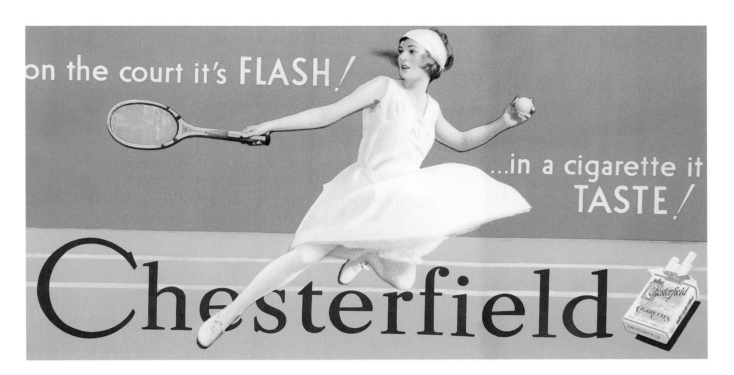

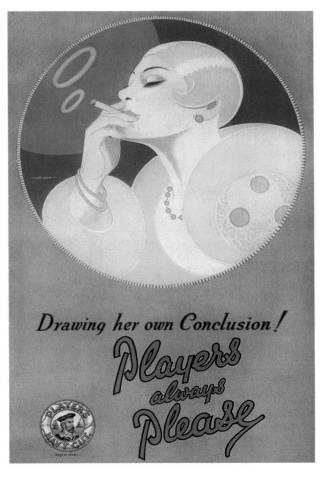

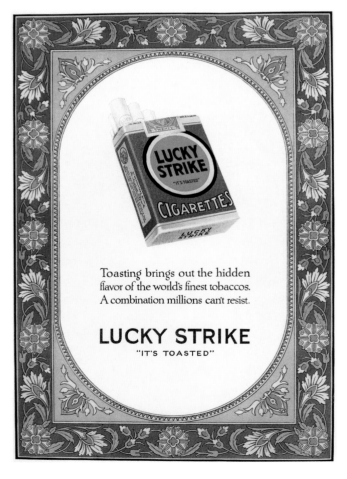

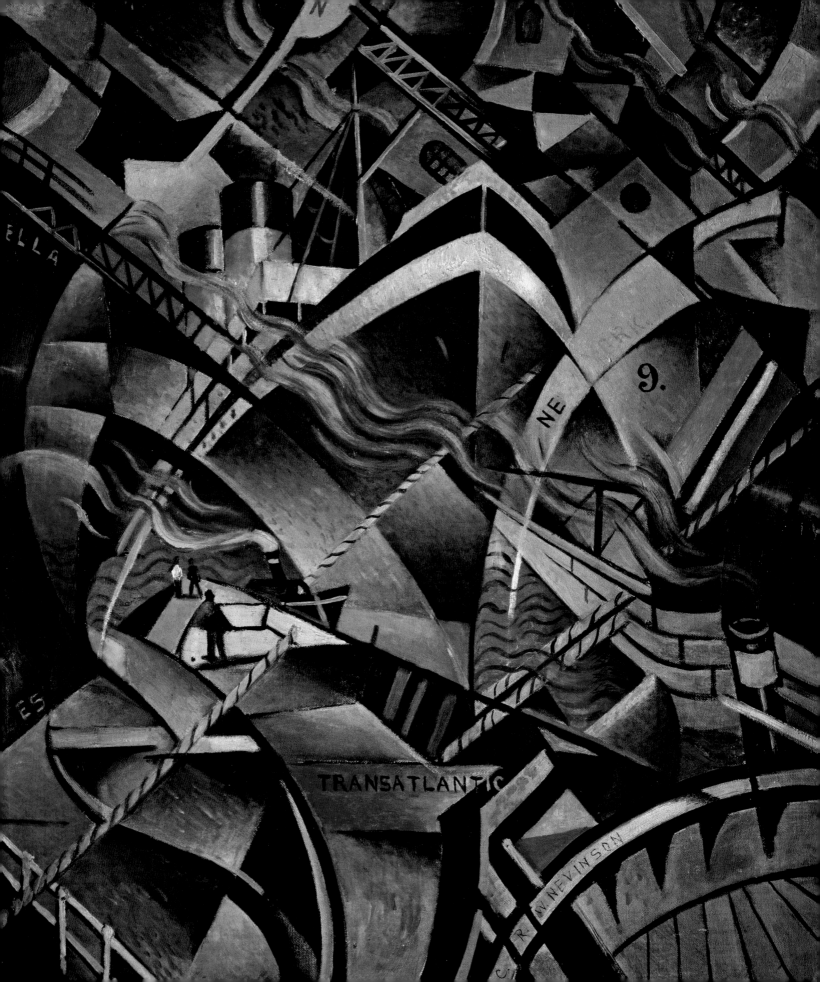

All the fervency of this new age demanded a new style, a means of expression that could be adapted to every aspect of design and to all areas of creativity. Art had already been moving towards the 'modern' before the war. The various avant-garde art movements of the first decade of the twentieth century together represented a complete discarding of the past and the birth of entirely new aesthetics in its place. In 1907 Picasso painted his *Demoiselles d'Avignon*, marking the advent of Cubism. In 1909 the Italian poet Filippo Marinetti published the Futurist manifesto, extolling the merits of the machine and modern urban culture, and only eight years later the Dutch De Stijl painter Piet Mondrian developed his own brand of abstract art and named it Neo-plasticism, while abstraction was presented in full technicolour by the Orphist artists Robert and Sonia Delaunay. By 1925 the cacophony of all these cultural voices had reached a climax.

Nowhere witnessed the exuberant atmosphere of creative exchange more

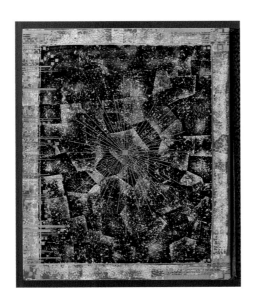

than Paris. The city was buzzing with an intoxicating atmosphere and it became the undisputed centre of the art world between the wars. Craftsmen, writers, painters, sculptors, architects and artisans of all types exchanged ideas and ripped the rulebooks to shreds in the cafés of Montparnasse, reinventing and rewriting their own scripts with gay abandon. Their passion fanned the flames of artistic expression everywhere, and if any one trend could be said to characterise the 1920s it was the way in which innovation was constantly celebrated, embraced and then translated into style. Out of this creative ferment in the visual arts emerged the first truly international twentieth-century design style. It was sumptuous, stunning, dramatic and dynamic, and later generations would come to know it as Art Deco.

Deco gathered inspiration from every direction, embracing riotous colours from the Ballets Russes and the Fauves; geometric shapes from Cubism; linear, grid-like forms and black-and-white contrasts from Neo-plasticism and a fascination with new technology from

A BRAVE NEW STYLE

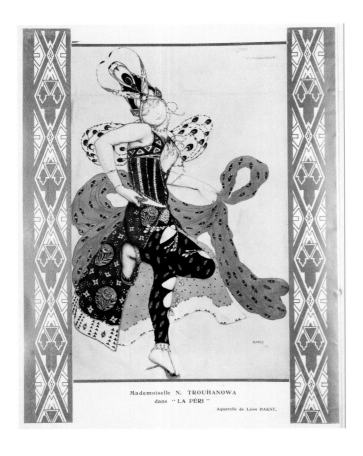

Mademoiselle N. TROUHANOWA
dans " LA PÉRI "
Aquarelle de Léon BAKST.

LEFT Costume design by Léon Bakst for Natalia Trouhanova in the Ballets Russes production of *La Péri*, Paris, 1911. V&A Museum, London. BELOW *Vogue* cover from 1923 showing a woman feeding sugar cubes to a Chinese dragon. OPPOSITE Costume design by Léon Bakst for the Ballets Russes production of *The Firebird*, Paris, 1910. V&A Museum, London.

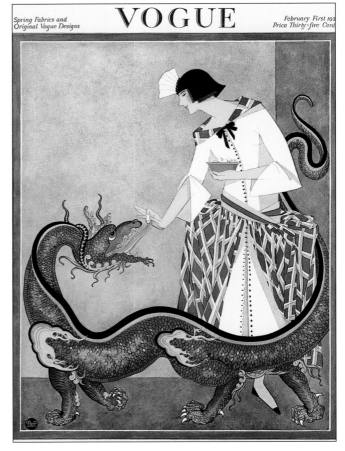

Spring Fabrics and
Original Vogue Designs

VOGUE

February First 192
Price Thirty-five Cent

Futurism. It was modern because it combined all these artistic ideas with the influence of the machine and the motifs of industrial design: the wings of aeroplanes, the portholes of ocean liners, the moving parts of automobile engines – all were discernable in the new aesthetic. It also encapsulated the modern in its adoption of new materials such as plastic, Bakelite and chrome, and in its use of the more traditional materials in striking new combinations and contrasts.

There seemed an unlimited supply of influences to draw upon and sources of inspiration were by no means confined to modern Europe: a taste for exotic cultures from overseas also provided a new repertoire of styles, iconography, motifs and materials. An Egyptian vogue was promoted by the discovery of 'King Tut's' tomb in 1922, while other fashions were borrowed from China and Japan and from Persia, India and Africa. All these

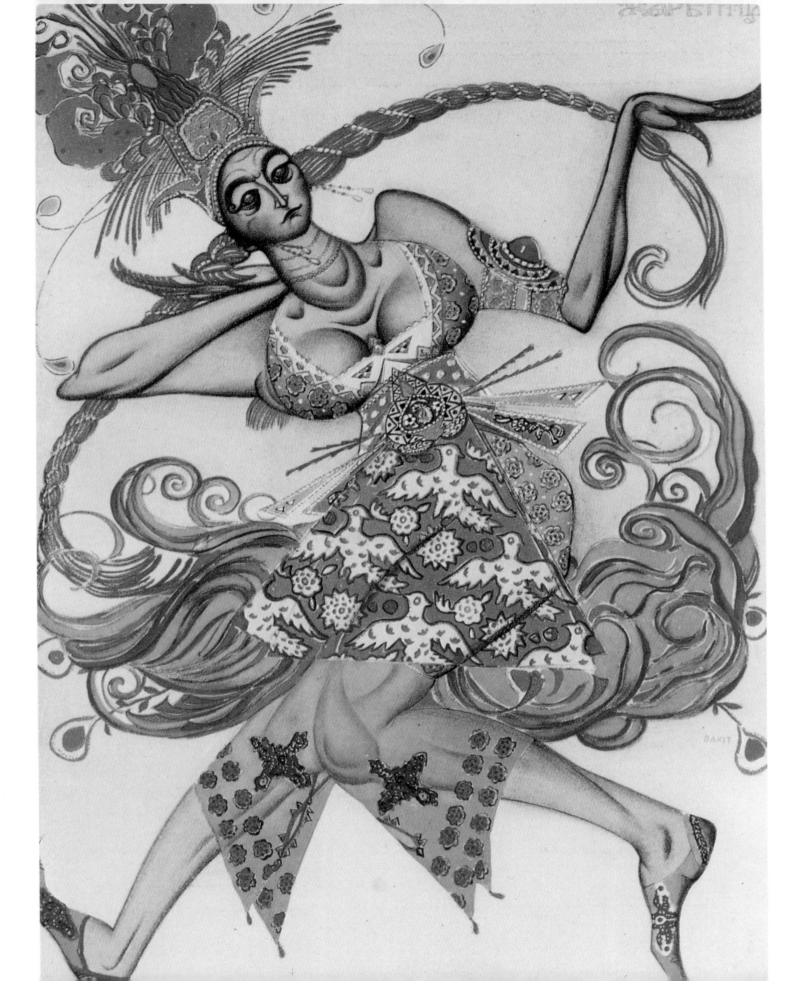

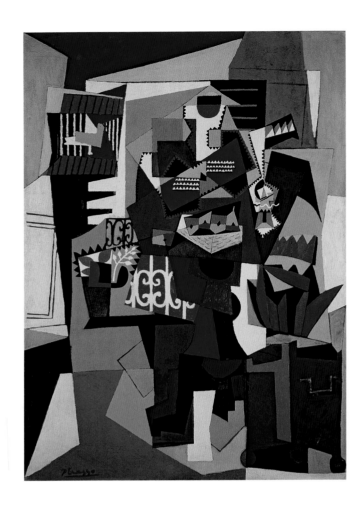

different artistic and aesthetic influences were acknowledged and incorporated into the designs of the day, producing a bewildering array of creations emerging from directions both divergent and yet parallel. And just as it appeared from these different sources, so Art Deco encompassed a range of stylistic variations, some more decorative and ornate, particularly in the early part of the 1920s, becoming more severe and geometric as the decade progressed. The underlying common denominator among all the disparate artists and designers who embraced this style, however, was a desire for modernity, a love of the striking and the dramatic, and a willingness to experiment and expand the boundaries of creativity to generate something entirely novel.

The new aesthetic seemed ubiquitous, influencing everything from art, architecture and interiors to automobiles and boats, as well as jewellery and precious objects. It pervaded all fields of creativity: 'Couturiers, barmen, snobs, wealthy art lovers, intellectuals and society figures strove with one frantic accord to reveal and perfect the bold aesthetic impulses of the age,' observed the writer and critic Jean Cassou. Objects had geometric lines, clean angles and smooth surfaces. Many featured unexpected contrasts between vivid and clashing colours, and between stones and materials which had been newly discovered or which were now selected for their aesthetic rather than commercial value. Arriving at a time when new forms of communication, travel, films, newspapers and magazines would all ensure its rapid spread and wide dissemination, Deco was an all-encompassing and all-embracing look that immediately captured the universal spirit.

RIGHT Bookbinding by Pierre Legrain for Francis Carco's *Tableau de l'Amour Vénal*, c.1925. Private collection, London. BELOW Bookbinding by Jean Dunand for Pierre Louÿs's *Les Chansons de Bilitis*, featuring *coquille d'oeuf* and mother-of-pearl decoration, 1922. Private collection, London. OPPOSITE Lavender jade clock made in Paris for Black, Starr & Frost, c.1925. Once in the collection of H. Robert Greene, it was sold at the landmark 1978 Christie's sale of clocks and vanity cases from the 1920s, which marked the first time these pieces were considered as minor works of art. Private collection, London.

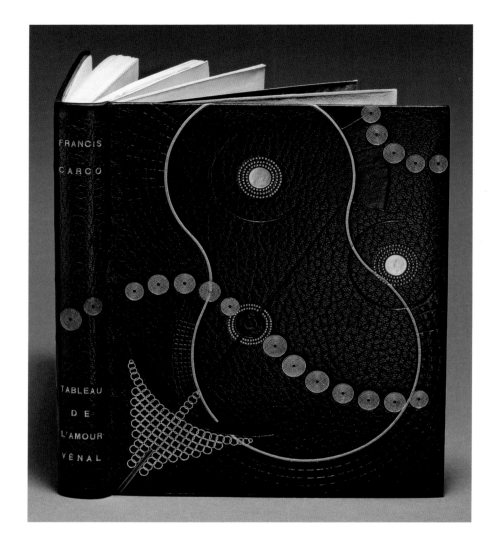

Where Art Nouveau had indulged in winding, curvilinear ornamentation, Art Deco was disciplined, clean and fiercely daring. It did not abolish decoration, but presented it in a more stylised, simplified way, sweeping aside elaboration and excess. But while Art Deco upheld the importance of individual craftsmanship and artistry, it also benefited greatly from the development of mass production, and many precious Art Deco objects intended for a rich clientele were quickly copied and manufactured in cheaper versions for less wealthy customers. All this fuelled the complete penetration of the new look across all walks of life and income brackets. The wide availability of less expensive materials allowed the 'trickle down' and proliferation of almost any item to any price point: silver, chrome or base metals, marcasite, paste stones and machine-finishing all brought costume jewellery and jewelled accessories within reach of the general public.

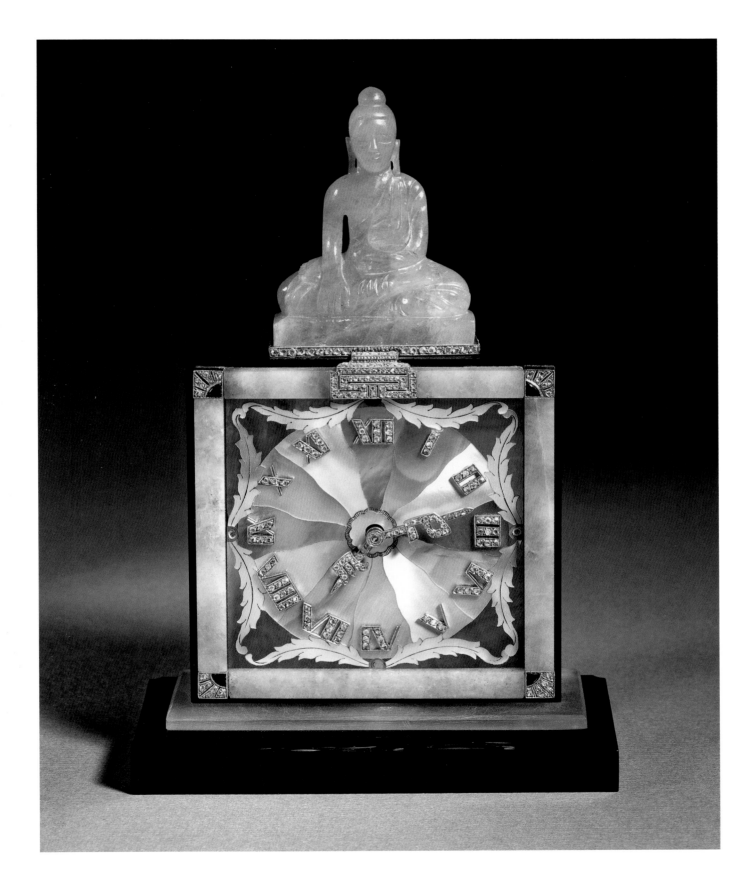

RIGHT Dining room designed by Emile-Jacques
Ruhlmann for his Collector's Pavilion at the 1925
Exhibition in Paris. BELOW Ebony dressing table,
c.1921–2, also by Ruhlmann. Private collection.

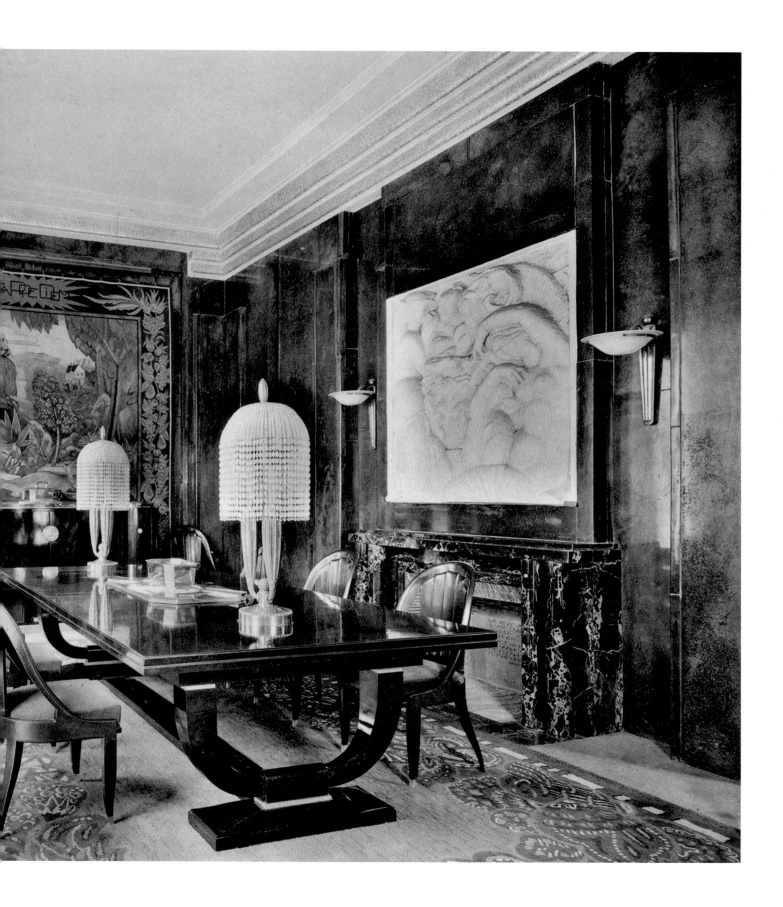

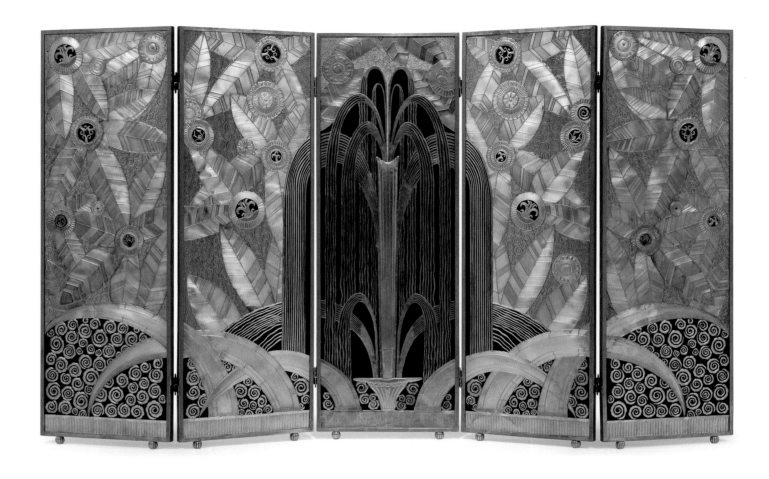

ABOVE Five-panel 'Oasis' screen in wrought iron, brass and nickel, made by Edgar Brandt in collaboration with Henri Favrier, shown at the 1925 Exhibition. Private collection. OPPOSITE Lacquer cigarette case by Jean Dunand, c.1925. Private collection, London.

Part of the reason for the rapid success of Art Deco was that it was embraced in every area of creativity and self-expression. It was so much more than just a fashion or an artistic movement: it was an entire aesthetic code for living. A 'dedicated follower of fashion' seated at a Ruhlmann table or someone sipping coffee from a Clarice Cliff cup would doubtlessly keep their cigarettes in a case designed by Gérard Sandoz, or at the very least aspire to. Each detail was a knowing little gesture, a small sign of acknowledgement and a message broadcasting that the owner understood and appreciated the very essence of what it was to be modern, to be *au courant*, and more importantly, this was abundantly obvious to everyone around them.

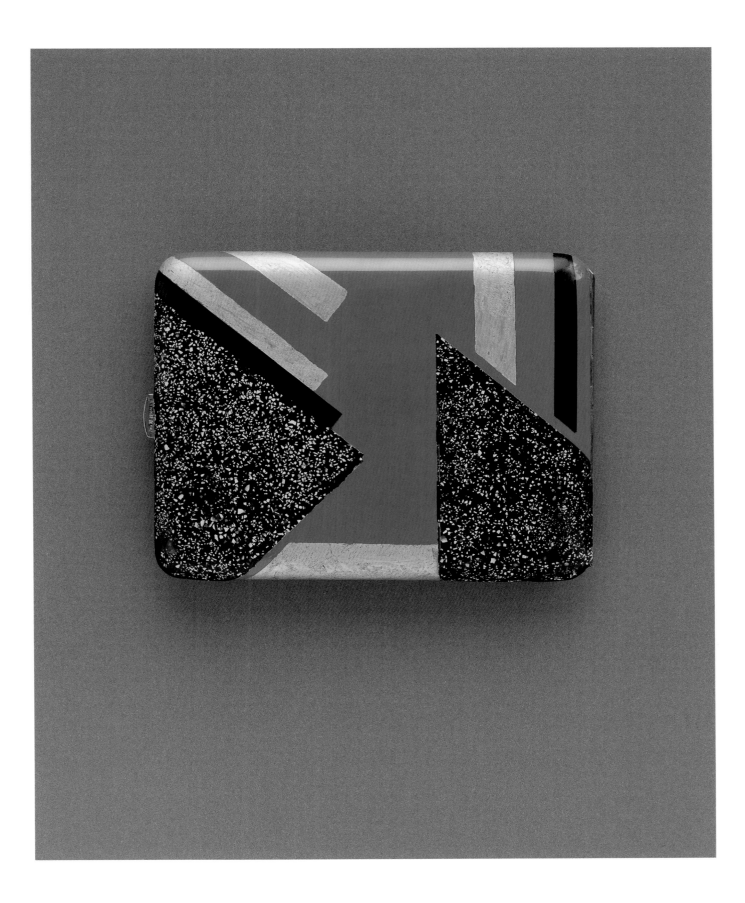

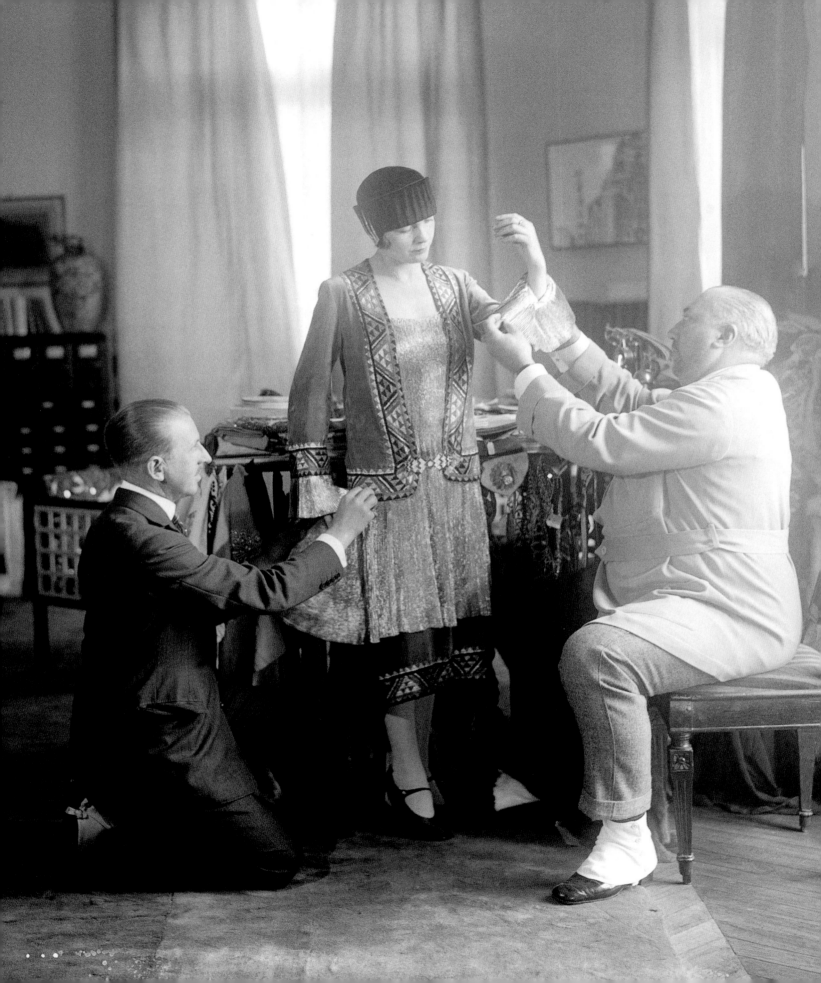

With her free spirit and new pastimes, the independent woman who appeared after the war was quick to challenge the confines of her predecessor's role in society, including what she looked like. In an era all about speed and energy she needed a new look and an entirely new wardrobe. Indeed modern dance styles demanded an overhaul of existing outfits: it was impossible to dance the Charleston in the aptly-named hobble dress or whalebone corset, and sweeping transformations liberated women everywhere from constrictive clothing as hemlines rose and hair was cut short in the ultimate display of daring and defiance. The silhouette of the body became long and slim and pencil-shaped, this verticality becoming the overriding new aesthetic in fashion: sleek and slender ruled the day. Sleeveless dresses with straight or flared skirts appeared, sometimes even slit at the side for added freedom of movement, producing an almost boyish look. Tube-shaped, low-waisted dresses were teamed with turbans, fantastically

bejewelled and plumed, or small cloche hats which completely covered the head from the eyebrows to the nape of the neck, necessitating the new shingle, bingle and Eton crop hair styles, finished off with the flair of a marcel wave.

This was a wholesale and astonishing change, and one young couturier in particular led the march towards this modern look: Paul Poiret, the uncontested leader of Paris fashion who reigned supreme for more than a decade. His vision of the modern woman was epitomised by his own wife and muse, Denise. Slim, youthful, and certainly uncorseted, she was the prototype of *la garçonne*, and Poiret used her slender figure as the basis for his radically simplified constructions. He told *Vogue*, 'My wife is the inspiration for all my creations; she is the expression of all my ideals.' He duly revolutionised women's dress by dispensing with rigid undergarments: 'I waged war on the corset', he explained, 'and like all revolutions mine was made in the name of liberty'. Having worked in the ateliers of Doucet and Worth he had

A NEW LOOK

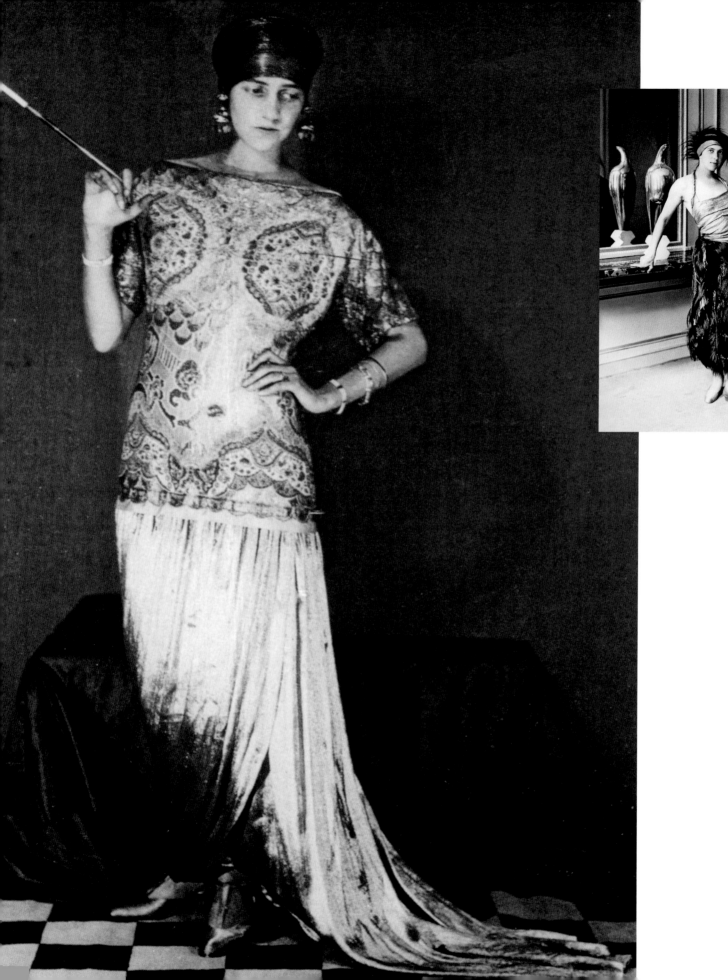

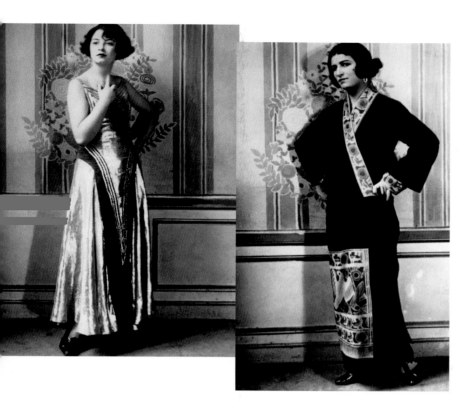

already begun to make his name by 1906 with his smooth lines and fluid dress designs. But the real breakthrough came with his 1912 Minaret collection featuring transparent gold gauze tunics worn over harem pants, which could not have been further from the delicate pastels of Belle Epoque femininity. Poiret's most significant achievement was to work with fabric directly on the body, pioneering a new approach to dressmaking that relied on the skill of draping rather than tailoring and pattern making, an approach that was to change the direction of fashion completely.

The other great influence on fashion before the First World War had been the Ballets Russes under the directorship of St Petersburg impresario Sergei Diaghilev, who brought his company to Paris in 1909. His magical touch was to have a momentous impact. The oriental splendour of his costumes, scenery and dance moves ushered in a tidal wave of colour and exoticism, and to have been at the opening night of *Schéhérazade* was surely to have witnessed the birth of this sumptuous age. First performed in Paris in 1910 with Leon Bakst's designs evoking an exotic sultan's harem, the 'Thousand and Second Night' swiftly followed, a theatrical costume party staged in 1911 at the Hôtel du Fauborg Saint-Honoré, where

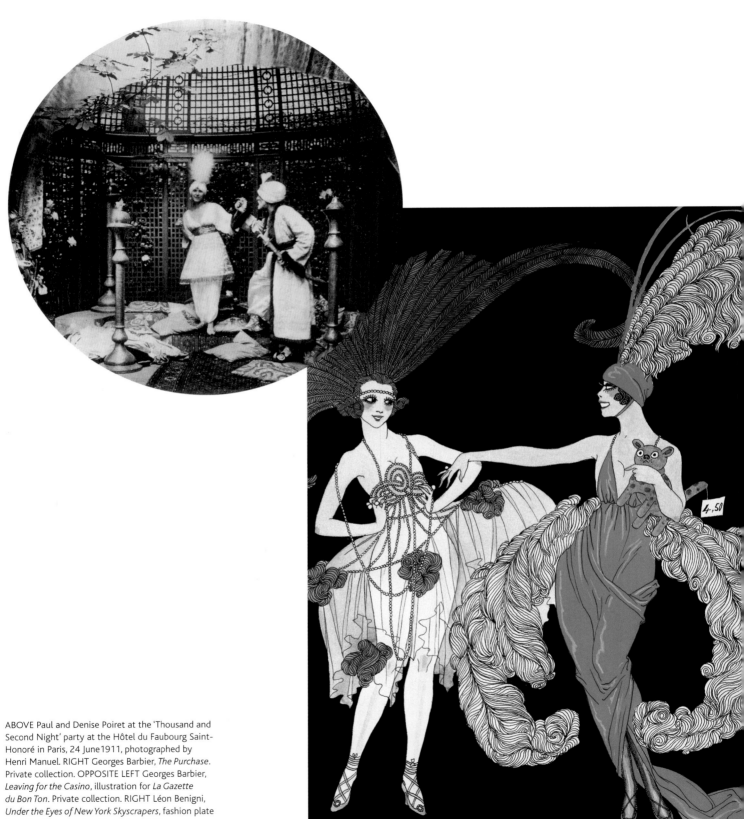

ABOVE Paul and Denise Poiret at the 'Thousand and Second Night' party at the Hôtel du Faubourg Saint-Honoré in Paris, 24 June 1911, photographed by Henri Manuel. RIGHT Georges Barbier, *The Purchase*. Private collection. OPPOSITE LEFT Georges Barbier, *Leaving for the Casino*, illustration for *La Gazette du Bon Ton*. Private collection. RIGHT Léon Benigni, *Under the Eyes of New York Skyscrapers*, fashion plate from *Femina* magazine, December 1928.

LE DÉPART POUR LE CASINO

MANTEAU DU SOIR, DE WORTH

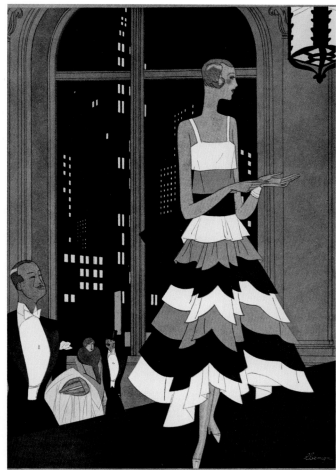

300 Parisians dressed Poiret-style in wide pantaloon trousers, bandeaus on their foreheads and feathered creations atop their bobs, carrying embroidered drawstring bags for their lipsticks and powder compacts. The pale pastels and hourglass figure of yesteryear were blown away in an instant. Clashing colours, geometric patterns and a completely new streamlined silhouette entirely overthrew all previous conceptions of acceptable female beauty.

Paul Poiret had indeed created a new woman, but he was quickly joined by Jean Patou (who outfitted the tennis star Suzanne Lenglen), Madeleine Vionnet (who invented the bias-cut), Jeanne Lanvin, Jeanne Paquin, Maggy Rouff, the House of Worth and Jacques Doucet, as well as Coco Chanel and then Elsa Schiaparelli. Chanel reinvented daytime chic by introducing fabrics and styles traditionally reserved for men. Tweeds, woollens and easy-to-wear jerseys were cut with almost masculine tailoring into her

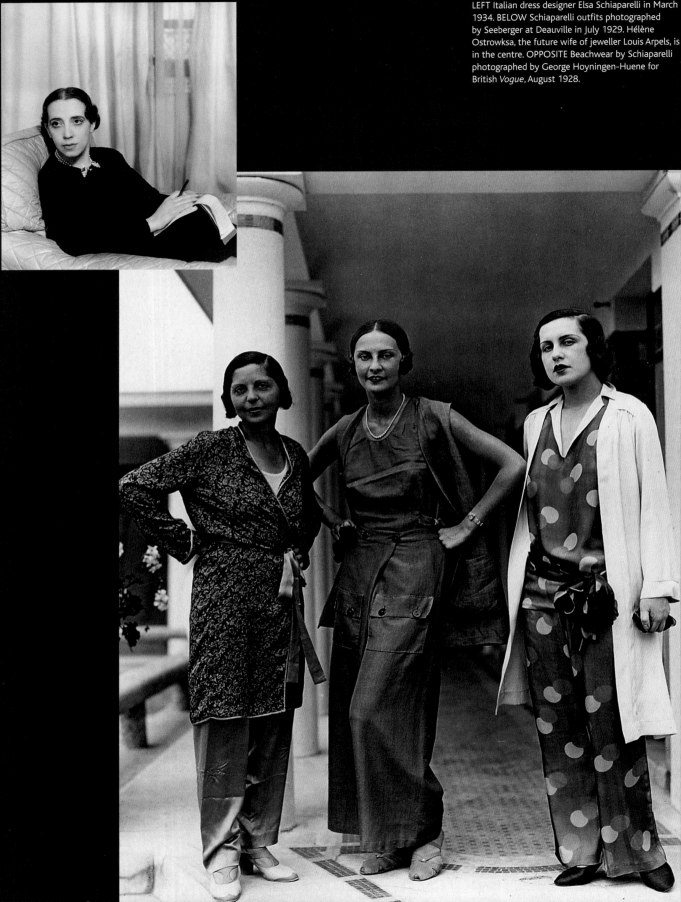

LEFT Italian dress designer Elsa Schiaparelli in March 1934. BELOW Schiaparelli outfits photographed by Seeberger at Deauville in July 1929. Hélène Ostrowksa, the future wife of jeweller Louis Arpels, is in the centre. OPPOSITE Beachwear by Schiaparelli photographed by George Hoyningen-Huene for British *Vogue*, August 1928.

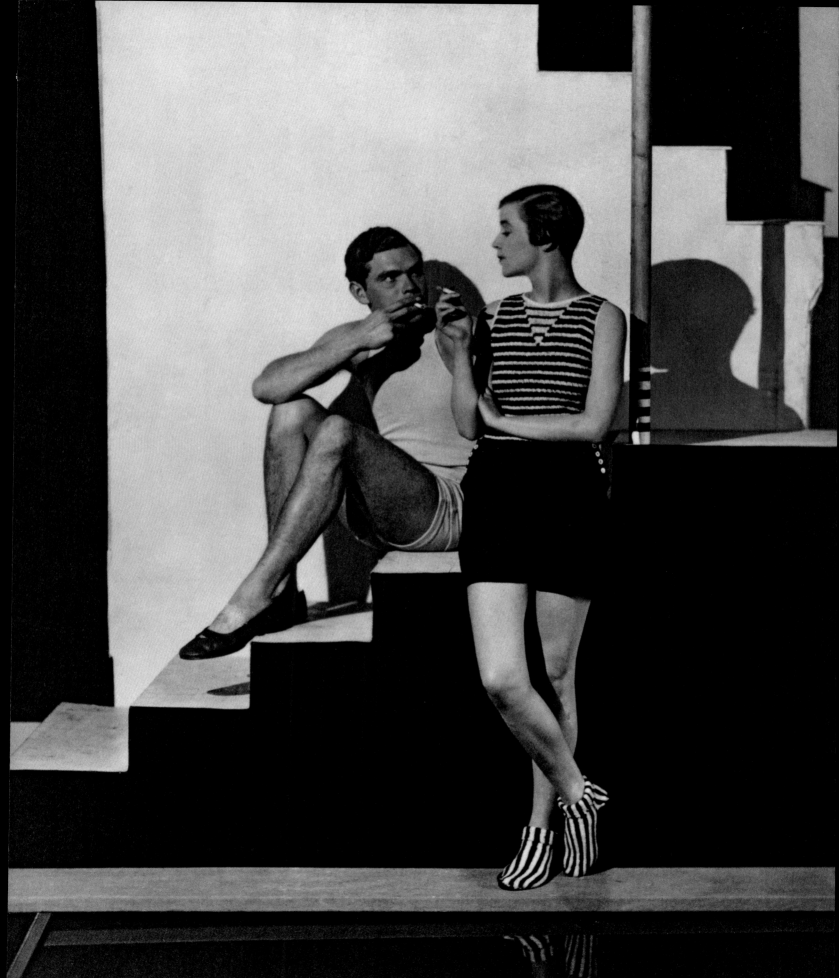

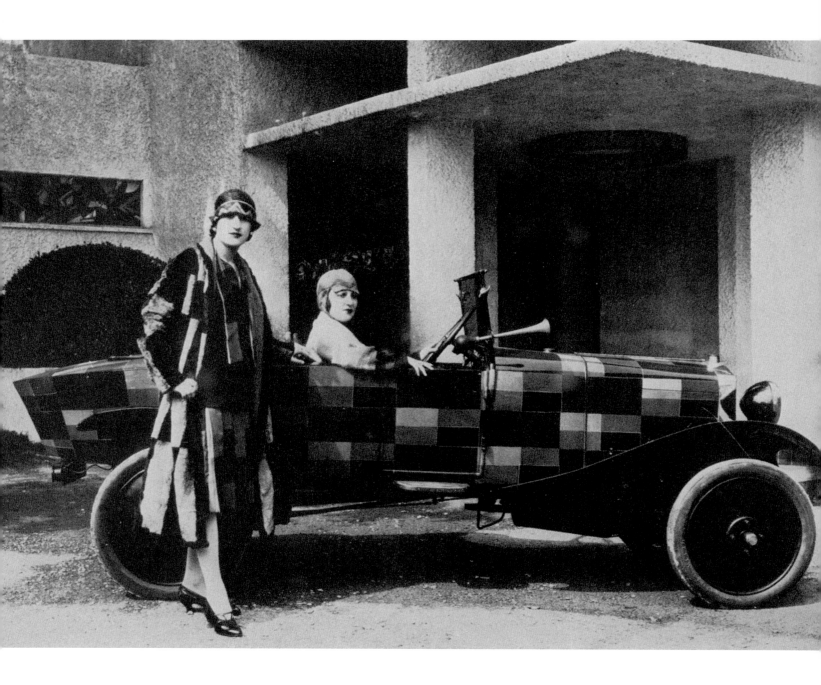

ABOVE 'Simultaneous' outfit with matching Citroen B12, both designed by Sonia Delaunay, 1925. OPPOSITE LEFT Sonia Delaunay and two friends in Robert Delaunay's studio, rue des Grands-Augustins, Paris, 1924. Photo © Fonds Delaunay Pracusa Artisticas, SA. RIGHT Illustration by Erté showing the design for a costume worn by Polish singer Ganna Wolkska in the opera *Fedora*, 1919.

FOLLOWING PAGES FROM LEFT TO RIGHT Red and silver dress by Paul Poiret; evening dress by Paul Poiret; *Vogue* cover showing summer fashions, June 1929.

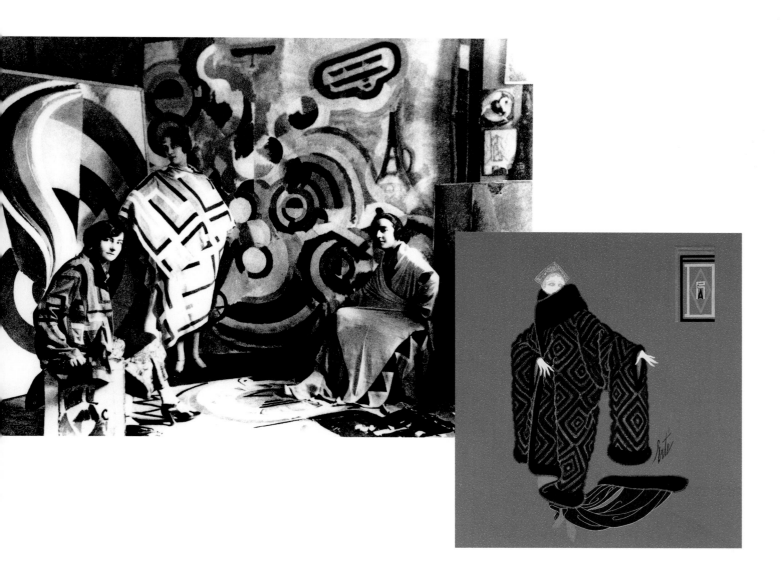

signature two-piece suits. Artists too made their mark on the fashion industry. Sonia Delaunay created multicoloured geometric textiles for brightly checked and patterned clothing, even adorning her own car with such decoration, reflecting the sheer eccentricity and exuberance of the day.

Fashion played an important role in Art Deco design not just for its direct influence but also because many of its leading lights, Paul Poiret and Coco Chanel in particular, were extraordinary collectors and tastemakers who themselves promoted and promulgated 'Le Style 25'. Poiret successfully spread his influence far wider than most of the other fashion designers, advancing the entire Deco style with the design school and workshop he founded in 1912, named Atelier Martine, after his daughter. Here he designed rugs and carpets, upholstery and curtain fabrics, wallpapers, furniture

and lamps – whole interior design schemes in fact – which he exhibited on decorated barges under the Alexander III Bridge during the 1925 Exhibition. Perhaps best known for the exotic ostentation of his hospitality, he was above all a patron of the arts, supporting young creatives, collecting their works and publishing books as well as holding his famous fancy dress balls.

This then was the ripple effect of the avant-garde designers of this period, whose reach was extended by a host of collaborations and mutual support: Paul Iribe and Georges Lepape produced albums of colourful ink drawings depicting Poiret's new fashions, the artist Raoul Dufy created textile designs for him and Romain Tirtoff, under his pen name Erté, was taken on by Poiret as a fashion designer in 1913 (and subsequently went on to create many designs for jewellery including sautoirs and hair jewellery).

Création Paul Poiret

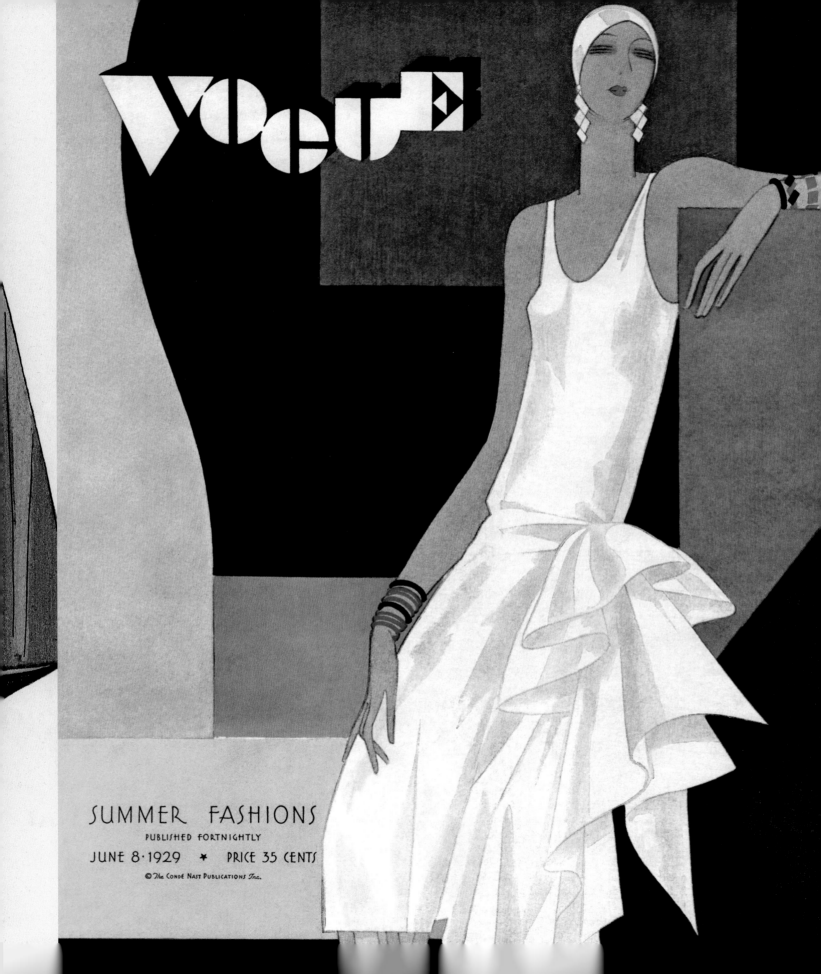

Vogue

SUMMER FASHIONS
PUBLISHED FORTNIGHTLY
JUNE 8·1929 ★ PRICE 35 CENTS
© The Condé Nast Publications Inc.

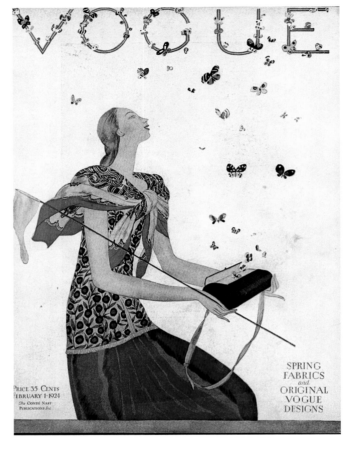

Yet fashion was not seen as exclusively the domain of the major couture houses and the upper classes, and new fashions seemed to percolate down through every social rank as style became commercial. The difference between mass fashion and couture was realised through the types and qualities of materials used, and this popularisation of fashion was influenced by the outfits and appearances of the newly created stars of stage and screen, as well as by the growth in circulation of women's magazines and journals. *Harper's Bazaar* first started in 1867 as a US publication marketed as 'a repository for fashion, pleasure and instruction', with a British edition launching in 1929. *Vogue* appeared in the US in 1892, then in the UK in 1916. These magazines came into their

own in the 1920s, becoming the absolute arbiters of taste and style for fashion conscious women everywhere.

Hollywood proved another infuence not only on fashion, but also on makeup, as it became an increasingly essential part of the new female look. Makeup had already enjoyed a long history dating back to the ancient cultures of Egypt, Persia and India. During the reign of Queen Elizabeth I, aristocratic English women followed their monarch's example by painting and powdering their faces white with mixtures of lead and arsenic. By the eighteenth-century, makeup in France had become more acceptable and elaborate, with potions and powders stored in glorious gold boxes known as *boites-à-rouge-et-à-mouches* which were kept

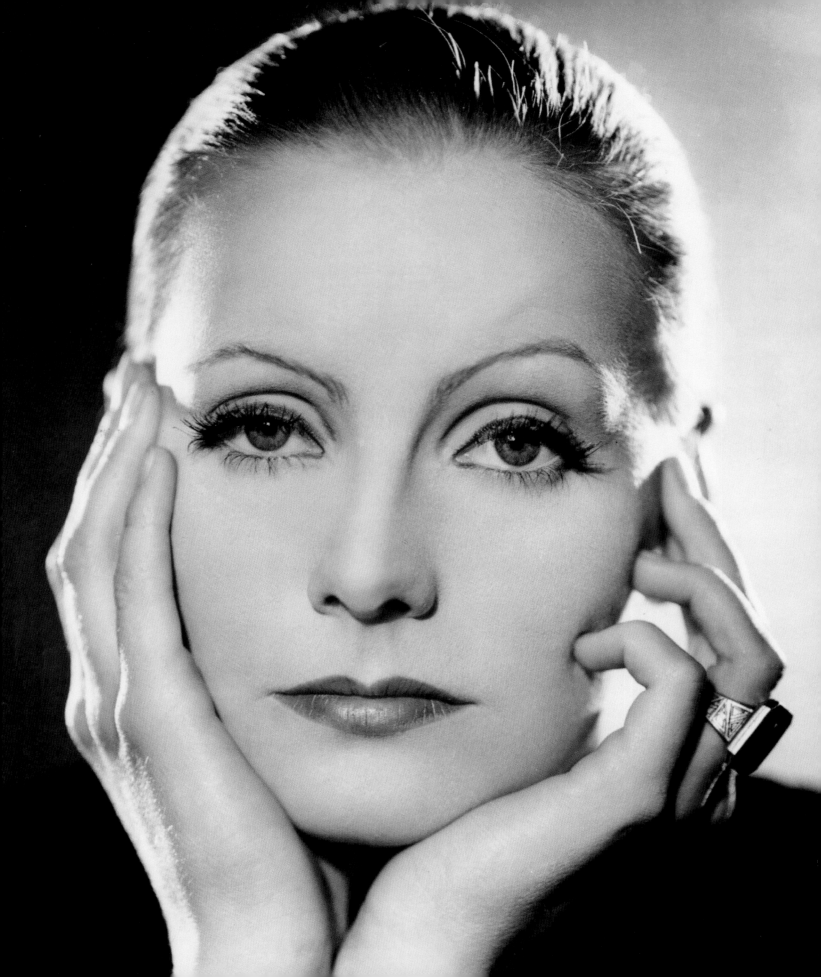

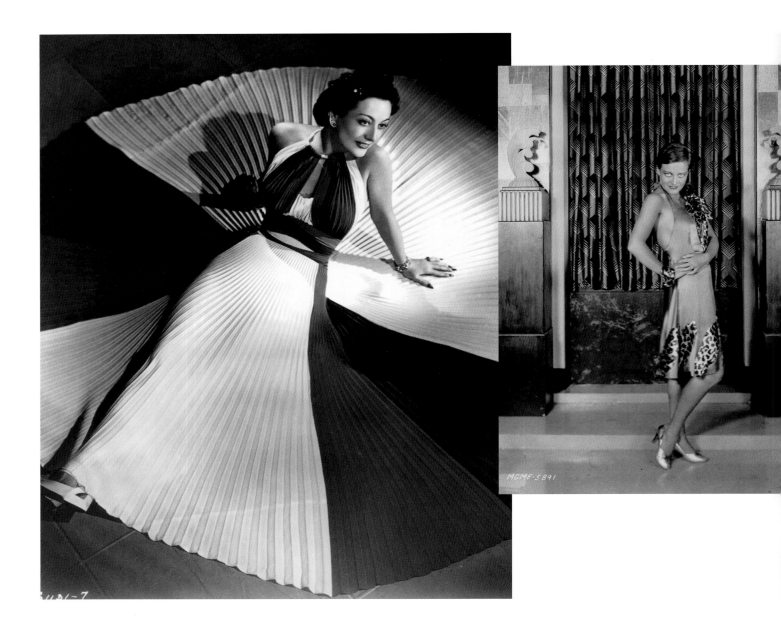

FROM LEFT TO RIGHT American actress and style icon Joan Crawford wearing a dress designed by Gilbert Adrian for her role in *Susan and God*, 1940, a flapper dress with leopard print trim, 1928, and two dresses designed by Adrian for *Letty Lynton*, 1932.

within the confines and privacy of a lady's boudoir. During the nineteenth century, however, as modesty and restraint became the watchwords for women, the use of makeup was generally condemned as vulgar and suitable only for actresses and the demi-mondaines. Society ladies conscious of shiny complexions might only use a surreptitious dab from a *papier poudré*, which was secreted away in a small bag or chatelaine as swiftly as possible.

It was only in the twentieth century, with the development of the fashion and entertainment industries, that progress really accelerated and an entirely new concept of beauty – and the means to achieve it – arrived. Grooming had previously taken place at the

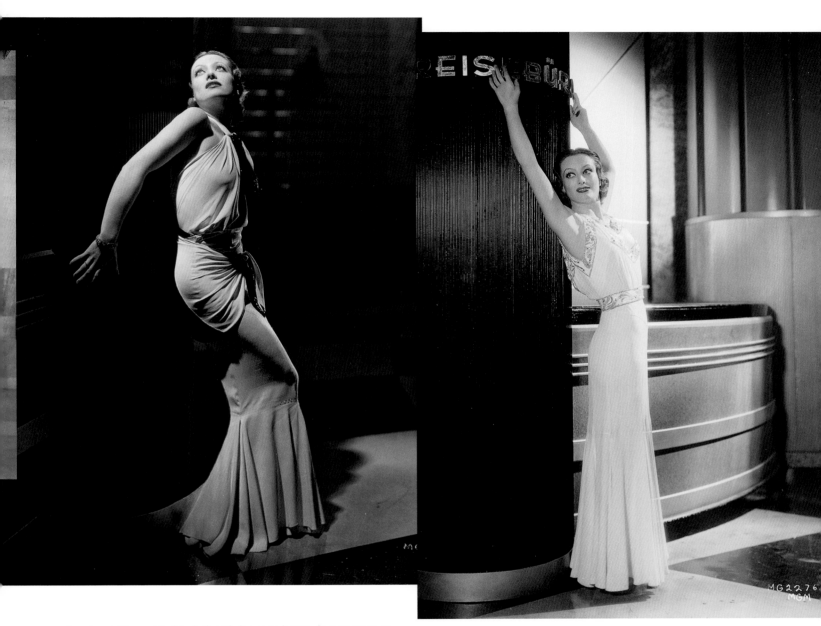

dressing table and behind closed doors at home, but as women led more active lives beyond the confines of the house they began to require cosmetic products they could carry in portable containers. As yet these containers remained rather rudimentary and utilitarian, and the products within them somewhat unsophisticated compared to today: powders were still coarse and not yet milled into more modern and refined versions, while basic lipsticks and primitive pots of rouge were kept hidden in simple bags or perhaps discreetly carried inside gloved hands.

It was the impact of the Ballets Russes that really catapulted colour into everyday life, and cosmetics quickly became big

FOLLOWING PAGES LEFT Holywood's cosmetic expert Max Factor applying makeup to Joan Crawford. RIGHT Queen of cosmetics and successful businesswoman Helena Rubenstein modelling a selection of jewellery. BOTTOM RIGHT A 1920s flapper in a convertible powdering her cheek in a mirror.

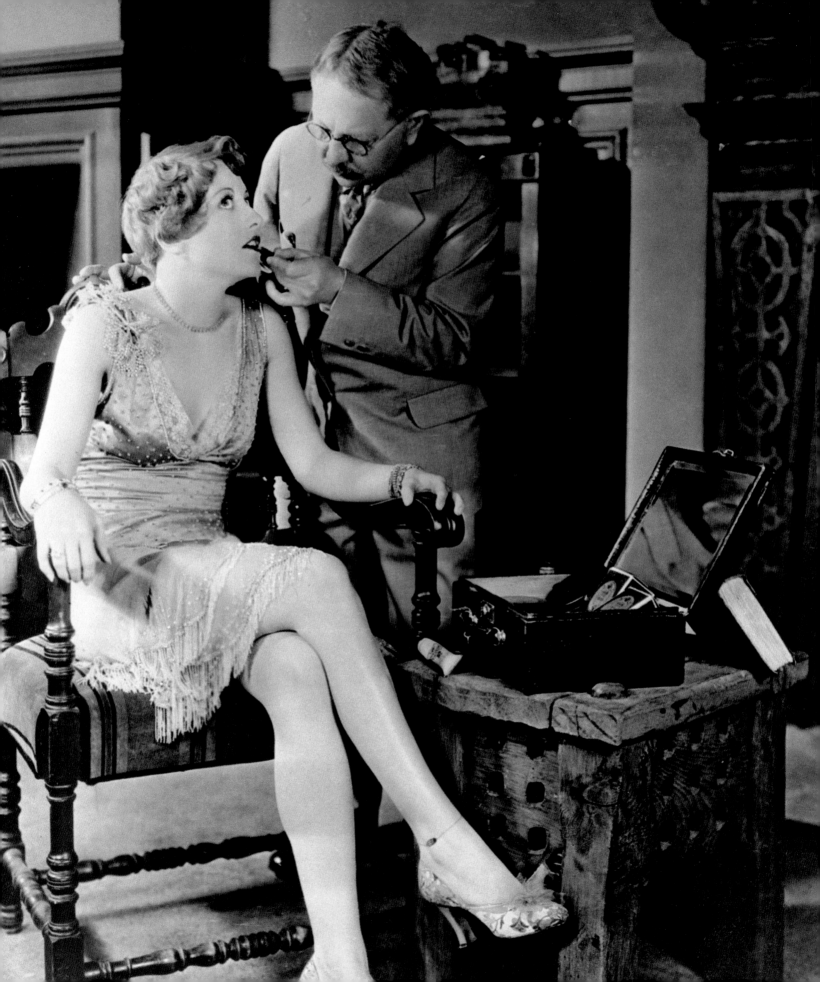

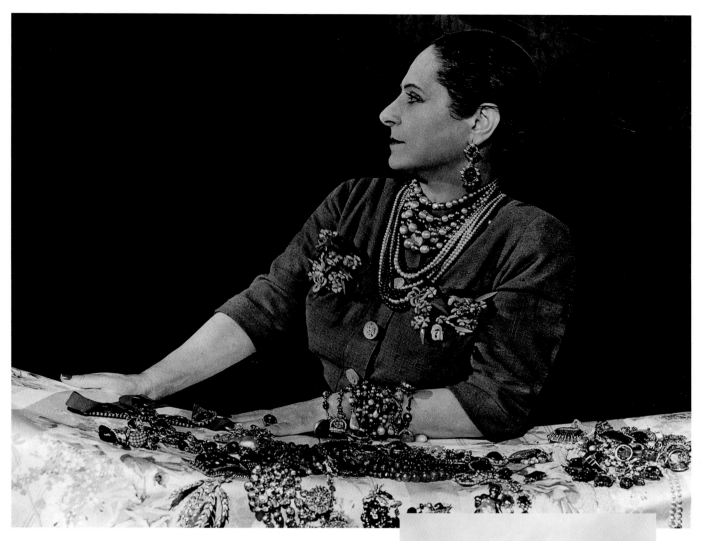

business. Selfridges department store, which had opened on London's Oxford Street in 1909, now introduced the concept of the 'cosmetics and fragrance department' on the ground floor. In-store demonstrations on how to apply the products became an integral and exciting part of the selling process, and cosmetics companies such as Coty, Bourjois and the House of Rimmel, together with Elizabeth Arden and Helena Rubinstein, soon became large commercial enterprises and household names.

Makeup was promoted with increasingly alluring advertising and the whole process of touching it up in public became part of this association with seduction. And as an obvious consequence of this new and glamorous habit the accompanying accessories became new and glamorous too.

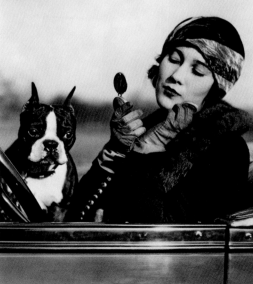

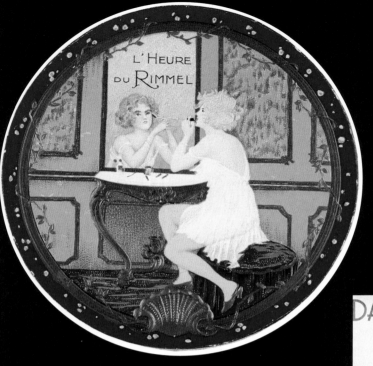

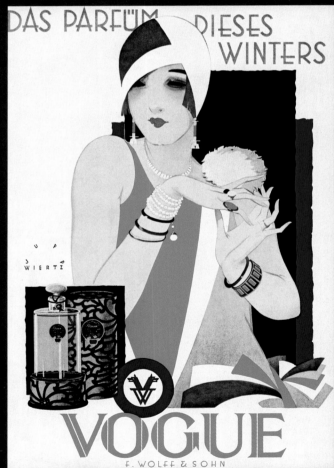

DAS PARFÜM DIESES WINTERS

JUPP WIERTZ

VOGUE

F. WOLFF & SOHN

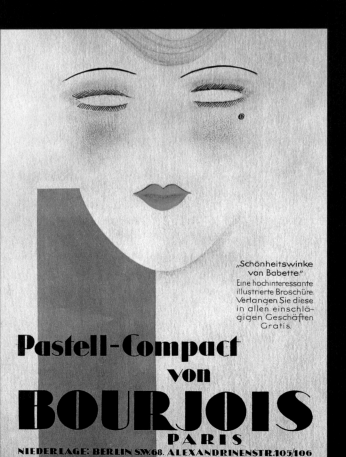

„Schönheitswinke von Babette"
Eine hochinteressante illustrierte Broschüre. Verlangen Sie diese in allen einschlägigen Geschäften Gratis.

Pastell-Compact
von
BOURJOIS
PARIS

NIEDERLAGE: BERLIN SW.68. ALEXANDRINENSTR.105/106

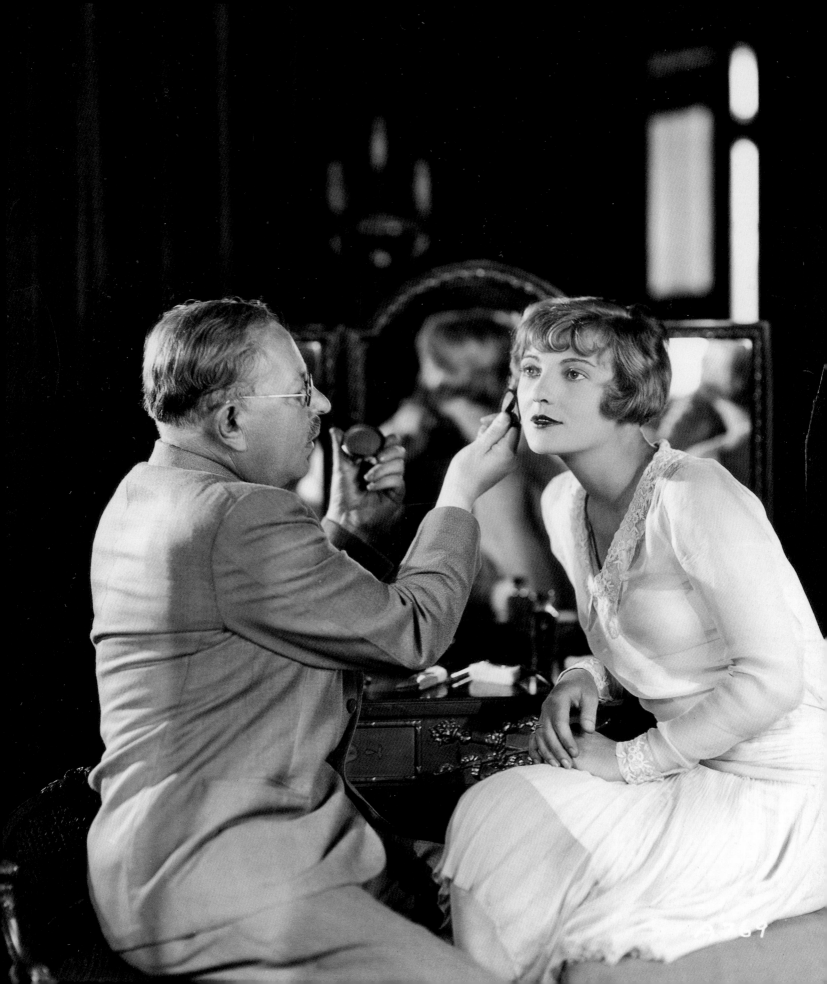

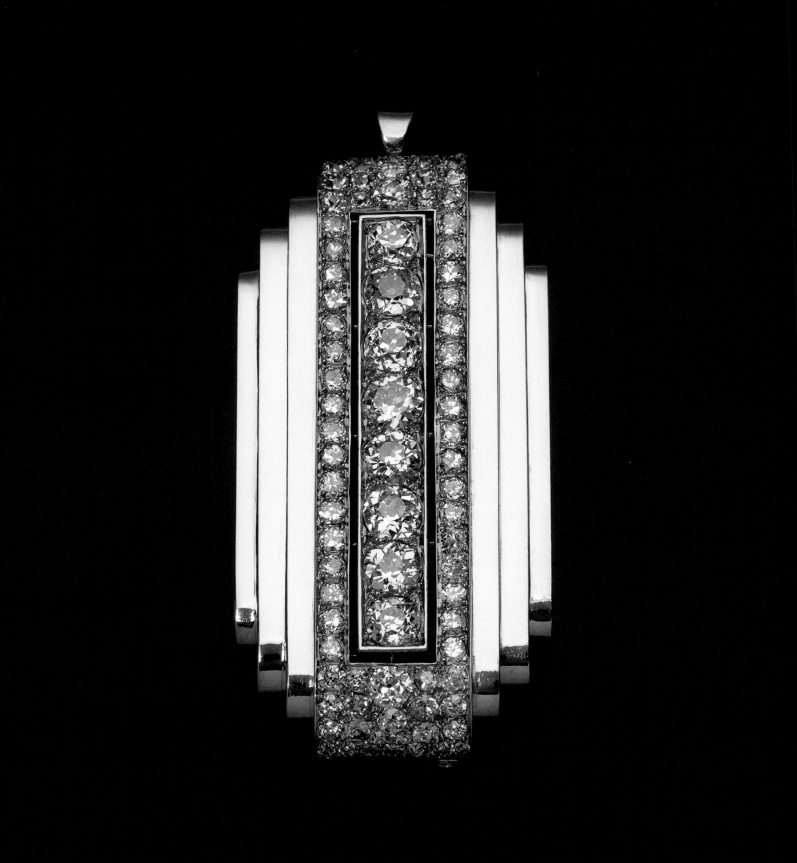

Jewellery shone out as one of the most exciting arts of the Deco era, and post-war female emancipation was reflected in the jewellery that was worn and admired by the very women who personified the new circumstances: Elsa Schiaparelli, Diana Vreeland and Louise de Vilmorin, all of whom were the embodiment of 'modern' and the very latest word in fashion. The soul of the era was speed, its essential geometry long-lined and vertical, and jewels were required to match this sartorial revolution.

Even before the war, many of the new artistic concepts were evident in jewellery design, particularly in France. A critic for the *Jewellers Circular Weekly* of 26 March 1913 asked, 'Will the new movement in painting and sculpture be reflected in the forthcoming jewellery?' It was to prove a rhetorical question, the article concluding that 'whether the exhibits appeal to us or not, the vital impulse toward something new and simple is apparent on every hand.' Yet when women cut their hemlines and their

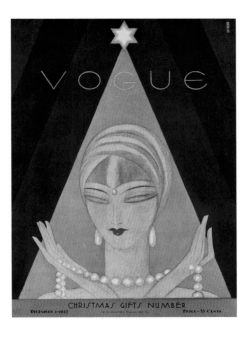

hair short in the 1920s, it could have been a catastrophe for the high jewellery houses. Dynamic women moving from the tennis court to the tea dance salon demanded very different jewels and accessories, and in an era when 'live with a vengeance' was the leitmotiv, jewellers had to reinvent themselves and their wares, and quickly. A piece of jewellery now had to be seen and immediately understood as 'up to the minute'. The intricate designs of the Belle Epoque simply didn't suit the popular demand for streamlining; there was clearly no longer a place for large corsage ornaments or the courtly diadem, so jewellers went back to their drawing boards, experimenting with new colour combinations, shapes and textures like painters with their palettes, and people were bowled over by the results.

As early as 1905, René Lalique had highlighted the necessity for the two disciplines of fashion and jewellery to work together when he complained about dresses that did not do justice to his jewellery: 'Few of my clients know how to wear my jewellery, which, if it

ART DECO SHINES

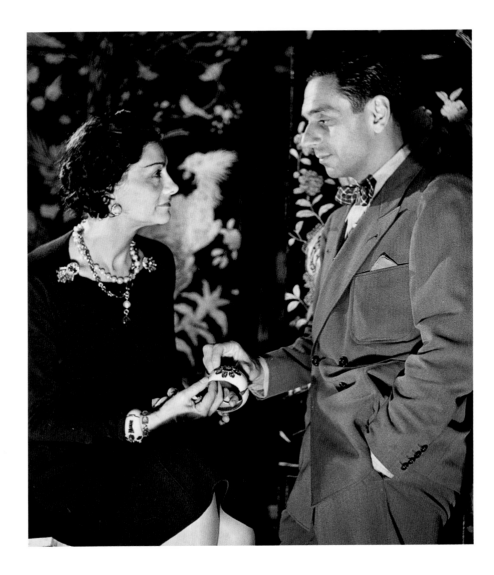

is to achieve its full effect, demands a unity of tone; you cannot wear an embroidered bodice adorned with an artistically designed brooch or pendant'. In the 1920s, however, the two worlds came together, teaming up to work seamlessly in the provision of a complete look for the fashion-conscious women of the day.

Coco Chanel opened a costume jewellery department in 1924 to accessorise her fashion line, and a year later was introduced to the colourful Sicilian duke Fulco di Verdura by mutual friends Cole and Linda Porter. Chanel originally employed Fulco as a textile designer, but quickly recognised his potential, commissioning him to rework her personal collection of jewels and to create a range of jewellery for Maison Chanel. Together, they popularised ropes of baroque pearls and carved gemstones, and the signature heavy enamel bangles set with jewelled Maltese crosses. In 1932, they presented Chanel's first – and only – collection of high jewellery, the Bijoux de Diamants collection. It included dazzling pieces with all the themes that are now so familiar within the Chanel design lexicon: stars, moons, constellations, comets, bows and sunbursts, all made from pearls, diamonds and gold. Shown on hairdressers' mannequins with tiaras turned upside down, necklaces draped down backs and brooches in the hair, they caused something of a sensation. Fulco was to later set up his own business with the backing of Cole Porter and Vincent Astor, in return for which he designed a series of cigarette cases to commemorate the opening of each of Cole Porter's musicals, as well as the famous 'Night and Day' cufflinks to celebrate the eponymous song.

René Boivin was another jeweller particularly aware of the link between the two worlds: his wife Jeanne was Paul's Poiret's sister

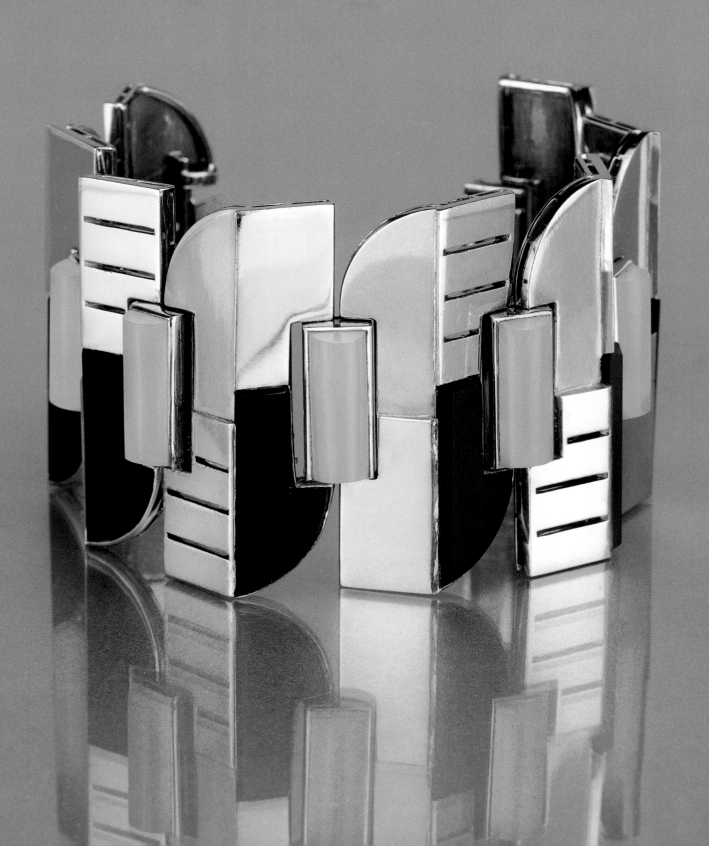

and Boivin was able to profit from this fortuitous connection to the famous couturier's reputation and client base. Another of the leading arbiters of fashion was also part of an existing jewellery family: Hélène Ostrowska, a former model for the House of Worth, married Louis Arpels, of the jewellery house Van Cleef & Arpels, in 1933. Living between America and Paris and holidaying in Deauville and Cannes, Hélène was a constant fixture on best-dressed lists, not only for her choice of elegant outfits from her favourite couturier, Jean Patou, but also for the individual way she wore her jewels: she was considered the very incarnation of chic.

Everywhere, the link between fashion and jewellery was utilised to the full. In Jean Patou's salon, dresses were shown together with jewellery created by George Fouquet, the colours of the stones selected by the jeweller to match the materials of the clothes. When Gérard Sandoz invited all the Parisian VIPs to the unveiling of his shop in the rue Royale in 1928, the models were carefully dressed in couture outfits to show off the jewels to their best effect. And by the time of the Exposition Coloniale of 1931, a soirée organised by the Paris Opera cleverly choreographed the work of fashion designer Jeanne Lanvin and the jeweller Boucheron alongside each other, each given equal standing. The two worlds were as one at last, walking hand in hand in a partnership made all the more successful by the birth of fashion photography. Black-and-white photographs had been gradually taking the place of the existing hand-drafted illustrations. To accompany the designs of the top couturiers, French *Vogue* now chose to use accessories made by the great French jewellers in Paris – Boucheron, Van Cleef & Arpels and Mauboussin in particular – while *L'Officiel de la couture et de la mode de Paris* showed itself to be more even more avant-garde, featuring pieces from artist jewellers such as Paul-Emile Brandt,

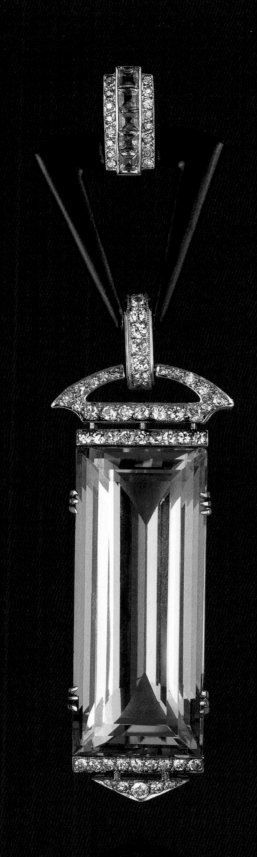

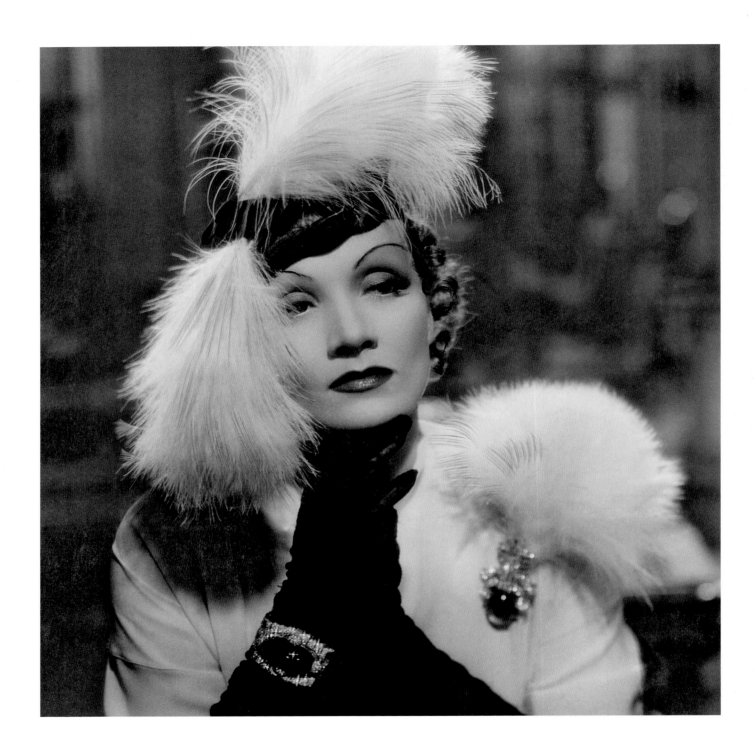

ABOVE and OPPOSITE Marlene Dietrich in the film
Desire, wearing the diamond and emerald brooch
made c.1935–6 by the American jeweller Trabert
and Hoeffer and the French firm of Mauboussin.
These two houses formed a partnership in 1935 to
help combat the downturn in business during the
Depression.

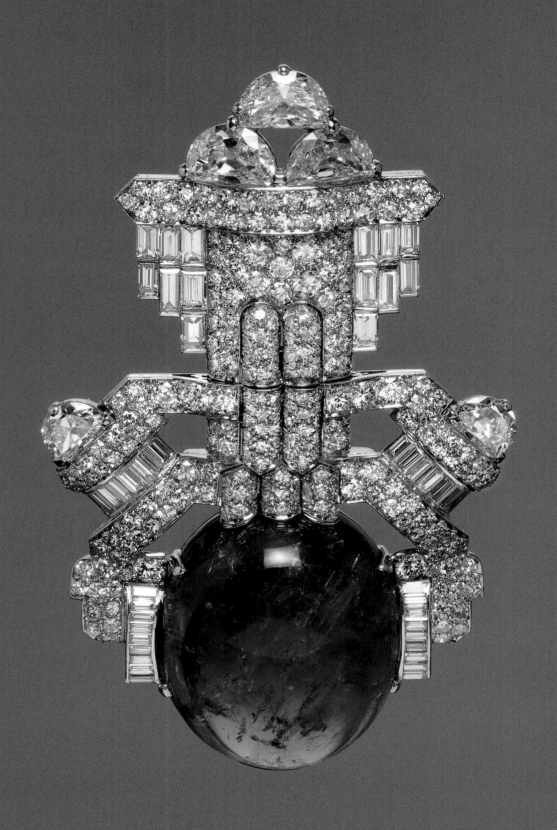

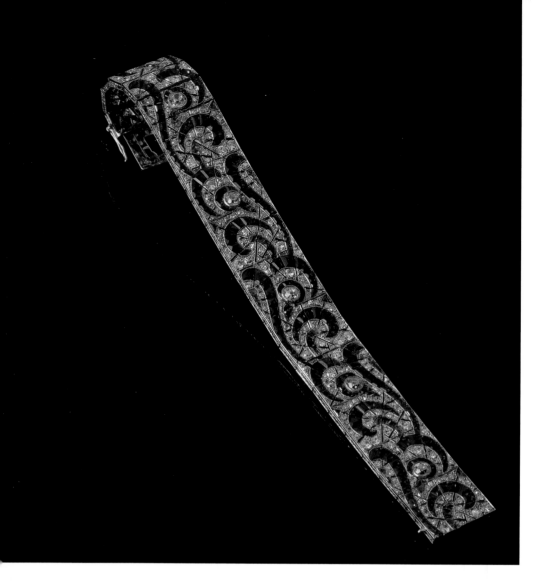

Jean Dunand, Jean Fouquet and Gérard Sandoz, all of whom were quick to make use of fashion photography to promote their work.

All this served to spawn entirely new shapes of jewels: tiaras became bandeaus worn low above the eyebrows; short necklaces became long sautoirs, sometimes swinging with pendants and worn provocatively down the back of a dress, while pendant earrings moved as pendulums below cropped hair. Brooches in a multitude of clip and pin forms were worn in myriad places, and arms fully bared (for the first time since ancient Greece) were stacked high with wide bangles and bracelets. As statement pieces like no other, cocktail rings topped off every evening outfit, shamelessly large in scale and adorning now gloveless hands, their bold designs making clear statements of their wearer's independent and daring taste. It was evidently all about the look, the *tout ensemble*.

As with other branches of design, there were many directions, hybrids and strains as there were practitioners. An Art Deco jewel might be a bracelet with stylised flowers or Egyptian motifs created in platinum, precious coloured stones and diamonds by one of the Haute Joaillerie houses, or a piece of multicoloured abstract jewellery by one of the innovative artist-designers. Essentially two branches of jewellery emerged. The 'bijoutiers-joailliers', the famous Haute Joaillerie houses, were mostly Paris-based and adopted the geometric and chromatic effects of the new style, but applied these less literally, borrowing decorative themes and colour combinations from other cultures, still using precious gems but now incorporating some semiprecious and hardstones into their designs as well, onyx, coral, jade, lapis lazuli, malachite and turquoise emerging as clear favourites. A wide variety of different shapes and stone cuts further emphasised the new, exotic motifs,

LEFT Bangle designed by Suzanne Belperron, c.1934. Unusually for the time, the metal is nickel-plated steel with a fine platinum mount for the diamonds. OPPOSITE Suzanne Belperron photographed by Horst in 1933.

with trapezes, semicircles, triangles and prisms teamed with the existing calibré- and baguette-cut gems already in use.

Conversely, the 'bijoutiers-artistes' produced a very different brand of jewellery. An elite group of young and forward-thinking designers, they were guided by their close association with modern art and created jewels that prioritised design over the intrinsic value of materials, using simple forms, mechanical patterns and bold colour schemes while reducing to the bare minimum, or completely abolishing, unneccessary decoration. Large expanses of metal were covered with lacquer and enamel, and the more traditional precious gems seldom appeared in

their work, aquamarine, citrine, topaz, amethyst and hardstones providing the colour for their creations instead.

Overall, jewellers of every persuasion embraced the challenge that the 1920s brought, and rose to it in spectacular, shining style. Jewels from this era all shared the same basic aesthetic: they were flat and flexible, sleek, streamlined and stylised in decoration, and all had a sense of speed and movement. Today it might even be argued that the great artistic revolution of Art Deco reached a crescendo of creativity in the field of jewellery and precious personal objects.

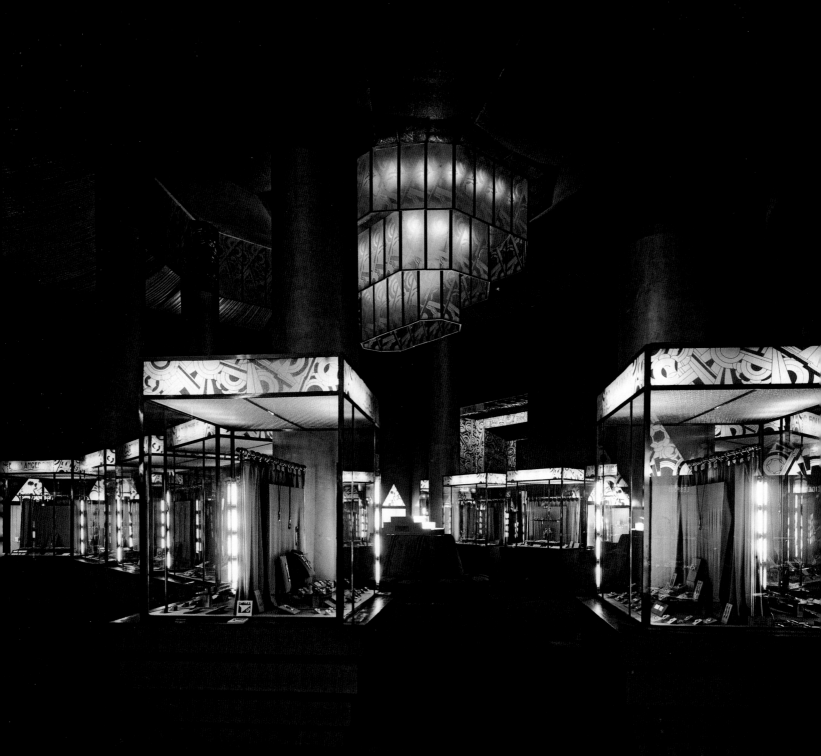

This was a truly international decade and the annual salons and great exhibitions played a pivotal role in both the development and dissemination of the decorative arts, creating a flow of ideas between different countries while at the same time bringing the latest creations to the notice of a wider public at home. It seemed fitting that the event which marked the climax of the new creative force was held in its capital, Paris. The mighty exhibition of 1925, a landmark in the annals of design history, consolidated all the various trends that together combined as 'Art Deco'. It was here that its various concepts and guiding principles were formally crystallised and the jewellery and objects that helped define the style of the era were cohesively presented for the first time in one place. It was an unprecedented event that was (retrospectively) to give the new style its name, a shortening of its full French title: *L'Exposition Internationale des Arts Décoratifs et Industriels Modernes*. It was as if the 'style moderne,' which already held sway with popular taste,

was given legitimacy and official status at this seminal event. First discussed as an idea in 1907 and planned for 1916, the realisation of this behemoth of shows was delayed by the upheaval of war, so it did not materialise for another nine years. But when it finally came to fruition, it presented a panoramic view of all contemporary applied art forms the like of which had never been seen before. Over a seven-month period, 34 countries (excluding Germany and the US) presented their creations to a staggering 16 million viewers. One hundred and thirty lavishly decorated pavilions sprawled out from the Esplanade des Invalides to the Grand Palais and along the banks of the Seine, taking in a bewildering variety of products made by almost every kind of artist and artisan. Each display was a testament to the aim and the mood of the show, summarised in Jules Laforgue's exhortation 'To be open to innovation, and to search for the forms best able to express it.' Each evening it was as if the sparkling firework displays, the shimmering reflections of Lalique's cascading Crystal Fountain, and the illuminated Eiffel Tower dazzled

NEW STYLES ON SHOW

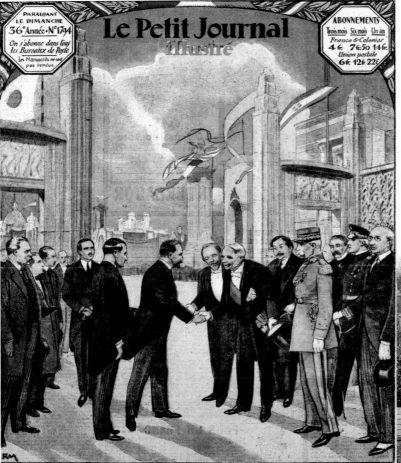

INAUGURATION DE L'EXPOSITION DES ARTS DÉCORATIFS

PREVIOUS PAGES LEFT Jewellery displays at the 1925 *Exposition Internationale des Arts Décoratifs et Industriels Modernes* held in Paris from April to October 1925. RIGHT Guide to the exhibition.

ABOVE Engraving from *Le Petit Journal* showing French president Gaston Doumergue opening the exhibition on 10 May 1925. RIGHT General view of the exhibition.

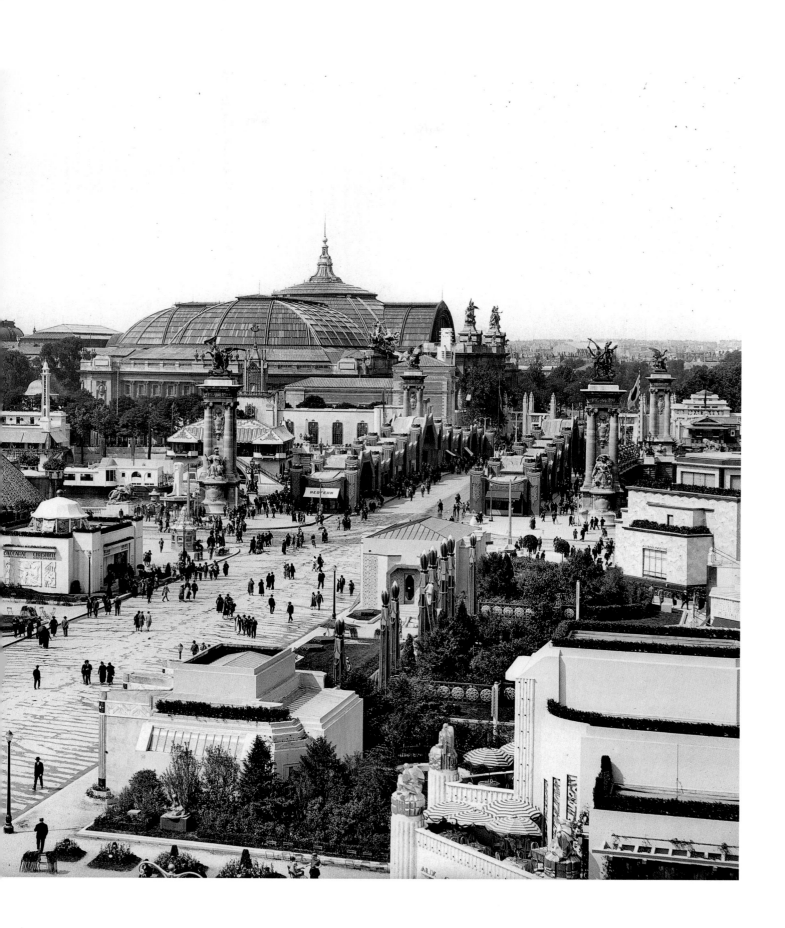

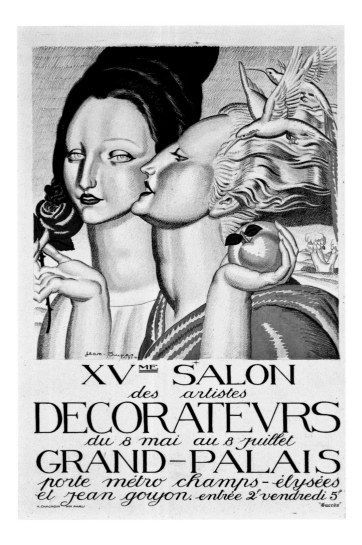

across the skies of all Europe, shining out as symbolic beacons of beauty and artistry.

By day, visitors could choose between the five different categories which together made up this comprehensive exhibition, one of which was classified as Parure (meaning 'dress' in its widest sense, and therefore including clothing, jewellery, accessories and everything that went to make up a woman's outfit). This class was situated in the right-hand side of the nave of the Grand Palais, one section of which was entirely devoted to jewellery and which occupied a total of 500 square metres. In a fairytale setting of silver columns designed by the architect Eric Bagge, and with all the showcases draped in the same pink crêpe de chine, the glittering displays of jewellery showed the work of both the well-known *maisons* and the new and upcoming designers. France had 30 exhibitors in total including Aucoc, Boucheron, Chaumet, Dusausoy, Lacloche, Linzeler and Marchak, Marzo, Mauboussin, Mellerio and Van Cleef & Arpels, as well as many of the 'artist-jewellers': Jean Fouquet, Raymond Templier, Gérard Sandoz, Jean Dunand and Paul-Emile Brandt. Only Cartier decided to install itself in the Pavillon d'Elégance, exhibiting its 150 jewelled creations alongside the great couturiers and fashion houses rather than among its fellow jewellery contemporaries.

The jewels on display in the Parure class revealed the clear dichotomy between the 'bijoutiers-joailliers' and the 'bijoutiers-artistes', as demonstrated by the Fouquet dynasty of jewellers: not content to use the showcases of his father Georges, a member of the older jewellery aristocracy, son Jean was positioned some distance

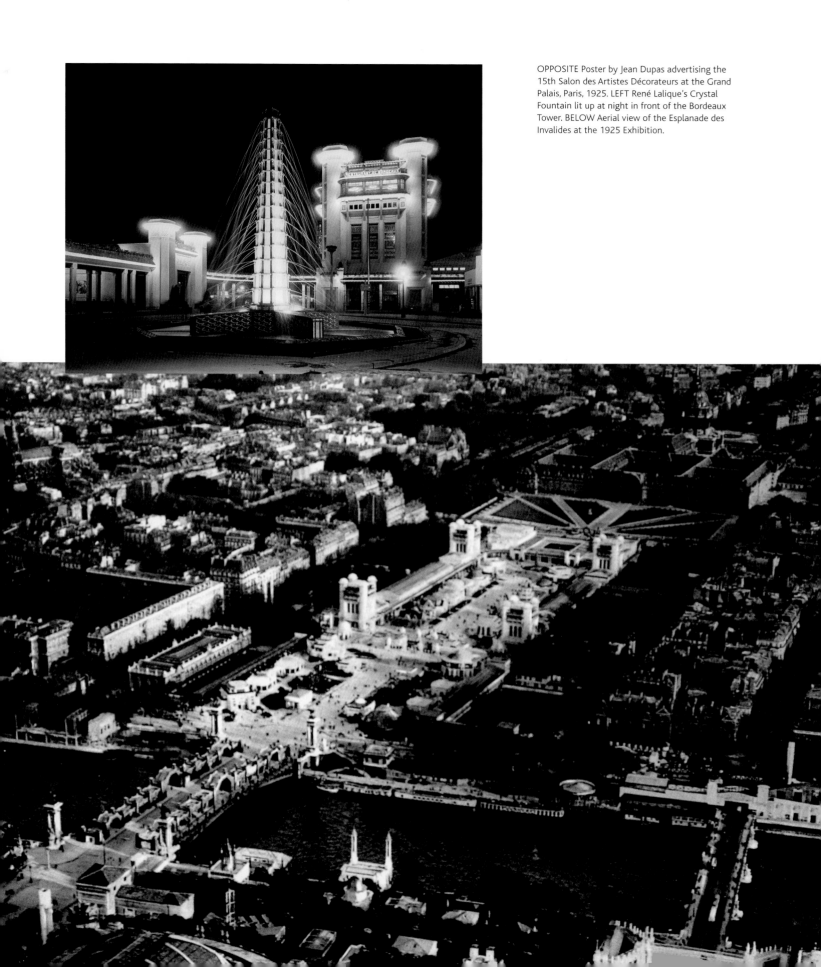

OPPOSITE Poster by Jean Dupas advertising the 15th Salon des Artistes Décorateurs at the Grand Palais, Paris, 1925. LEFT René Lalique's Crystal Fountain lit up at night in front of the Bordeaux Tower. BELOW Aerial view of the Esplanade des Invalides at the 1925 Exhibition.

away and classed with fellow artist-jewellers such as Jean Després. This dividing line between the establishment and the progressives, the contemporaries and the moderns, preempted their ultimate division and the subsequent creation of the Union des Artistes Modernes (or 'UAM') in 1930, when Jean Fouquet, Gérard Sandoz and Raymond Templier joined forces with architects such as Le Corbusier, Walter Gropius and the sculptor Joseph Csaky, to promote an art that was modern and entirely rational.

Several of the young avant-garde designers really made their mark for the first time at the exhibition in 1925: cigarette cases and lighters designed in the new graphic style by Sandoz were particularly well received and a brooch by Templier was immediately bought by the Musée des Arts Décoratifs, while the Georges Fouquet, representing the old guard, was awarded a diploma of merit. Indeed the French exhibitors as a whole stood out above all others and were given recognition in almost every press review and this, combined with the fact that the leading couturiers, designers and cosmetics manufacturers were also French, led to Art Deco becoming widely regarded as a French movement.

The precise criterion for exhibiting was, according to Georges Fouquet, to 'only include those works of new inspiration and real originality, excluding all copying, inspiration from or imitation of ancient or past styles'. This ruling meant jewellers had to reinvent and reinterpret the modern world around them, and their output brought all the new ideas and inspirations which had been quietly evolving into a coherent new aesthetic. The year 1925 marked the pivotal moment, a tipping point when shaping the future and looking forward became even more important than escaping the past. Art Deco was flying high. Yet just as quickly as it dazzled, like the fireworks in its celebration, so it vanished, suffering the fate of many items in the world of parure – to become obsolete and unfashionable, and then broken up, melted down, or at best, unworn and left in a bank vault.

By the time the next great Exposition Internationale came around in 1937, austere geometry was already making way for the return of curves and figuration and ornament, as romanticism superseded severity and softness replaced strict stylisation. As if in homage to the waning of this era, the palette had faded to the pale and sober hues of platinum, diamonds and jet black onyx. It was the end of an era that full of ingenuity and imagination, which had nurtured creativity in all its guises, producing an unfettered and unbridled freedom we still marvel at a century later. Though there may be many more wealthy people alive in the world today than during the 1920s and 1930s, we are unlikely to witness the style and the elegance that was Art Deco again.

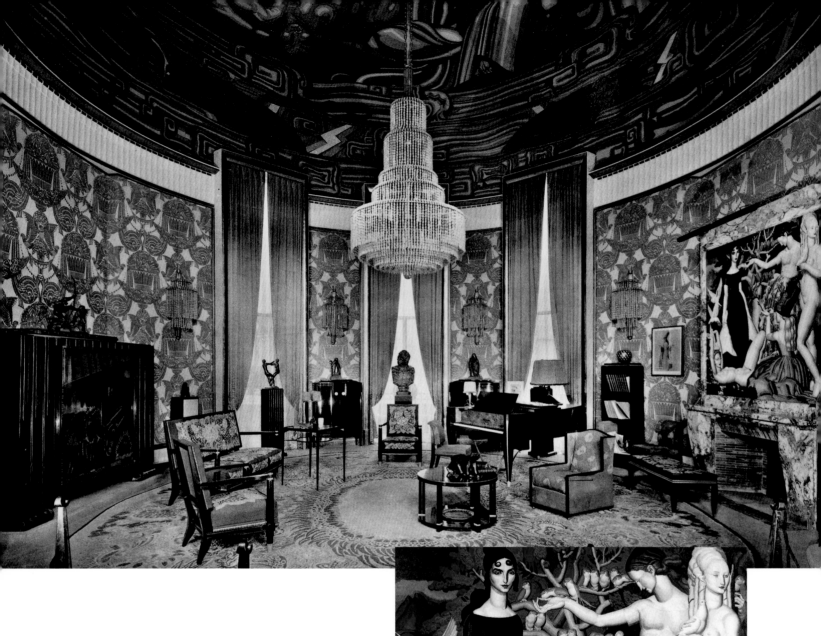

ABOVE The Grand Salon designed for the Collector's
Pavilion by Emile-Jacques Ruhlmann for the 1925
Exhibition. RIGHT Jean Dupas, *The Parakeets*, 1925,
which hung above the fireplace in Ruhlmann's Grand
Salon. Private collection.

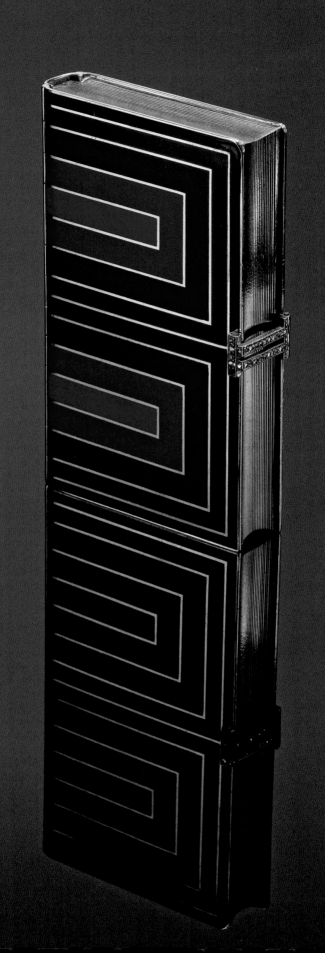

2

'VANITY FLAIR'

ART DECO CASES AND BOXES

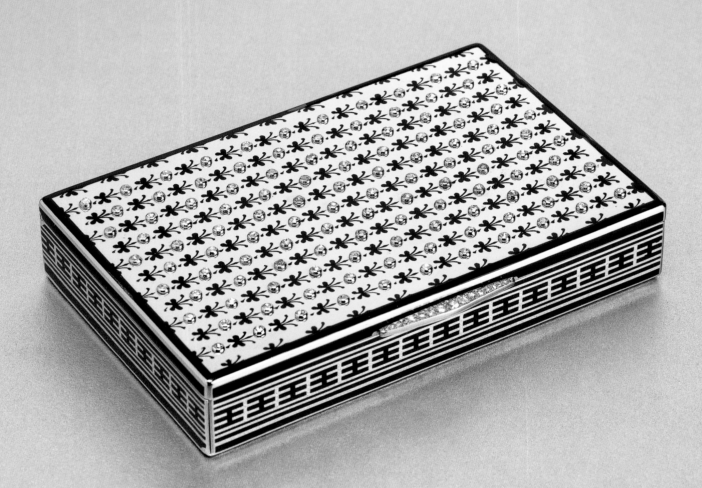

The vanity case encapsulated everything jewellery designers were seeking to achieve during the Art Deco period. Also known as the *nécessaire de dame, nécessaire de soir* or *nécessaire de beauté,* it was considered the epitome of elegance, while remaining practical enough to accommodate everything a stylish woman might need, day or night, when out and about. *Vogue* magazine concluded: 'Fashionable women pout. The act of reapplying one's face powder takes on great importance. Ladies no longer have to struggle discreetly with a tiny powder puff; they can make full use of a conveniently long mirror and all the paraphernalia in their vanity box which provides essential first aid for emergency repairs. It is like a Pandora's box and its modern precision evokes a machine-made object like an aeroplane part. The interior is admirably ingenious: within a confined area, like a jigsaw puzzle, and with much economy of space, there are precise partitions, following the classical definition of Order (with a capital O) where there is "a place for everything and everything in its place".'

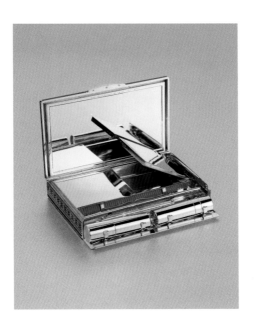

In an age when cocktails vied with cabarets and fine dining as the last word in elegant entertainment, these small but stylish additions to the overall parure were required to match the spirit and flair of the modern world around them. The fashionable woman could now smoke, apply lipstick and powder her nose in public, and the vanity cases created to accompany these new habits were unrivalled in their sheer beauty and sumptuousness. More than any other accessory they brought together the practical with the aesthetic, as utilitarian boxes were transformed into masterpieces of design and craftsmanship in the hands of contemporary jewellers. The adage 'form follows function' was evident in Louis Cartier's guidance to his designers: 'We must make it our business to build up an inventory that responds to the moral mood of the public by producing articles which have a useful function but which are also decorated in the Cartier style'.

A MODERN PANDORA'S BOX

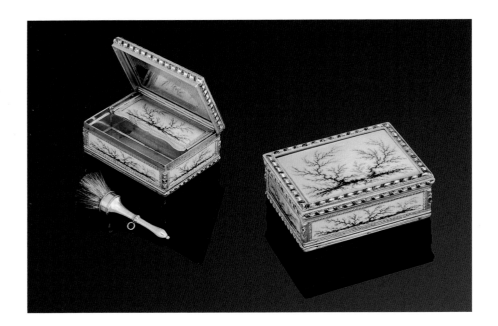

Yet while they provided a practical means of transporting personal items, the new vanity cases were more jewellery than mere accessory, such was the level of craftsmanship and materials used to create them. Set in precious metal and often elaborately lacquered or enamelled, with decorative elements carved in precious and semiprecious stones, they were made with the maximum of detail in the minimum of space and in myriad different styles borrowed from a vast range of cultures and influences. The Great Age of Glamour was the golden age for these jewelled creations and each provided a glorious chance for jewellers' imaginations and ingenuity to run riot, creating truly unique works of art. There had already been several forerunners to these precious boxes and cases. Snuff boxes were the cigarette cases of the eighteenth century and every gentleman had one, or several (perhaps even one for every day of the week). Inhaling snuff, or 'snuffing', first appeared in the fifteenth century when tobacco from the New World arrived in Europe, and by the second half of the seventeenth century ornate boxes were being produced to keep such expensive contents safe and dry. French goldsmiths made the containers out of gold, sometimes setting them with gems, and by 1740 specialist artisans had taken over the production of these so-called tabatières, using engraving, chasing and rich enamelling to decorate their surfaces. At the same time, the ancestor of the vanity case first appeared, known as the boîte-à-rouge-et-à-mouches:

a beautiful box for powder and rouge fitted with mirrors, two compartments and a little brush. But its place was strictly confined to the dressing table, and though ornate it would certainly not have been seen in a public context or outside the home.

Perhaps the most influential predecessor of the vanity case in terms of its quadrangular or barrel shape was the Japanese inrō, a small portable medicine chest divided into several compartments, each with different drawers containing various herbs and medicines and other personal accoutrements. These compartments were stacked horizontally, one on top of the other, slotting together and then held in position by a silk cord around the sides. The cord could be tightened at the top using a sliding bead, or ojime, and then attached to the belt with a decorative netsuke of carved wood, ivory or lacquer, which also acted as a counterweight. Vanity cases usually replaced the Japanese silk cord with a more practical metal chain, perhaps enamelled or even gem-set, and instead of the netsuke, a finger ring at the top for carrying it. Sometimes a tassel might be added to the ring, despite there being no equivalent on original inrōs: this idea was an entirely Western interpretation of Chinese pendants, and very few of these tassels survive today.

Of course, the necessities required by a lady in her everyday life continued to change over time, and how she carried her 'vanity items' largely depended on her outfit and the extent to which pockets and a chatelaine or belt could be accommodated

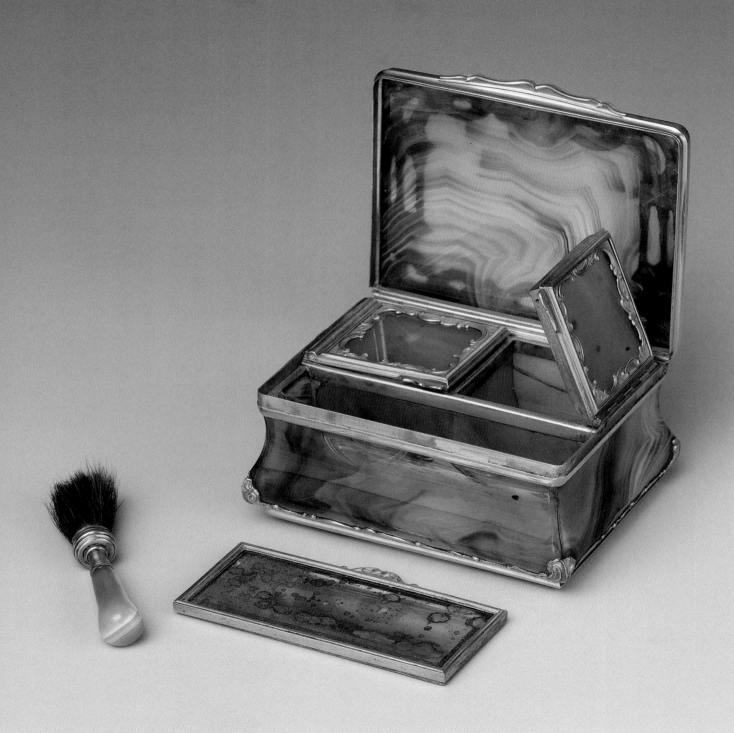

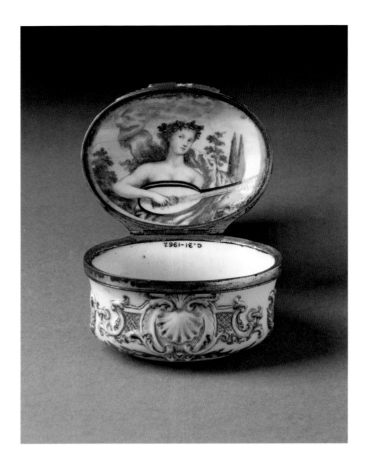

ABOVE Doccia porcelain snuff box painted with enamels and mounted in gilt bronze, c.1760. V&A Museum, London. OPPOSITE Japanese inro c.1750–1850, with gold and red *hiramaki-e* ('flat sprinkled picture') lacquer on a gold-sprinkled black lacquer ground. V&A Museum, London.

within current fashions. Pockets were simply not feasible within a wide crinoline or a clinging dress, necessitating the use of a small drawstring bag, or reticule, made in various fabrics such as silk or velvet, often with embroidery, brocade or beading added as decoration. What was really required, however, was an up-to-date combination of the previous means of carrying personal items, and the vanity case stood by, poised in the wings to bring everything together in one perfect invention.

Its moment came after the First World War when cosmetics took centre stage at last, in the home and beyond, rather than being hidden away in a drawer. As the ranges of powders, lipsticks and blended sticks of perfume grew, so it became obvious that the existing, and rather makeshift, containers were no longer fit for purpose. Interior divisions and compartments were needed to accommodate and organise the many forms that the new cosmetics now took, and by 1920 a plethora of different types of vanity cases, along with cigarette and powder boxes and lighters, had become essential accompaniments to the new habits of lives lived in the fast lane.

These precious yet practical containers, sometimes made to order for specific clients, were miniature miracles of design and manufacture, and were as slim and flat as possible in keeping with the streamlined look of the day. Most importantly, they had to match the appearance of the society ladies who owned them. The use – and now the application – of makeup had become a sophisticated art to be enacted in public. The dressing table at home was still perceived as a glamorous setting, but what really

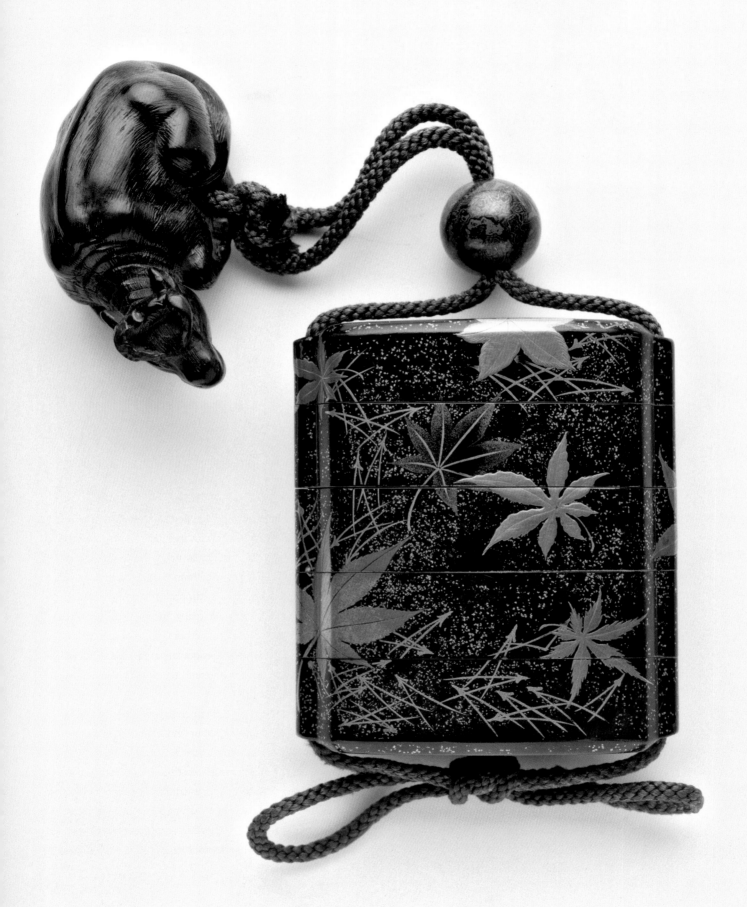

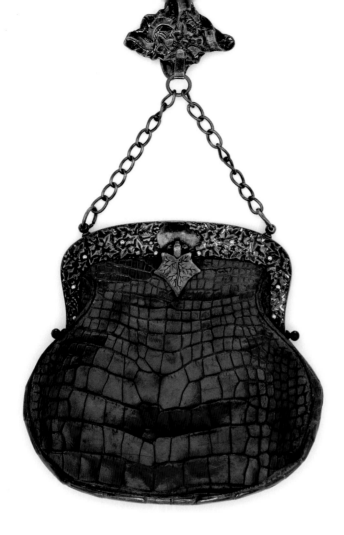

mattered now was the performance of putting on makeup in front of people. The process of application was as important as the finished effect, and all part of the seduction of beautification. It was clear that women needed a means of carrying their cosmetics that was every bit as handsome as the rest of their attire.

The new vanity case was quickly considered indispensable in high society; *Harper's Bazaar* referred to 'the kind of compact you can pull out and make a great show of at the table' – and this was the point. These creations were designed to be highly visible when out at lunch, dinner, the theatre or a nightclub, placed prominently on the grandest of dining tables or atop the most fashionable cocktail bar, to rest, dazzling, in full view of admiring onlookers. It was not considered vulgar to show off a case in this way, to make it a talking point and to pass it round to other guests, while it would have been unthinkable to do the same with a piece of jewellery. Vanity cases were miniature status symbols, made to be admired and shown off. They took many hundreds of hours to produce, showcasing superb and often unique bespoke craftsmanship. Most

of them were created in Paris, often by the great jewellery houses of the day, and were owned by ladies of the highest social standing. They were truly one-off creations, sometimes commissioned and always treasured, each one a triumph of the jeweller's art.

Many were made to order to match couture outfits from the leading fashion designers: Chanel, Patou, Lanvin or Vionnet. Little wonder they became the most desirable accompaniment to smart lives led in the public eye. Stars of stage, screen and style all added to the hype, captured on film and in magazines with these symbols of modern elegance always to hand. A lady like Florence Gould, an American heiress married to the railroad magnate Frank Jay Gould and living in Paris, might have several cases: colourful examples with floral motifs for day wear, and carried instead of a handbag, with more streamlined, diamond-set examples used at night in place of an evening bag. Mrs Gould was habitually photographed with waved hair, pearl necklace, black fur stole, jewelled bracelet and glittering vanity case, a combination considered by her contemporaries to be the personification of chic.

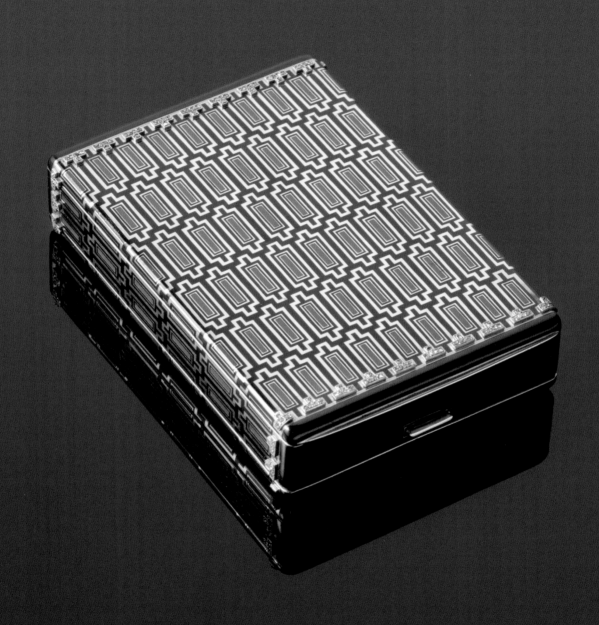

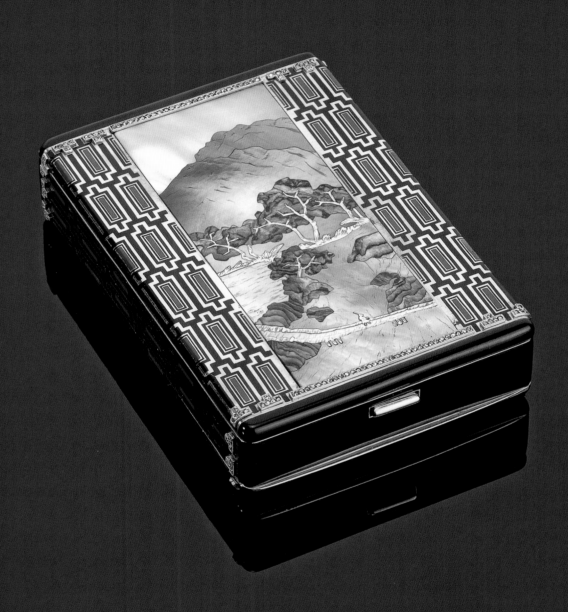

OPPOSITE Double-sided case with onyx body,
makeup and cigarette compartments, ivory panel
and pencil. Marzo, Paris, c.1920–3.

FORMS

Vanity cases were made in a vast variety of forms and there was no such thing as a 'standard' model. The first simple cases were in made yellow gold, perhaps embellished with a monogram, and these were quickly followed by models with Russian-style enamelling as decoration. Flat or possibly cylindrical, they might be up to 12.5 centimetres in length, and soon developed into some of the most sophisticated and embellished creations of the Art Deco period, set with precious stones, carved jade plaques, elaborate Chinese lacquer panels or mosaics of mother-of-pearl inlay. Some cases had a simple lid that was opened with a push piece, while others were attached to a finger ring (often made of onyx) by a silk cord and tassel, giving a more obviously 'oriental' look. We know that Mrs Vanderbilt owned a vanity case decorated with striped black enamel and an onyx ring to loop over the fingers as a safe and stylish means of carrying it. In other more elaborate examples the finger ring was replaced with a separate matching lipstick case at the opposite end.

Even more ingenious in their manufacture were the double-sided, multi-compartment or 'combined' cigarette-and-vanity cases, which at their simplest had one side for the storage of cigarettes (the lid) with the base containing the usual powder and rouge compartments. These examples were often oval or cylindrical in shape to provide the necessary depth inside, also enabling them to be carried and cradled comfortably in the hand. They were more difficult to produce, however, requiring dexterity of unrivalled virtuosity since the process of decorating the second side often damaged the first.

Whatever their shape and form, these portable little beauty kits had one overriding requirement – the need to fit the largest possible number of elements into the minimum amount of space. They were as intricate on the inside as the decoration on their exteriors, their internal engineering requiring absolute precision on a miniature scale: lift the lid and a veritable dressing table was revealed with everything condensed into a miraculously small area. The extensive range of women's 'vanity necessities' now included – in addition to powder, rouge, perfume, lipstick, and a comb – a pencil with an ivory slate to write on and even a concealed watch as the ultimate symbol of daring modernity, which could be discreetly seen when reapplying makeup. (Mrs Evalyn Walsh McLean went one better and commissioned a miniature vanity case with a leather strap in 1930 to be worn on the wrist like a watch.) In fact the only item missing from the list was money, which was naturally regarded as entirely superfluous to a society lady's requirements. As well as containing these various vanity items, as much of a *nécessaire*'s interior as possible needed to be mirrored, allowing the owner to perfect her makeup without having to retire to a restroom, an essential feature given that the display of application was as important a part of the allure as the finished effect of bright red lips and flawless skin.

There were endless different arrangements of the various compartments: those for powder and rouge often had mirrored lids that were lifted with the fingernail or by using sunken hinged handles, which lifted and sprang up automatically, as if by magic, when the box was opened. Lipstick tubes could be purchased on

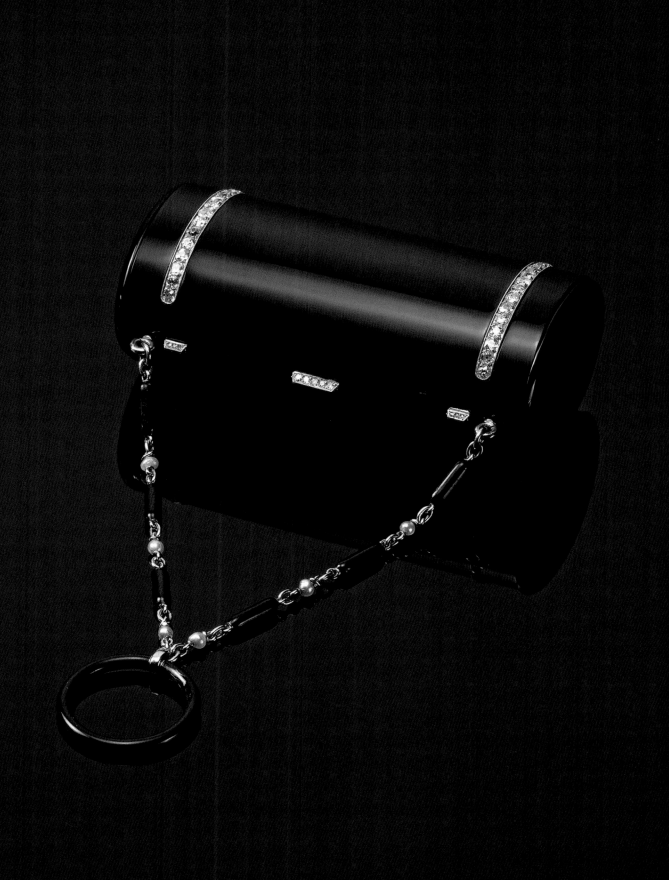

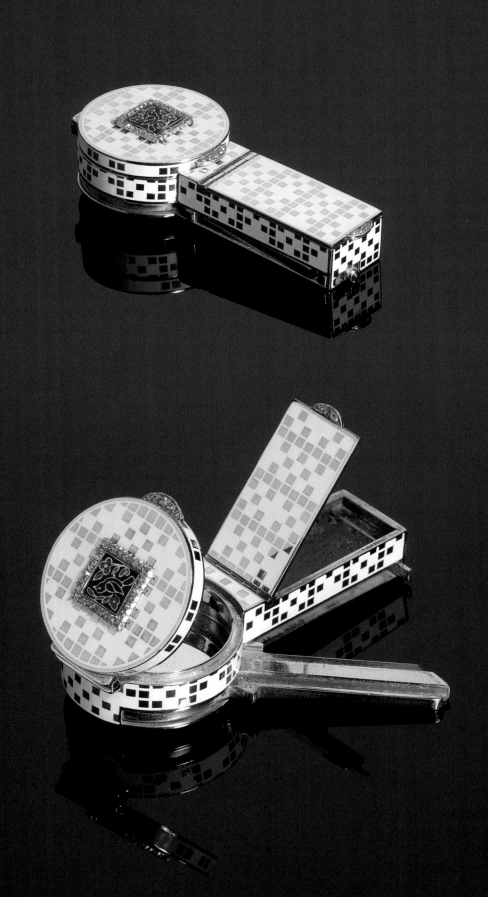

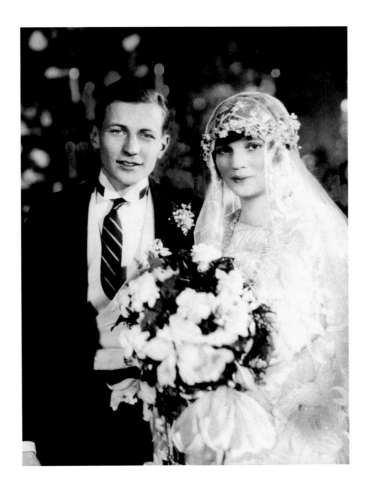

OPPOSITE Miniature vanity case with black and cream decoration and compartments for rouge and lipstick and a hidden gold key revealed by opening a small recessed catch. Cartier, New York, 1930. Formerly the property of Consuelo Vanderbilt Earl. LEFT and BELOW Consuelo Vanderbilt Earl, once considered the richest woman in America.

their own, and were often designed to match a separate vanity case, but the majority were designed to fit perfectly into the interior of the case itself, either with their own spring fitting so that as the lid was lifted the tube popped up, or with a clip to hold them inside the lid of a tiny compartment. In either case, the owner would have to have these minute lipstick tubes replaced by the jeweller when they had been used up. Sometimes there was also space left for a comb, possibly made of blond tortoiseshell and backed with gold, though these have rarely survived intact today. In all, a vanity case of this kind might weigh between 200 and 250 grams, surprisingly heavy for an article of this size, yet understandable given its complexity and the extent of precious materials and gadgetry used in its construction.

Other myriad variations included space for a cigarette holder that could clip into the lid, and a gold bar (sometimes pierced or decorated) to keep the cigarettes in place. Some had the base

ABOVE Elsie de Wolfe (Lady Mendl), who owned a custom-made powder box, impersonating Mistinguett at a birthday party for Elsa Maxwell in Paris. OPPOSITE The top and base of a powder box with agate body and *lac burgauté* panels of Chinese figures. Cartier, c.1920.

compartment spilt into two lidded spaces: matches with a strike-a-light on the inside of the lid, and powder with a mirror on top of the lid, and maybe even a lipstick in the middle of these two. Yet others opened at both ends as well as in the centre: Cartier made examples with powder – in the form of *papiers poudrés*, since loose powder would have spilled out at one end – and matches with a strike at the other.

The closure mechanisms of these cases were no less varied: some had a 'kodak' system of opening, so-called because of the shutter mechanism by which the lid sprang open when the ends were pushed in. A beautiful example was given to Coco Chanel by the Duke of Westminster in 1924. The combinations seemed never-ending, bounded only by the fertility of the maker's imagination and the technical capabilities of the materials he chose, and to protect the final article many of these creations also came with their own suede pouch to prevent chipping and to cushion the delicate corners from damage. Ever more complex and elaborate interiors, closures, forms and designs were developed – each one ingenious in its own way – many of which were patented by the maker or retail jeweller.

Smaller than vanity cases, powder boxes were more simple in construction, being used for just one product, but they too were fabulously creative in their manufacture. They had mirrored lids and kid leather powder puffs, often with an extra lid or gauze sifter to keep the powder from spilling. Some powder boxes had a lipstick attached by a chain: a very early octagonal-shaped box with a matching lipstick was created for fashion leader and American

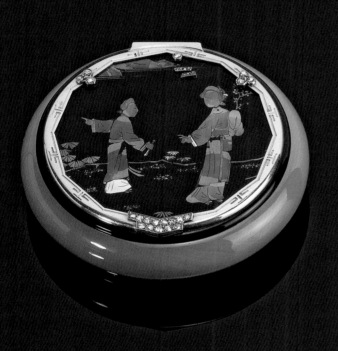
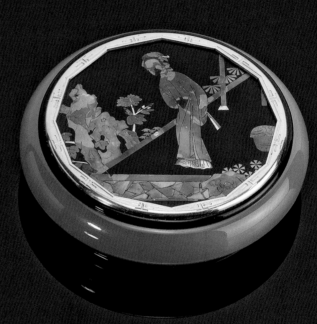

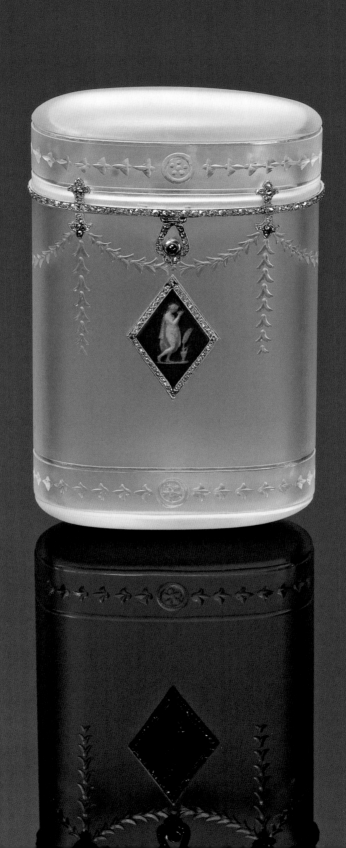

decorator Elsie de Wolfe. Made of black enamel bordered with
diamonds and engraved in the centre with a tiny wolf's head, it
had a mirrored lid and contained loose powder, while the lipstick
tube was in a matching style and joined to the powder box with
a fragile diamond and platinum chain so it caught between the
fingers as if it were a large ring. Made the same year that Helena
Rubinstein opened her Paris salons, it was mentioned in an article
in French *Vogue*. Archive records show that Cartier exhibited a
circular version as their only example of a powder box and lipstick
combination at the 1925 Exhibition, while another octagonal type
was sold to the Duchesse de Talleyrand in 1929.

By 1930 a compact version of powder had been perfected for
commercial use (hence the term 'powder compact'), all examples
of containers used for loose powder being known thereafter as
'powder boxes.' The name 'flapjack' was used to describe these
large new powder compacts that were flatter than the earlier
versions, while the term also referred to the method of opening,
whereby the two push pieces, one on the lid and one on the base,
were twisted against each other so that the lid flipped up.

Cigarette cases, too, were beautifully decorated and elegant.
Those for men had very specific requirements: to be flat and
sleek (and easily slipped into a pocket), to be durable and
scratch-resistant and, naturally, to be elegant yet restrained in
ornamentation in comparison to those used by ladies. Some were
flat but with rounded edges, and described as 'forme coussin' or
cushion-shaped in Cartier's archive records, while others were
given a curved shape to fit more comfortably into a back pocket, a
design harking back to the early nineteenth century. Other boxes
produced in the same vein included card cases, simple lipstick
cases, and even key cases.

Alongside all the different variations of boxes and vanity cases
the jewellers of the Art Deco era also retailed a wide range of more
traditional handbags. For daytime, the smartest versions were
made using the exotic skins of lizards and snakes, or sharks and
stingrays (shagreen), and they tended to be quite small, either
in a simple clutch style or with little handles. Jewellers would
outsource this work to leather workshops with the specialist skills
and expertise needed to make handbags to order on commission,
as Hermès did for Cartier. Records reveal that Gérard Sandoz
designed handles for handbags, and Jean Fouquet's clutch bags
were works of decorative art of which he was obviously proud,
including them in the published anthology of his wider oeuvre,
Bijoux et Orfèvrerie. Evening bags generally had a richer feel and
might be created using softer fabrics such as taffeta, silk or velvet,
then decorated using oriental brocades, embroidery, pearls or
gems, and perhaps even featuring a jewelled clasp or closure made
to match the chosen outfit, gown and jewels, thus completing the
whole parure.

OPPOSITE 'Garland' vanity case with black and pink enamels and rose-cut diamond flowers. Van Cleef & Arpels, 1925.

FOLLOWING PAGES LEFT Vanity case with an onyx body, an arch of frosted rock crystal with diamond 'fleur de lys' motif and diamond decoration around the arch. Strauss Allard & Meyer, c.1925. RIGHT Cigarette case with a yellow enamel body and end pieces with turquoise flowers bordered by rose-cut diamonds. Charlton & Co, New York, c.1925.

DECORATION AND MOTIFS

Whatever its exact form and configuration, each and every box was intended as a one-of-a-kind creation. Like other handiwork of the day including jewellery, furniture, textiles and ceramics, vanity cases displayed a vast repertoire of decoration. The dichotomy in Art Deco design was self-evident in these creations: the modern avant-garde style, incorporating abstraction, machine imagery and geometry, and the equally modern but entirely different influence of the exotic, starting with the Ballets Russes and including Egypt, Persia, India, China, Japan and even Africa. By the 1929 exhibition *Les Arts de la Bijouterie, Joaillerie et Orfèvrerie* held at the Musée Galliera in Paris, the distinction was obvious, as one contemporary observer noted in *Art et Décoration*: 'the different influences on the decorative arts over the last 15 to 20 years are clearly visible here. I am speaking of the two trends that gave rise on the one hand to the school of so-called "Neostyles', and on the other to the school of the straight line.'

Within these two approaches the decorative possibilities seemed endless, and in many cases the two were tastefully combined in concoctions quite unlike anything created before. At their most simple and elegant, models made in gold might be enamelled in black or red, simply highlighted with small geometric decorations in diamonds or coloured stones, or have agate or enamelled plaques at their ends so the owner's monogram could be incorporated. In more complex examples, the lid would be decorated with discreet materials and motifs, while the most elaborate versions had decorative devices covering the entire surfaces of both sides, overflowing from one side to the other, and even spreading to the inside lid. Everything from Arab hunting scenes, Pharaonic motifs and Chinese or Japanese landscapes, to beautiful birds of paradise and bountiful carpets of flowers were depicted, and then sometimes artfully combined on a geometric ground or decorated with a linear border in order to reconcile the two reigning tendencies, showing how they could be used in conjunction to complement one another.

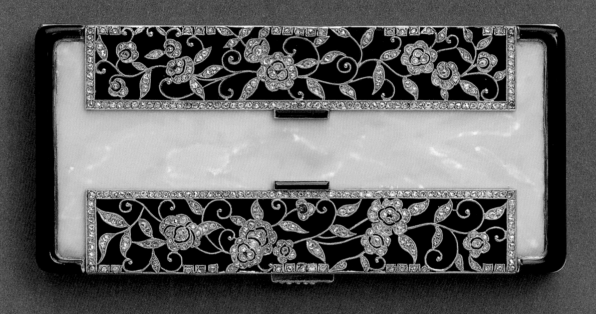

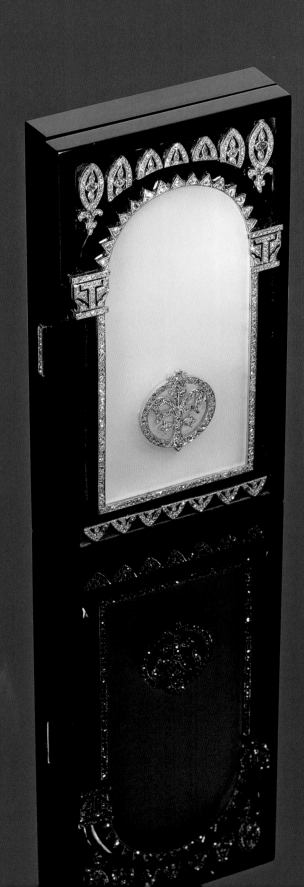

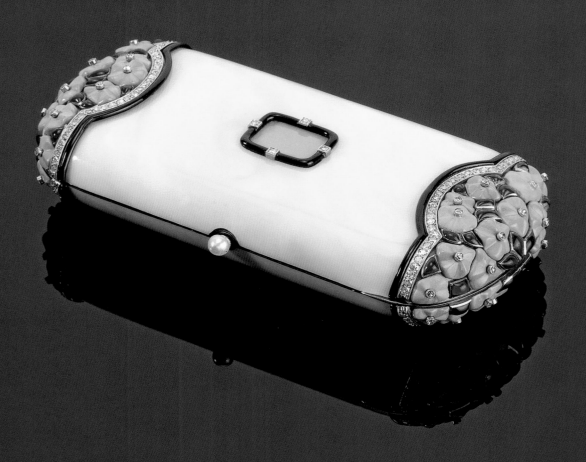

FLORA, FAUNA AND FIGURATIVE MOTIFS

Art Deco floral jewels have an illustrious pedigree that includes the botanical pieces created by masters such as René Lalique and Peter Carl Fabergé, jewellery in the Belle Epoque style and the pieces made by Chanel in the 1920s, when she first started incorporating her favourite flower, the camellia, into her designs. And despite innovators such as Paul Iribe urging all to 'sacrifice the flower on the altar of Cubism and the machine,' in reality there was no shortage of vanity cases for fans of flowers, who were presented with choice enough to suit all tastes. Colour bloomed everywhere in the gardens of post-war Europe, and by the 1920s diamond-set flowers from the classical naturalistic repertoire of the past had been replaced with a wide range of floral interpretations. Flowers might be two-dimensional, the linear treatment and stylisation of their petals and foliage being deliberate in these designs, while in other examples the high relief and three-dimensionality of nature was achieved using various sizes of buff-top gems, further enhanced with diamond-set accents.

Figurative ornament also featured in the designs of the day, and birds, insects and animals were an important part of the Deco design lexicon. When used, however, the animals chosen tended to be creatures known for their speed and grace – the greyhound, gazelle, deer, and at Cartier, the panther – these animals inspiring some of the most exotic vanity cases of the period.

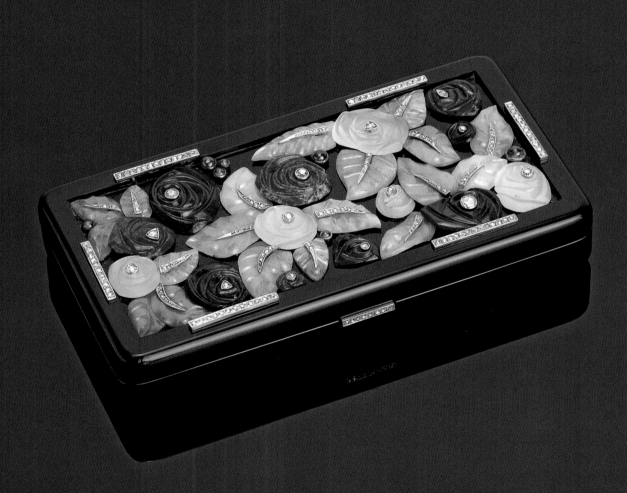

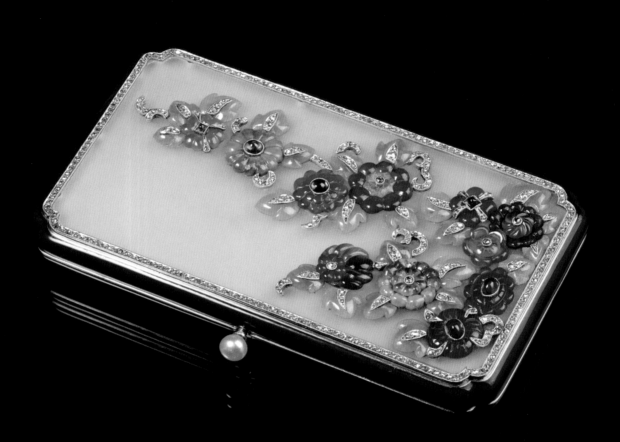

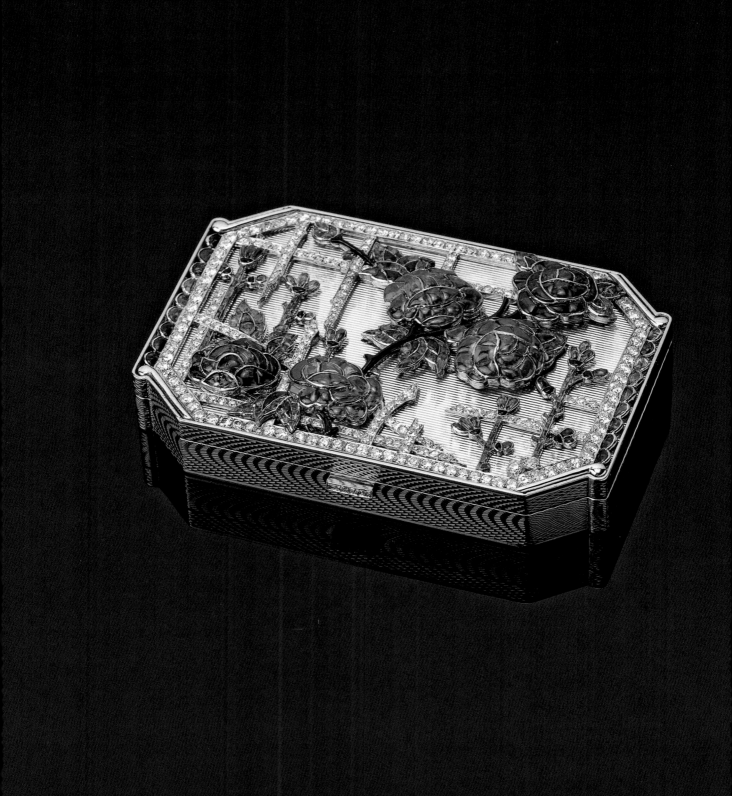

MACHINE-ABSTRACT STYLES

On both sides of the Atlantic the interwar period seemed enthralled by the march of technical progress, and the flat surfaces of vanities and boxes were ideally suited to showcasing the machine aesthetic and the glories of abstraction. The principal motifs were simple, colourful geometric forms: squares, circles, rectangles and triangles, often juxtaposed, overlapped or repeated to create more complex configurations. Even decorative patterns derived from the architecture of ancient civilisations were incorporated, including Babylonian ziggurats and stepped Mayan and Aztec symbols.

While the more traditional Haute Joaillerie houses found their major sources of inspiration in the Near and Far East, the avant-garde jewellers in particular contented themselves with the modern environment at home. For them, abstraction was the embodiment of avant-garde styling, and the best exponents of this trend emerged mid-decade, many of them second or third generations of established families that had worked in the jewellery trade since the nineteenth century, including the 'artist-jewellers' Jean Fouquet, Gérard Sandoz, Raymond Templier, Paul-Emile Brandt and Jean Dunand.

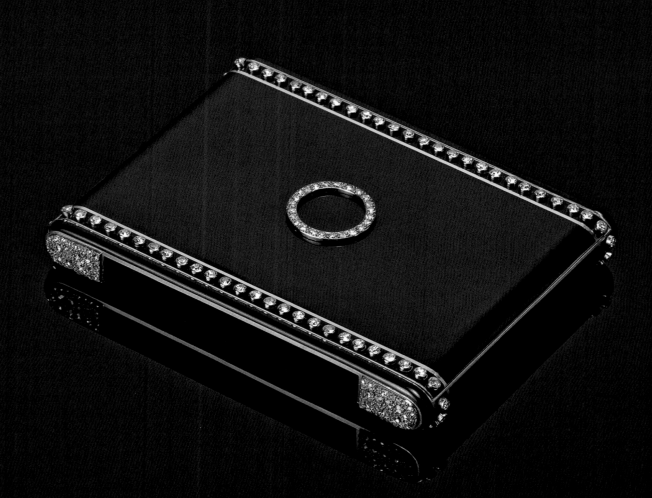

EGYPTIAN EXOTICISM

The expanding world and the lure of exotic travel, the public's increasing curiosity about foreign cultures fed by magazines, books and exhibitions, and a burgeoning base of international clients, all led jewellers to produce objects inspired by far-flung parts of the globe.

Egypt had been a recurrent theme in the history of jewellery from the days of ancient Greece and Rome, and interest was rekindled in the late eighteenth century with Napoleon's Egyptian campaign, and was further stimulated by the building of the Suez Canal in 1859–69 and Auguste Mariette's excavations in the early 1860s, when European museums were virtually flooded with finds. But it was during the first quarter of the twentieth century that Europe completely succumbed to 'Egyptomania'. The performance of *Cleopatra* by the Ballets Russes in 1909, and the Franco-Egyptian exhibition at the Louvre in 1911 both made their mark, but things really took off in November 1922 with the historic find of Tutankhamun's tomb by Howard Carter. It quickly became the most influential archaeological event of the century, capturing the imagination of the world as newspapers painstakingly followed the excavation's progress day by day for the next ten years.

While most of the major jewellery houses produced creations reflecting the 'Egyptian Revival' or neo-Egyptian taste, two distinct groups of vanity cases emerged that reflected the Egyptian craze in different ways. One group featured designs based on Egyptian motifs, with an entire ornamental vocabulary of the most common figurative symbols: pharaohs, gods, lotus flowers, scarabs and sphinxes, as well as hieroglyphs, although these were used purely for their pictorial quality rather than their symbolic significance, and as such were legible but meaningless in translation. The second group actually incorporated genuine Egyptian antiquities into their designs, such as original faience scarabs or other ancient amulets, combining the old and the new.

Some designers became known for their imaginative success within this Egyptian genre. Charles Jacqueau, hired by Louis Cartier in 1909, was especially inspired by both Egyptian and oriental themes. His knowledge and skill set the highest standard within this genre, and many Egyptian-style jewels sketched by him survive in the company archives today. He and the other Cartier designers would have seen examples of Egyptian works in the Louvre, which inspired them to create exotic new pieces involving unheard-of combinations of stones in keeping with the Art Deco palette: cornelian and lapis, cornelian and turquoise, and turquoise and lapis. The colours of the gemstones and enamel were intended to loosely evoke those of ancient Egypt rather than copying them exactly. Lapis lazuli and turquoise had been used in combination since antiquity, but designers also exercised some poetic licence in their choice of materials: coral and emerald were almost never used in ancient Egypt as neither was available locally in any quantity or quality (the so-called 'Cleopatra's emerald mines' only ever producing small included stones of low quality).

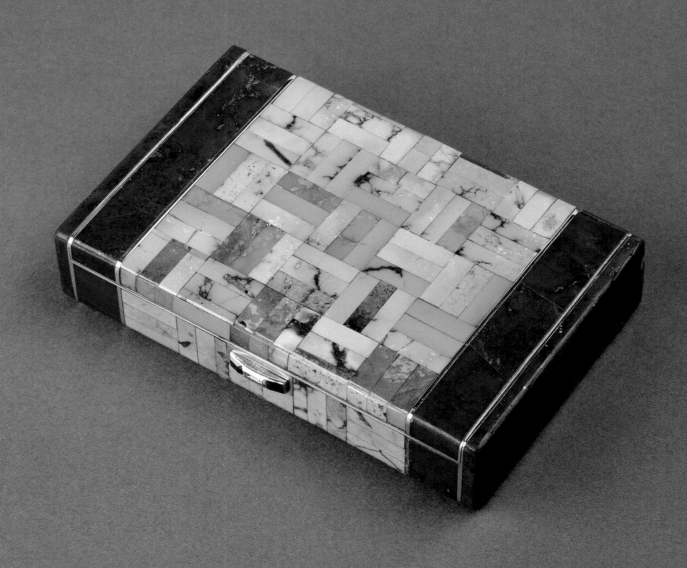

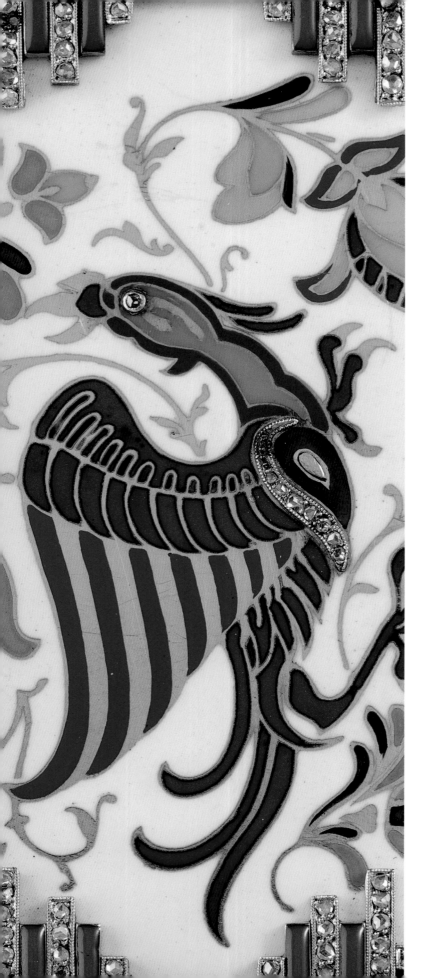

INDO-PERSIAN MOTIFS

As early in the century as 1903, the landmark *Exposition des Arts Musulmans* held at the Union Centrale des Arts Décoratifs in Paris included paintings, manuscripts and bookbindings in a quantity and variety that had never been seen before, laying the foundations for an interest in Islamic art later capitalised on by the jewellers of the Art Deco era. Louis Cartier had a superb collection of Persian miniatures, manuscripts and bookbindings of his own, as did the pre-eminent French jeweller Henri Vever, and both possessed examples from the greatest periods of Mughal book painting. Louis also collected Persian carpets and objets d'art, some of which were shown in the 1931 *Exhibition of Persian Art* at the Royal Academy in London. What really set the Persian craze alight, however, were Léon Bakst's Persian-influenced designs for Diaghilev's *Schéhérazade*, the ballet based on *One Thousand and One Nights* performed in Paris in 1910. The following year another ground-breaking *Exposition des Arts Musulmans* came to Paris, prompting yet more themed celebrations and 'bals persans' held in high-society circles in the French capital. Anything 'Arab' was all the rage.

Cartier maintained this momentum with an exhibition held at their New York Fifth Avenue premises the year before the outbreak of war, an extravaganza which lasted five days and was accompanied by a comprehensive colour catalogue with a Persian bookbinding design on its front cover. The exhibition comprised a total of 50 pieces, some incorporating antique elements, others remaining entirely European creations made by Cartier but with clear Indo-Persian design influences. In the post-war period

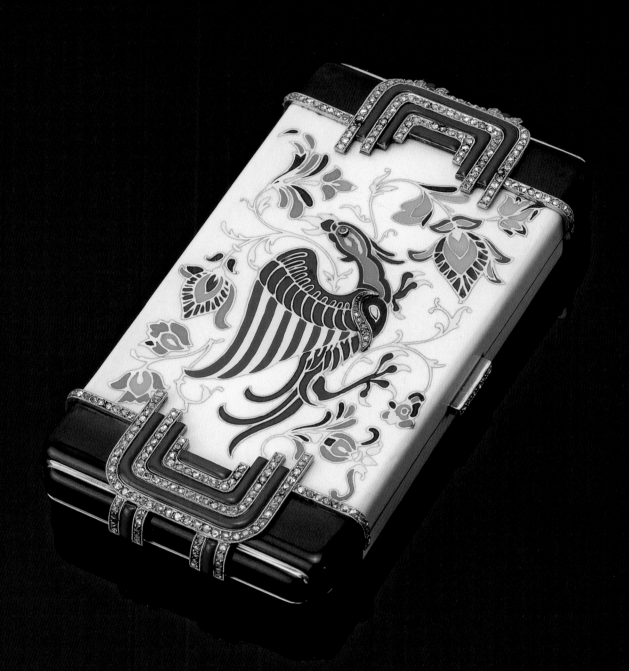

OPPOSITE Vanity case with a Persian design in enamels and borders of fluted aventurine and onyx with diamond highlights. Van Cleef & Arpels, 1928. LEFT The original design card for the case.

and throughout the 1920s, Indian royalty travelled in increasing numbers to Place Vendôme to visit the great Parisian jewellery houses, and something of a cultural two-way street resulted from this interaction. Europeans became ever more exposed to Indian aesthetics and design motifs with their exotic iconography, both figurative and abstract, and their strong use of colour. The gilded designs found on bookbindings, tooled and pressed into the leather, were creatively copied in different materials on cigarette and vanity cases, while cartouches were also common, sometimes diamond-set or surrounding a plaque. Equally popular were scroll patterns of animal and foliate 'arabesques', the delicately curvilinear motifs inspired by patterns common to many branches of Islamic art and traditionally inlaid in black.

In fact almost everything Persian or Indian, from Islamic architectural elements to Mughal carved precious stones, was used as source material and inspiration, appearing both on the body patterns of vanity cases and on their borders. Even the colour schemes typical of India and Persia affected designs and materials,

with delicate variations of rose-pinks, yellows, greens and mauves frequently appearing as well as combinations of colours such as blue and green using emerald and sapphire, or lapis and jade. All the great jewellery names incorporated these themes into their jewels and jewelled accessories, perhaps none more successfully than Maison Cartier in Paris under the directorship of Louis. Within a short time of his brother Jacques's first trip to India in 1911, the firm had established a network of buying agents in India, enabling them to source Indian gems for relatively modest sums, which Louis then used in Cartier designs manufactured in the French capital. Carved and ribbed or 'melon-shaped' gems, as well as cabochons and buff-tops with their high domes, all featured. The rich cross-fertilisation of ideas and iconography between Western and Indo-Persian aesthetics seemed infinite, and the resulting production was breathtaking.

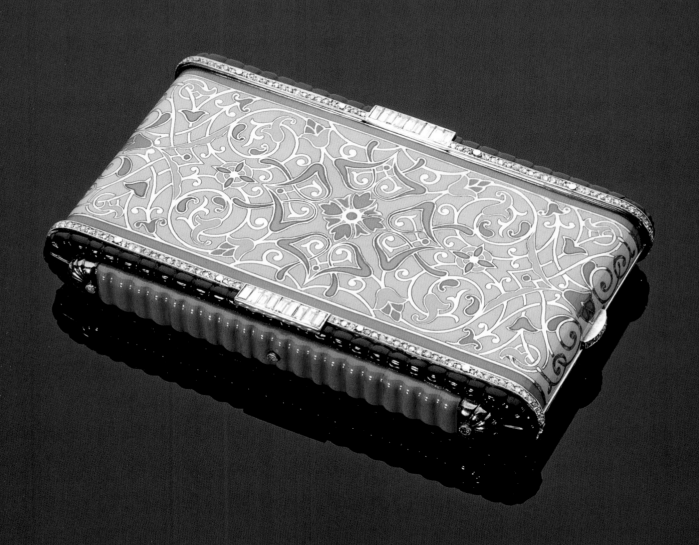

CHINESE MOTIFS

Although both Japan and China remained distant and mysterious to the public at large until the end of the nineteenth century, in reality Western artists had been drawing inspiration from these ancient cultures for centuries. After the establishment of the 'Silk Road' in the second century BC, merchants travelled this route across continents to trade in exotic fabrics and silks, spices and metalwork. The passion for Chinese silk later extended to porcelain and lacquer, brought over to Europe by the Dutch and British East India Companies, whose profits consequently boomed. As wealthy travellers began to visit China themselves in larger numbers from the 1890s onwards and Asian wares were increasingly presented at world's fairs, ever more astonishing Chinese art treasures were brought to the attention of Europeans. Indeed Chinese motifs had become familiar in jewellers' design repertoires before the onset of the First World War, and Cartier's New York exhibition of 1913 included a whole section titled 'From Chinese Art'.

But it was really in the 1920s and 1930s that interest in Chinese culture and design reached a crescendo, and this was particularly evident in objets d'art and vanity cases (while by comparison, jewellery design tended towards more Indian influences). Shanghai, the enigmatic trading outpost of the forbidden empire, became the destination of choice for smart European society wishing to experience the mystery and intrigue of the Orient. As Western travellers brought home carved jades, lacquer boxes and the various fruits of their shopping expeditions, films were made in Hollywood about Shanghai and its population of Russian refugees, notably the 1932 *Shanghai Express*, starring Marlene

Dietrich. Ever more imaginative chinoiserie creations appeared, all significantly influenced in their choice of colour, motifs and materials and all reflecting this oriental interest, even though the cases themselves were Western in their forms and functions and the motifs were interpreted loosely in what was described as 'in the Oriental manner'.

Objects as diverse as porcelain plates, carved wooden furniture and hardstone snuff bottles all provided impetus and inspiration for vanity cases. Motifs copied from the blue-and-white porcelain of the Ming and Qing dynasties of the seventeenth and eighteenth centuries were used, as well as a host of other Chinese motifs, often as straight imitations of common images such as the dragon, the pagoda or peaceful landscapes, yet all depicted in a Western version of 'the Eastern style'. Dragon motifs inspired by Chinese embroidered textiles from the eighteenth and nineteenth centuries were perhaps the most prevalent, often combined with red backgrounds to imitate Chinese lacquer (although unlike in Europe, dragons were worshipped in China as auspicious symbols of the Emperor). Also popular were intricate little panels depicting exotic landscapes and scenery, with Chinese Buddhist and Taoist figures going about their daily business, all using an Art Deco colour palette of coral, lapis and onyx, and sometimes accented with further gemstone embellishment.

Chinese scroll patterns were particularly popular for border decorations on vanity cases. These were taken directly from patterns found in Chinese textiles. Indeed some designers went further, covering the entire exterior of their boxes with these

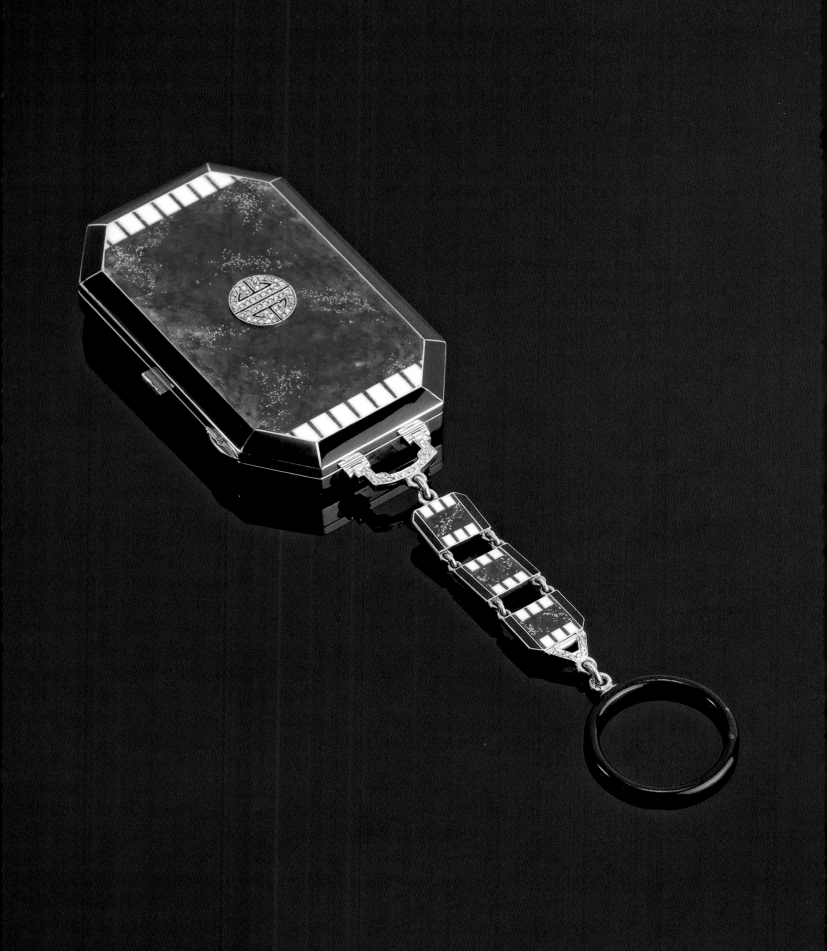

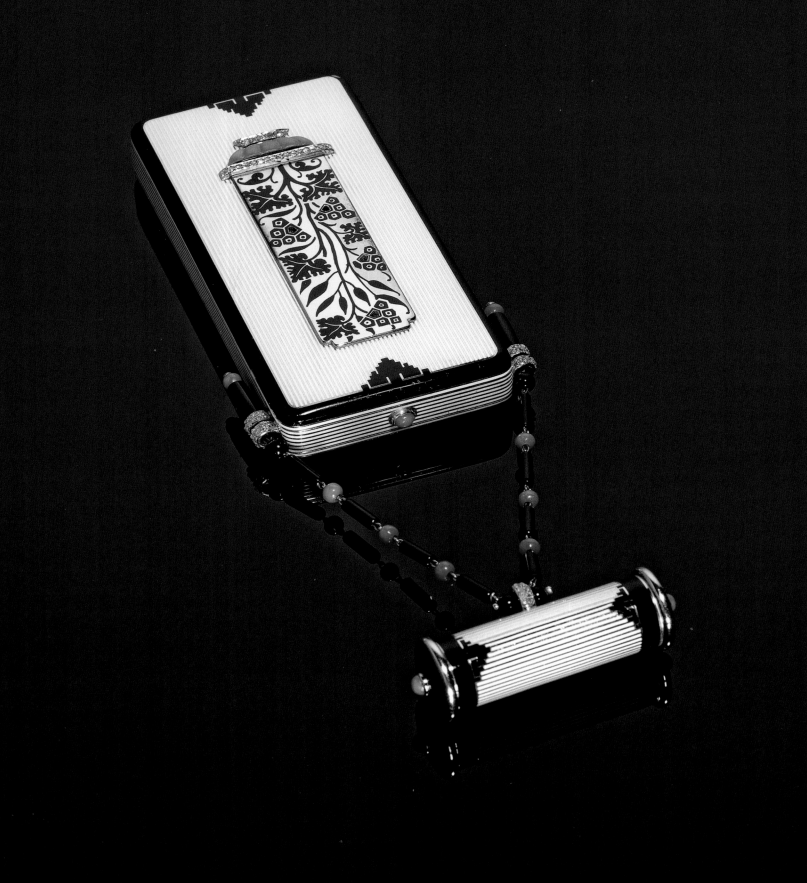

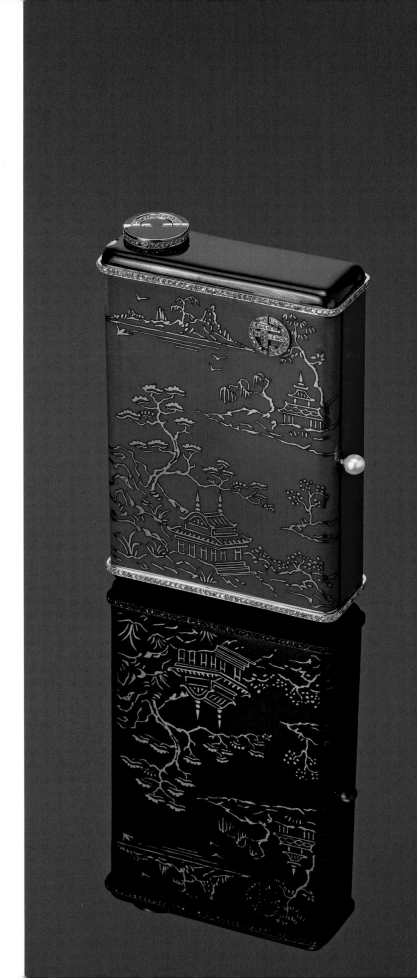

OPPOSITE Vanity case in striped white enamel within a black enamel border, with a central plaque of a coral and diamond urn with black enamel foliate motif and a coral and enamel suspension chain with similarly decorated lipstick holder. Cartier, Paris, 1924. RIGHT Vanity case decorated with a chinoiserie scene on a red enamel background, the top and base of black enamel, with a separate lipstick holder. Lacloche, Paris, c.1925.

patterns, embellishing every available surface in repeating rhombs, hexagons, scales or circles, producing marvellous mosaic-like effects. Chinese decorative symbols and signs were also adopted into jewellers' lexicons, either directly or in adaptation, such as the ubiquitous *shou*, the character for longevity, a round symbol with horizontal arms. The Chinese variant of the Greek meander pattern was also popular as it made an ideal repeating border pattern, finishing off the oriental look.

Some vanities incorporated actual Chinese or Japanese elements such as original carved jade and lacquer, while others used Chinese or Japanese motifs in their design but were entirely made in Western workshops. Cartier, Van Cleef & Arpels, and Lacloche created some of the most exquisite vanity cases featuring Chinese motifs, using enamelled gold, mother-of-pearl marquetry and lacquerwork of the highest quality, together with jade, onyx, coral and other hardstones, with precious gems perhaps included as accent stones. These were nothing less than mighty works of art in miniature.

OPPOSITE Card case with a frosted rock crystal
body, lapis lazuli panels to top and base, a Japanese
weeping willow applied in black enamel, rose-cut
diamonds and a *shou* sign. Lacloche, Paris, c.1920–5.
This was the first case acquired for the collection.

FOLLOWING PAGES Double-sided vanity case inset
with *lac burgauté* panels of oriental landscapes
bordered by fluted corals and rose-cut diamonds.
Signed and numbered. Cartier, Paris, c.1925.

JAPANESE MOTIFS

The traditional Japanese inrō certainly inspired the basic form
of the vanity case, and following Commodore Matthew Perry's
expedition to Japan in 1853–4, this newly discovered empire began
to open up to adventurous travellers on an unprecedented scale.
Nineteenth-century jewellers had started to research Japanese
techniques such as lacquer and cloisonné enamelling and to use
Japan as a new source of stylistic motifs. At the Paris Exposition
Universelle of 1878, the dealer Samuel Bing showed Japanese
bronzes and lacquerwork, while an exhibition in the Trocadéro
also presented Far Eastern finds. In the Art Deco era, Japonisme
was all the rage. Just as with China, all manner of influences and
iconography were evident in vanity cases, from woodblock prints
to colourful enamels, metalworking, inlay and lacquers, using
botanical motifs from bonsai trees, chrysanthemums, plum and
cherry blossom, to cranes and country landscapes, with some
vanity cases even opening out to look like Japanese screens.

And so it continued. Designers raided almost every culture
imaginable to come up with their vast array of exotic prototypes,
together creating an enormous, colourful eclecticism. African,
North American Indian and South American art and architecture
with its stepped elements were all to feature in boxes and cases.
Whatever the style and motif identified by Art Deco craftsmen and
then conveyed to the public, the mantra was the same in all cases:
bold design. Jewellers did not simply copy motifs, but studied
them to create their own unique combinations and effects.

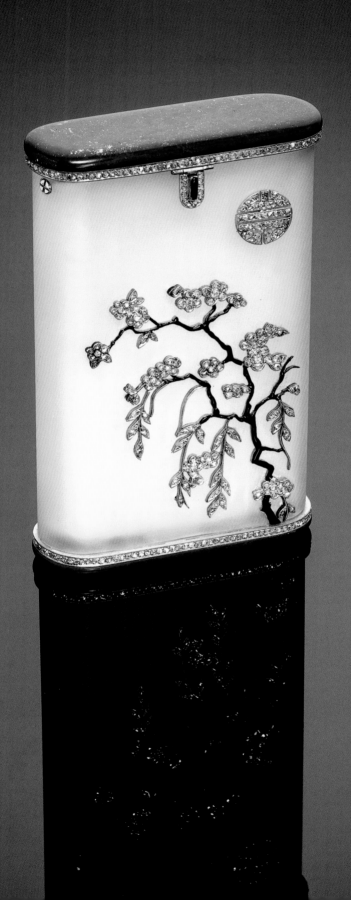

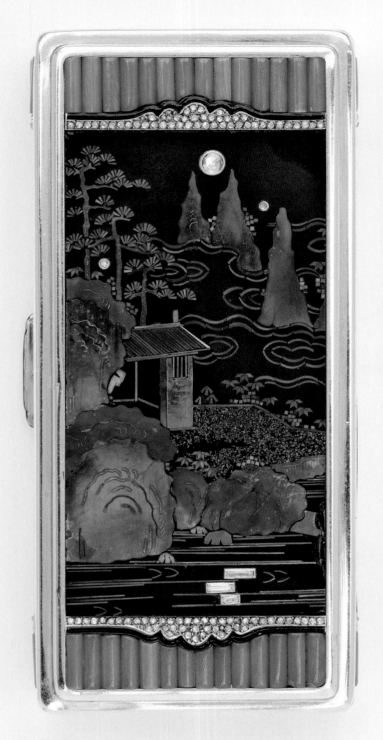
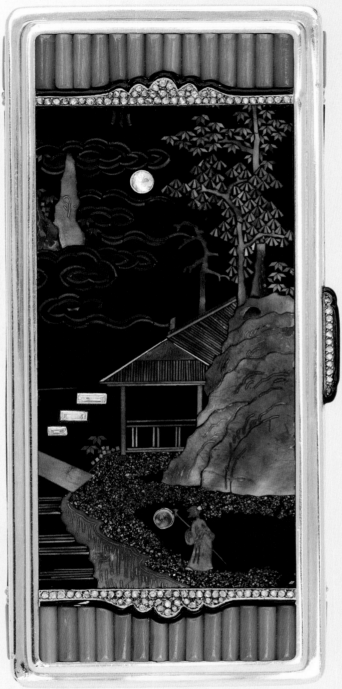

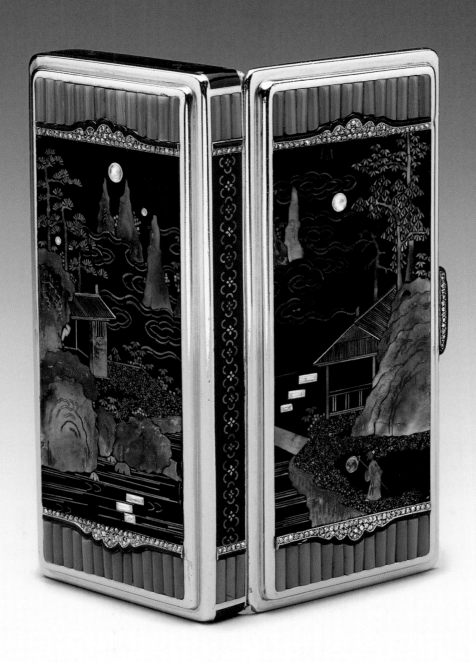

MATERIALS AND TECHNIQUES

The materials used by Art Deco jewellers ranged from traditional and precious, to unorthodox and innovative, and were as varied as plastic, chrome, onyx, rock crystal, tortoiseshell, turquoise and coral. Technical advances in metallurgy and new techniques in stone cutting facilitated novel combinations of surfaces and colours, turning the natural hierarchy of materials on its head and giving free rein to design imagination. No expense or effort was spared as vanity cases were treated as blank canvases: precious metals were combined with enamel, lacquer and inlaid mother-of-pearl; opaque gem materials (jade, turquoise, coral, onyx and lapis lazuli) were given equal standing with precious gems, set off with brilliant-cut diamonds and accented with emeralds, rubies or sapphires, and all these materials were used in ways that emphasised their colour and texture. Combined, they produced an explosion of visual excitement.

LACQUER

Black lacquer was one of the quintessential Art Deco materials. It is a naturally occurring polymer obtained from the bark of the *Rhus vernicifera* tree native to China, Japan, Taiwan and Vietnam. Traditionally the raw brown sap, known as *urushi* in Japan, is collected, filtered and stirred to produce a varnish which, when dry, is hard and impervious to water. Coloured pigments are added in the form of iron oxide to produce the ever-popular black lacquer, ferric oxide and vermilion for red, Prussian blue for blue, and cadmium and chrome for yellow. The varnish is then applied to a wooden or metal surface in many layers, with each layer cured in a warm, dust-free but high-humidity environment for two days before being sanded, polished and buffed by hand. Traditionally up to 200 layers are used, the top layer being hardened at 100–180°C to create an end product whose malleability, adherence, resistance and elasticity combine to make it an ideal material for decorative artistry. In *lac arrachée*, a variation of the technique, a layer of lacquer is lifted with a wooden spatula and reapplied to another lacquered surface to produce a sort of mottled effect, which can then be further accentuated with metal shavings, gold leaf or gold powder before the final coat of varnish is applied.

Lacquering is believed to have been discovered in China over two millennia ago and was used widely throughout Asia, especially in Japan. It was brought to Europe by traders in the sixteenth and seventeenth centuries, and became highly fashionable during the Art Deco period, when it was put to a vast variety of uses: in the fit-out of couturier Madeleine Vionnet's new salon, aboard the luxury liners *L'Atlantique* and *Normandie* and on the best-known private yachts of the day – the Vanderbilt family's boat *Alva* and the Duke of Westminster's *Flying Cloud*. It even had an impact on toiletries: Elizabeth Arden's perfume 'Ming', which came out in 1925, was presented in a lacquer bottle.

During the First World War, skilled Chinese and Indochinese workers had been recruited by French manufacturers of aeroplanes to lacquer propeller blades, their skins proving less susceptible to the toxic fumes than those of their European counterparts, and their skill in lacquering was unrivalled. Some of these craftsmen remained in France after the war, settling in Paris

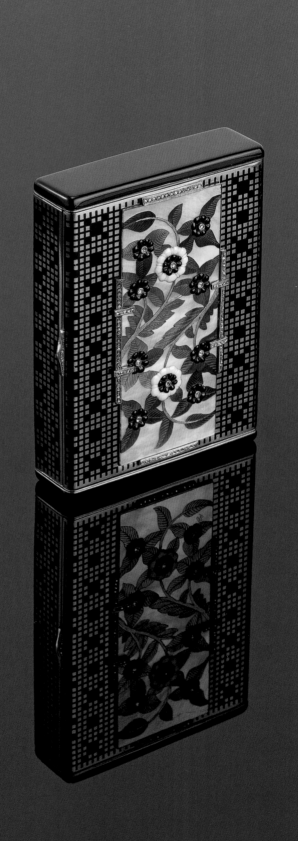

and congregating in communities where they ran workshops that took on commission work from the top Parisian jewellers. Some Western artists attempted their own production: the versatile French designer Jean Dunand became a skilled lacquer artist in his own right, learning traditional Japanese *urushi* techniques from Japanese masters Seizo Sugawara and Hamanaka Katsu, who were working in Paris at the time.

MOTHER-OF-PEARL AND LACQUER

Like many artistic techniques imported into seventeenth- and eighteenth-century Europe from East Asia, the combination of lacquer and mother-of-pearl proved a hugely popular one, and a key feature in many Art Deco vanity cases was the reuse of original Chinese lacquer inlaid with tinted mother-of-pearl mosaic or marquetry, more commonly known as *lac burgauté* ('burgauté' meaning 'mother-of-pearl mussel'). Chinese craftsmen had learnt how to inlay black lacquer tablets with tissue-thin slivers and sections of the innermost layers of mussel shells to produce a kaleidoscope of scintillating colours – pinks, purples, blues and delicate greens – which they used to create extremely detailed chinoiserie scenes. Mother-of-pearl was enormously symbolic within the Taoist scheme, its colours evoking eternity and the ethereal nature of life. Some examples were further tinted with artificial colour to enhance the vivid contrasts and shimmering hues within the natural material, with additional gold and silver foil inlays sometimes used to make it stand out more against the black background. Finally, multiple layers of lacquer and various

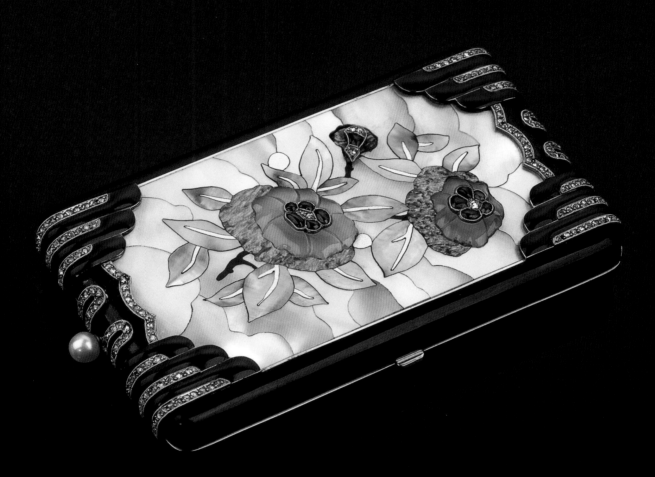

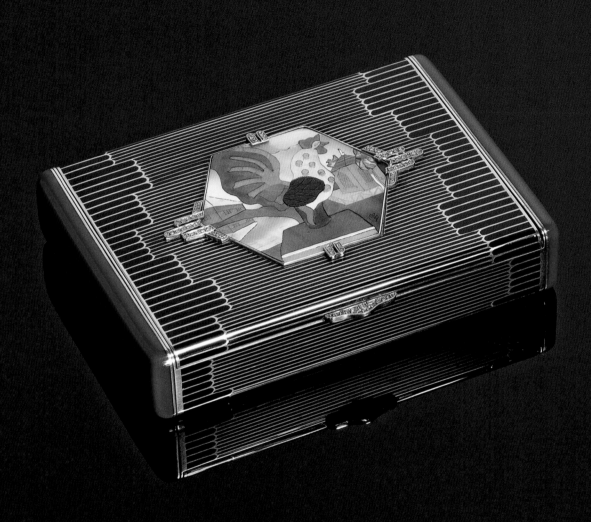

OPPOSITE Cigarette case with black enamel strip decoration to the front and back, red enamel on the sides, and a central plaque depicting a cockerel in mother-of-pearl and hardstone by Vladimir Makowsky. Black, Starr & Frost, c.1925–30.

polishing techniques were painstakingly employed to give the plaques a seamless, rich and glossy effect.

In an effort to preserve this ancient technique and the integrity of the precious objects featuring them, the high jewellery houses of Paris began collecting original mother-of-pearl lacquer from the leading antique dealers of the time. The panels were extracted from existing bowls, tables or trays and then reused, sometimes with further embellishment of enamel, jade, coral, lapis lazuli and onyx, cabochon gemstones and small diamonds, in typically Art Deco ensembles. Judging by the large number of small objects decorated with lacquer produced by Cartier alone, these were extremely popular: in 1926 James de Rothschild ordered 34 such vases to give as Christmas presents, with the company order books revealing that although some of the decorative panels were already in stock, others had to be bought in specially to fulfil the commission.

Not all these little panels originated from Asia however, and some were made in situ in Paris, still based on oriental models, yet rather different in their creation with only 20 or so layers used in the production process. These Western mosaics used tinted mother-of-pearl but also a variety of hardstones inlaid into a pale mother-of-pearl ground, producing an effect that was very different from black *lac burgauté*. Many of these Western inlays were the work of one craftsman in particular – Vladimir Makowsky, a Russian emigré artist living in Paris who specialised in the creation of Chinese lacquer and gemstone work, using traditional Chinese iconography and perspective to produce a fully authentic effect. The resulting tablets might then be set within a geometric border of enamel, in a typically Art Deco pastiche, combining traditional Asian methods of manufacture with modern Art Deco designs and bold colour schemes. While Cartier may have been the pre-eminent maker of these Chinese lacquer vanity cases (they produced their first cigarette cases based on nineteenth-century Chinese mother-of-pearl mosaics as early as 1913), other notable jewellers also created equally beautiful Chinese-inspired cases using different techniques such as enamelling.

One further lacquer effect particular to the Art Deco period was championed by Jean Dunand. Known as *coquille d'oeuf*, it was introduced by Dunand to make up for the absence of white when working with the dark brown coloured *urushi*. He used crushed eggshell fragments, placing these on freshly applied lacquer with either their convex or concave side facing up, depending on the effect he wanted. Once smoothed and polished, he applied a final coating of transparent *urushi* to seal in the eggshell fragments as part of the pattern. Dunand used the technique to create very effective geometric designs with the eggshell as a contrast to the lacquer, this effect becoming a speciality of his workshop and popular enough to prompt him to keep a chicken coop in his back courtyard to guarantee a steady supply of eggs. Dunand even used the eggshells of ducks, partridges, and exotic birds on occasion to create different shadings and colour contrasts. His methods were taken up by other designers and craftsmen, notably Gérard Sandoz and Paul-Emile Brandt, who used the lacquer and eggshell combination together with metal, often silver, or with geometrical shapes in enamel.

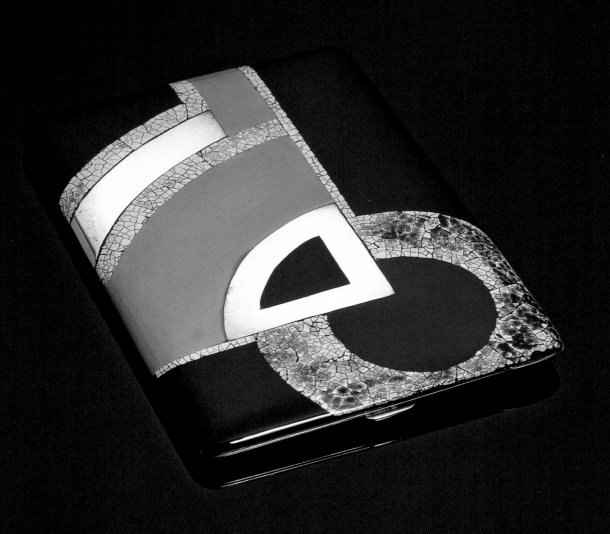

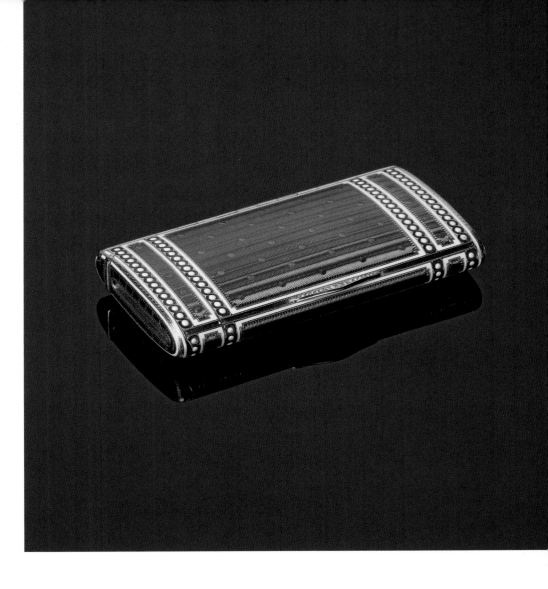

OPPOSITE Silver cigarette case decorated with lacquer and eggshell lacquer, with a silver gilt interior. Designed by Paul-Emile Brandt for Cartier, Paris, and made by Felix Montel, c.1925. RIGHT Cigarette case decorated with translucent grey-blue guilloché enamel and a white champlevé enamel border, with a match compartment and strike. Cartier, Paris, c.1910–15.

ENAMEL

The use of enamelling in jewellery dates back to the ancient Persians, Egyptians, Greeks and Chinese before it was popularised by the Romans and spread to Western Europe. Used to decorate objects and jewels in the Medieval and Renaissance periods, enamelling underwent a revival in the hands of French craftsmen in the eighteenth century. By the nineteenth century Swiss and Russian craftsmen had further developed the technique, and Peter Carl Fabergé perfected the use of translucent enamels in his magnificent oeuvre. Vanity cases provided perfect surfaces for the huge variety of decorative effects made possible using this material. Enamel is essentially a mix of ground, powdered silica – glass, in effect – with a variety of metal oxides added as colouring agents, which are then bonded by fusion to a heat-softened metal surface in a kiln. Of course, the metal surface to which the enamel

adheres must tolerate temperatures higher than the melting point of the enamel mixture itself. Each colour has a different melting point, the highest temperature being for the first firing, allowing subsequent colours to be added without melting those previously applied. When executed well, the colours produced can be truly vibrant, the vitreous nature of the enamel giving a smooth, reflective surface. Despite this finish being hard and scratch-resistant, enamelling used on large areas such as vanity cases, and particularly on corners, is delicate and can chip. Black lacquer on silver is generally cheaper and more durable than enamelled gold, and for this reason was sometimes used in preference to enamel for the vanity cases of the Art Deco era.

A simple but striking enamelling technique used at this time produced a striped effect known as 'email pékin mille raies', which exploited the contrasts obtained using coloured gold with

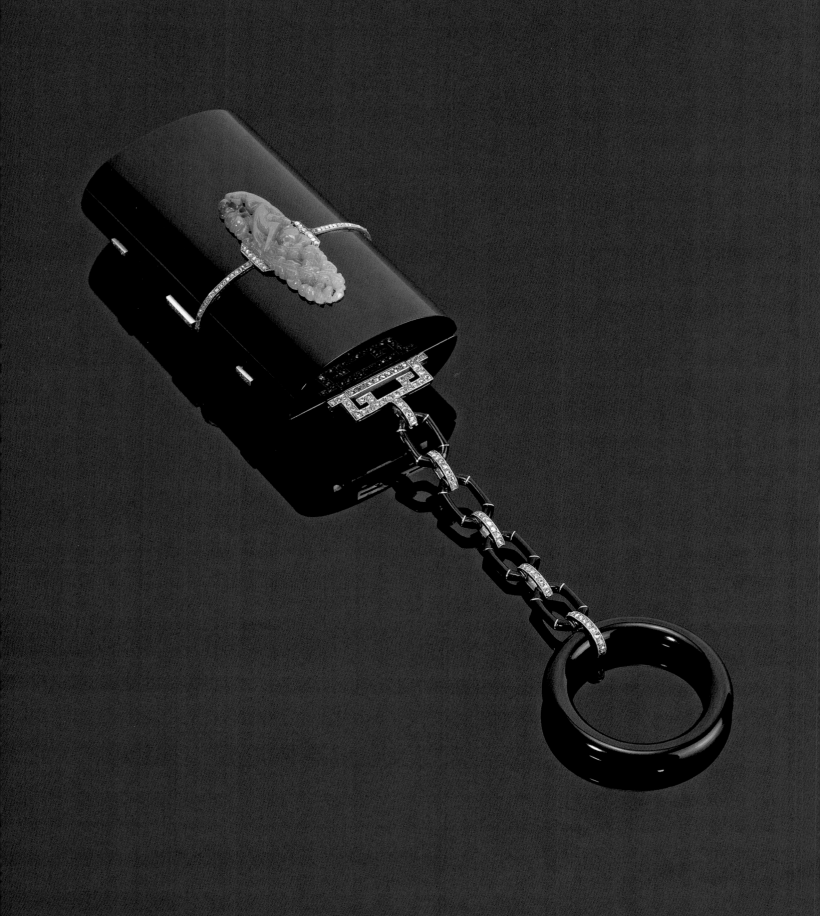

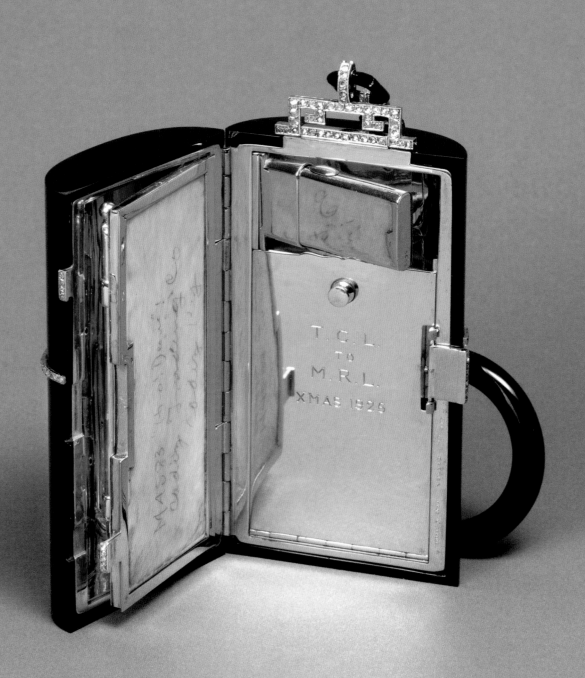

T. C. L.
to
M. R. L.
XMAS 1926

two-tone enamelling, either one colour with gold, or two contrasting enamel colours such as black and cream. All-over geometric patterns were also used as decoration and were achieved using enamel of different colours in a kind of 'patchwork' style, largely inspired by oriental patterns and Japanese inros.

A second popular technique known as 'guilloché' enamelling involved engraving the metal shell of the case with intricate patterns created using engine-turning before the subsequent application of several layers of enamel over the top, each fired successively to achieve the desired strength of colour yet maintaining the translucency of the metal ground below. Such machined finishes particularly suited the repetitive geometric patterns favoured by Art Deco designers, playing to the overall machine aesthetic of the day. A shaded or so-called 'ombré' enamel could be achieved by varying the thickness of successive layers to produce a more iridescent or opalescent surface, while borders of chased gold and opaque enamel in relief were often used to complete the effect. This technique was one of Fabergé's favourites, and used by the Russian master to great success. Inspiration also came directly from gold boxes and étuis (flat cases for notebooks or implements), made in Paris and Geneva in the late eighteenth century. The handsome collection of these French gold boxes built up by Edmond de Rothschild in Paris would have been one of several collections familiar to designers of this era. Enamel thus played a crucial part in Art Deco design, and although, initially at least, the main jewellery houses commissioned workshops in Moscow and St Petersburg to execute the various types of enamelling to their order, it was not long before their own ateliers in France began mastering the full range of Russian techniques, each building up its particular area of expertise.

GEMSTONES AND HARDSTONES

Together with enamel, all the top jewellery houses of the time incorporated colour into their creations by using a wide variety of gems and hardstones, cut and carved in a multitude of different ways. Despite their indisputable beauty, 'hardstones' fall outside the prestigious category of precious gems, nor can they strictly be called 'semiprecious', forming instead a third category of opaque minerals that are not as rare or therefore as expensive as others. Yet the interest in opaque, ornamental stones is as old as humanity itself and actually pre-dates man's use of precious metals or gems. Antiquity was the golden age for hardstones, but their appeal returned during the Renaissance with the revival of Classical culture, and then again in the late eighteenth and early nineteenth centuries when the Neoclassical style rekindled the taste for the glyptic arts (carved cameos and intaglios).

In the twentieth century, gem materials including jade, coral, lapis, malachite, turquoise and coral were once again prized by designers, and used to produce startling visual effects, especially when juxtaposed with gemstones of the more traditional type. Some were carved into floral motifs, while others were used in intricate inlay work, with the production costs of boxes using this sort of elaborate lapidary work being generally much higher than for the equivalent enamelled versions: an inlaid vanity case

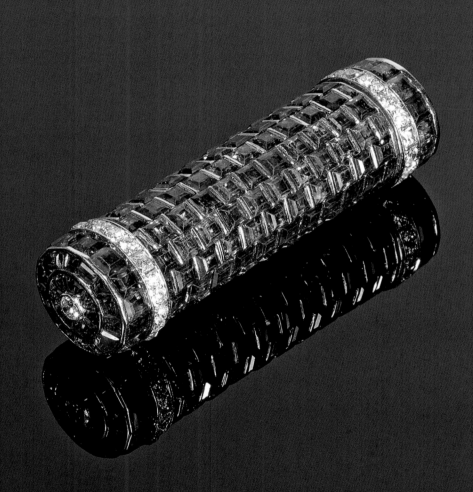

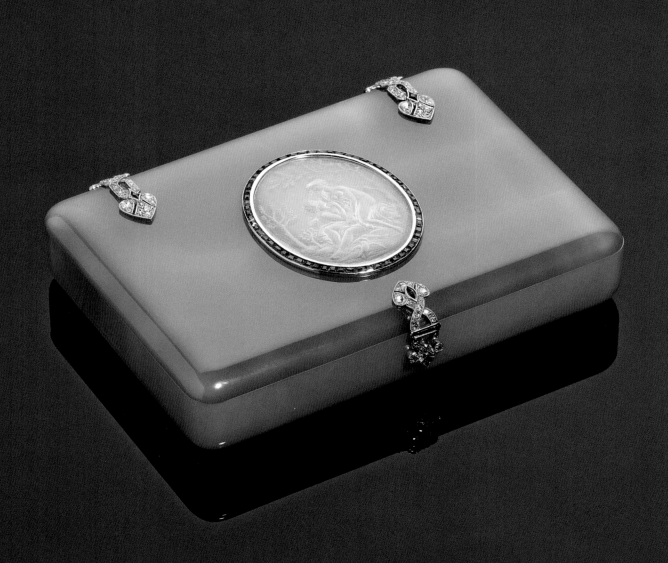

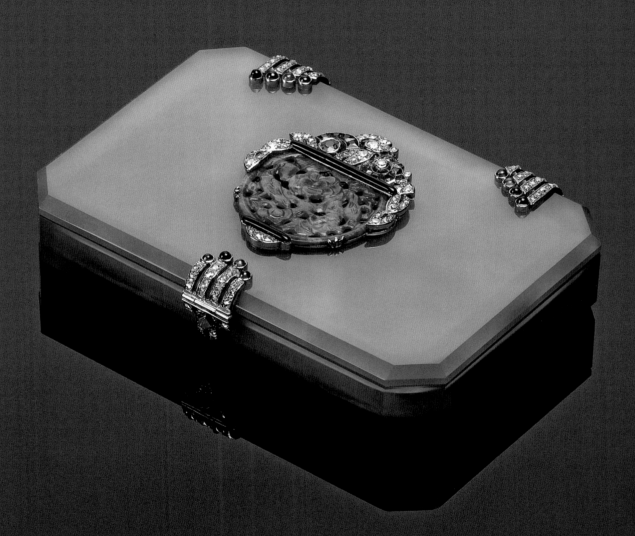

might cost almost twice as much as one decorated with all-over enamelling. Generally speaking, cigarette cases were less expensive to produce than vanity cases: the cost of an enamelled cigarette case was about half that of an equivalently decorated vanity case, while a cigarette case with carved hardstones and inlay work might be priced similarly to an enamelled vanity.

The boundless enthusiasm for anything 'Eastern' ensured that, as well as enamel, lacquer and mother-of-pearl, jade was also in demand and used to produce original decorative effects with an oriental flavour. In August 1928, an American newspaper noted that 'Parisian women cast envious glances at Cartier's windows, with their new collections of bracelets that join jade with lapis, jade with sapphires, jade with topaz.' As well as newly crafted material, original jades, perhaps engraved or open-worked, were also used to great effect, and jade was particularly popular for evening wear accessories, including vanity cases.

Along with lacquer and enamel, onyx was similarly valued and utilised as one of three important materials available to create the colour black in designs. The combination of black and white was perennially popular, especially for evening wear, and was a longstanding signature of Cartier creations from 1910 onwards, when jewels began to be made using the so-called 'panther skin' ornament: pavé-set diamonds accented with small onyx cabochons, pyramids or chips. Onyx is the black variety of chalcedony (a crystalline form of quartz), while agate is similar in its composition but is brown, and rock crystal is colourless and can have a polished or frosted surface. In the Deco era these materials

were sometimes carved from blocks of rough material in a single piece to be used instead of metal for creating the translucent bodies of small cases and boxes.

The three most precious brightly coloured gemstones – rubies, sapphires and emeralds, always prized by jewellers – were used sparingly on vanity cases and mainly for those carried in the evening, appearing as accent stones or carved into leaf and flower shapes in the Mughal manner. Other coloured stones were used in all their faceted, cabochon and engraved forms, with buff-tops and calibré-cut stones (those specifically cut to fit a designated position in a bespoke jewel) particularly prevalent. Diamonds also moved on from simple pavé setting and classic cuts such as rose and brilliants, to novel baguettes, prisms and trapeziums, all used together to create new and interesting patterns and light effects.

METALS

Gold, always considered to be rare and precious, has traditionally been regarded as the most important metal used in jewellery. Its great ductility and malleability and the fact that it is unalterable by heat, moisture and most corrosive agents made it perfectly suited for vanity cases, which were required to carry cosmetic materials of a chemical nature. However, pure gold is too soft for the purposes of jewellery and is usually mixed with other metals to make an alloy, the proportion of gold to the other constituent metals being expressed in karats as a number out of 24 parts by weight, pure gold being 24K. Being largely manufactured in France, most vanity cases were in 18K gold (the French third standard gold of 750

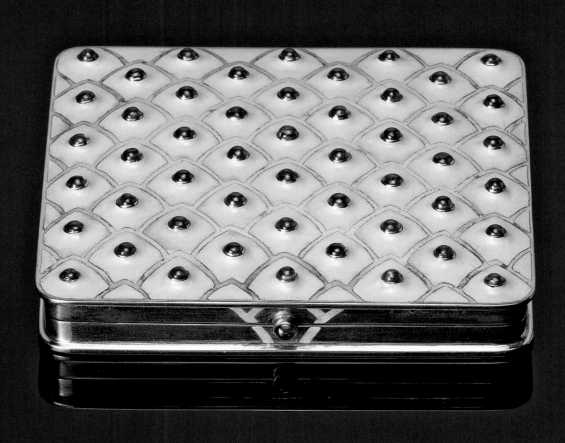

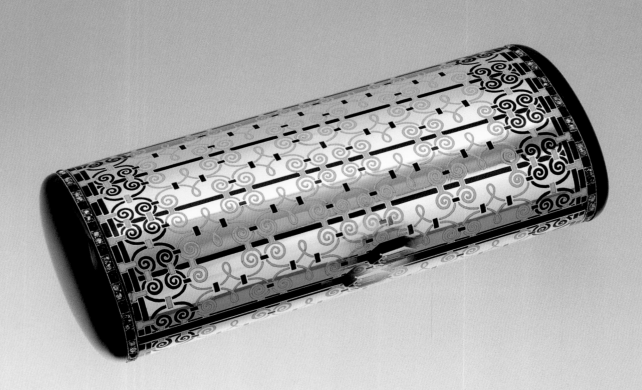

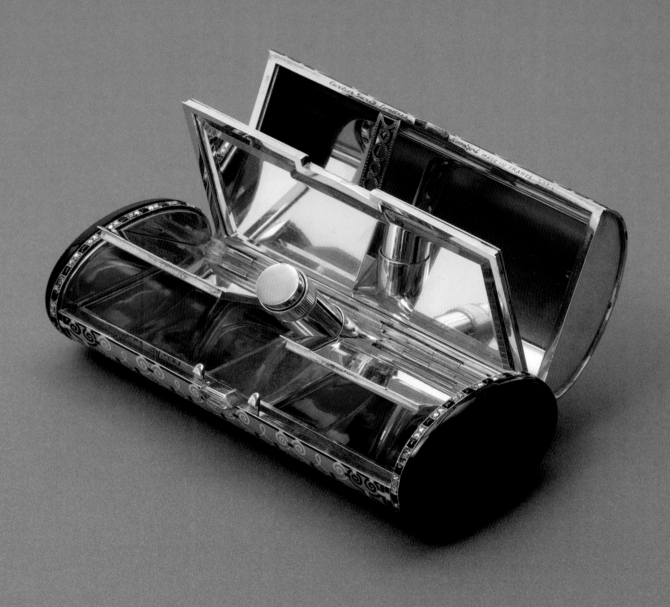

parts in 1000), while some might be made in 14K in the US and Germany. Gold can be mixed with other metals to make coloured alloys depending on the exact mix: rose gold is made by mixing gold with copper, and white gold by using a high percentage, 10–12 per cent, of other metals such as palladium, nickel, manganese, zinc or silver.

The discovery of how to use platinum as a setting metal in the first decade of the twentieth century, and its perfection a few years later (it was used in the manufacture of explosives during the First World War), revolutionised the jewelled arts. But though it reigned supreme as the white metal of choice in top-quality jewellery, it was expensive and rare, its higher density making it 30 per cent heavier than gold. To fulfil the range of manufacturing needs a substitute had to be found. In 1918 an alloy named Osmior, Plator or Platinor was discovered, and it was used great deal by artist-jewellers such as Jean Fouquet. Silver was another less costly alternative to white gold or platinum, and used particularly by the artist designers, but it tarnishes in air and is too soft to be used in jewellery without being mixed with copper. The expression 'sterling silver' refers to the usual alloy of 0.925 parts silver and 0.075 parts copper, which would be stamped as '925' on the body of a vanity case. Finally, the interiors of many vanity cases were made in silver gilt, or vermeil, sterling silver that is coated or plated with a thin covering of yellow gold, giving a thoroughly 'precious' feel to the insides of vanity cases as well as their exteriors.

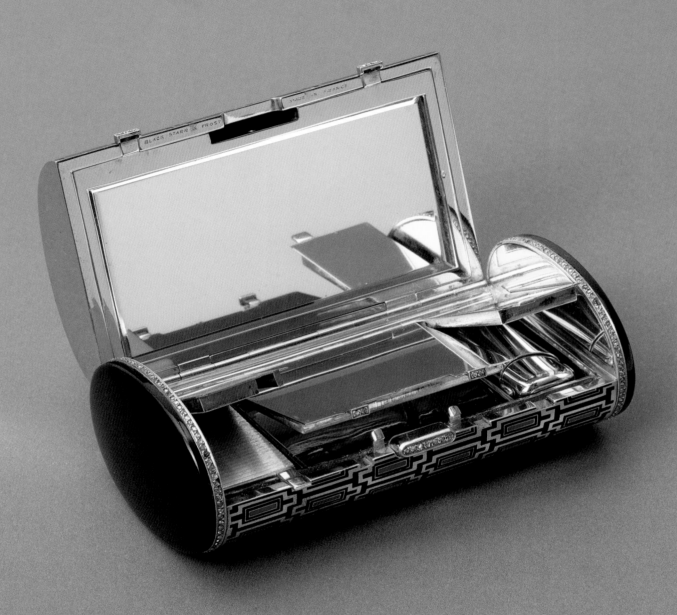

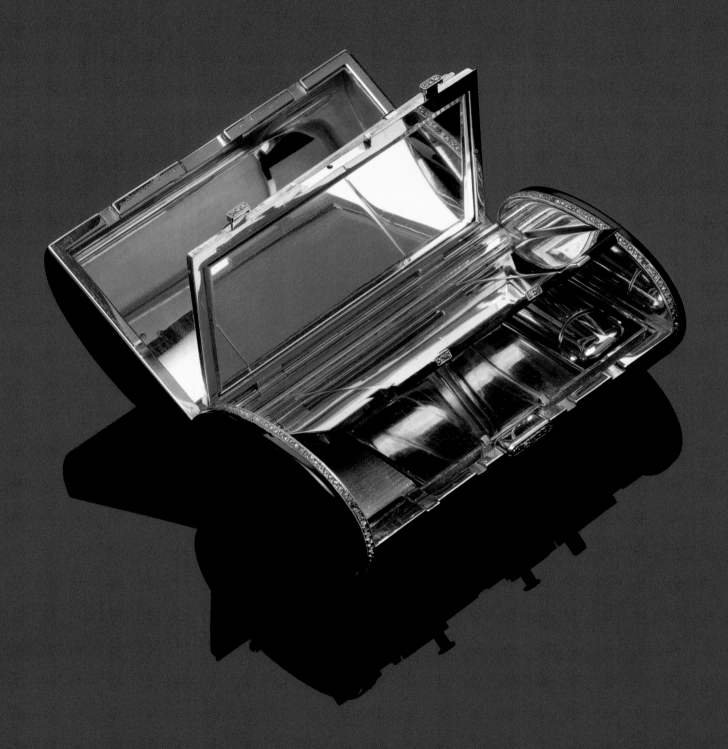

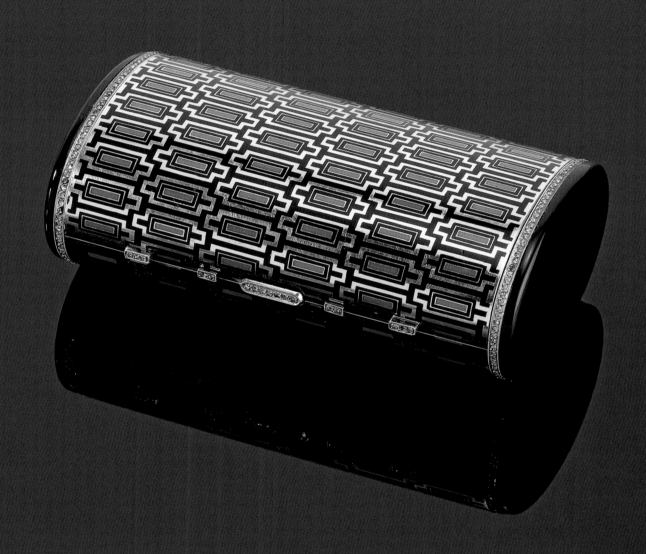

3

MASTER
JEWELLERS
AND
CRAFTSMEN

PEOPLE AND
PRODUCTION

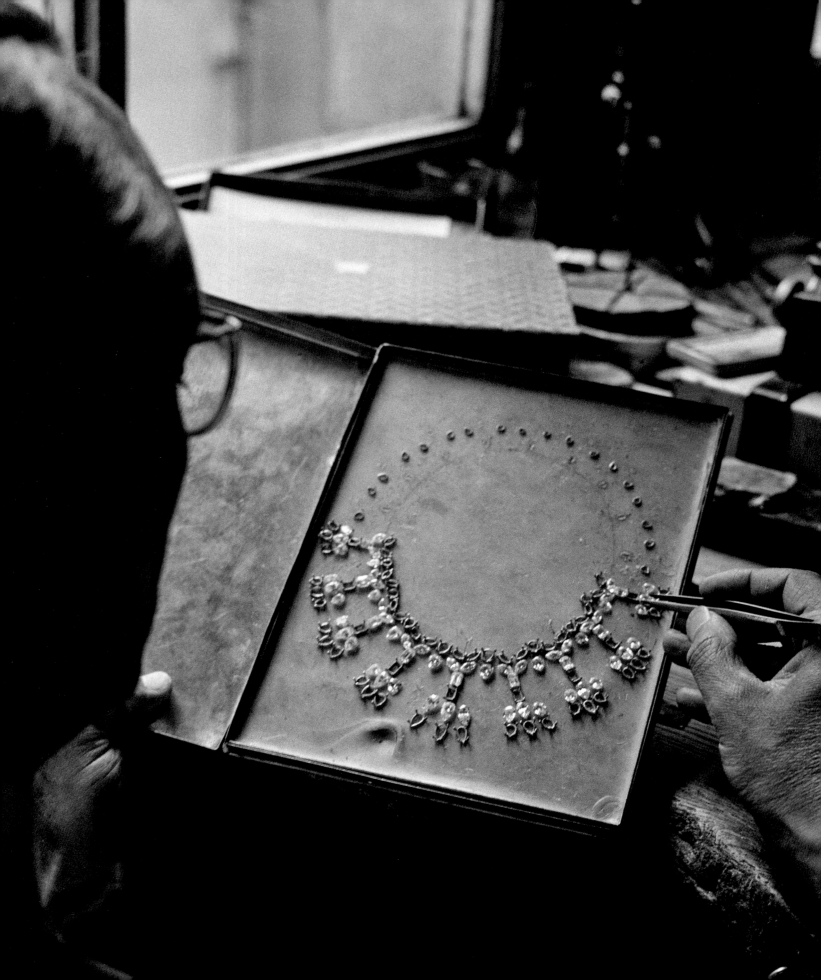

The most prolific and successful creators of jewellery and jewelled accessories were the high jewellery houses of Paris: Cartier and Van Cleef & Arpels, together with firms such as Boucheron, Lacloche Frères, Boivin, Janesich, Linzeler-Marchak, Ostertag, Ghiso and Marzo. While the jewellery firms of Paris were acknowledged for their new products at the 1925 Exhibition, their contemporaries across the Atlantic were also producing important Art Deco pieces on a par with their European counterparts. American jewellers, led by Tiffany & Co, Raymond Yard, Marcus & Co, Black, Starr & Frost and Charlton & Co were all active in the 1920s, selling to a client base that included the wealthy Vanderbilt, Morgan, Gould and Astor families. The impact of Art Deco style can be seen on the streets of New York to this day, from the majestic Chrysler and Empire State buildings to the interior of Radio City Music Hall.

All the top houses of Europe and the US vied with each other for business, each attempting to outdo their competition with the sheer

originality and opulence of their creations. While top clients might commission a vanity case, it was more usual for a jewellery house to take the initiative in the design of their new boxes and cases, sending drawings to the appropriate workshop and then stocking the completed box ready to display, and hopefully sell, in the showroom. The profusion of designs for vanity cases in jewellers' archives illustrates the fertile imaginations of the designers, but also the ingenuity of the actual makers and craftsmen working in the various studios and workshops attached to each house. Their skill at translating ideas and designs into reality, each a masterclass in miniaturisation, remains unsurpassed to this day.

The success and endorsement of the *nécessaire* by elegant women everywhere provoked fierce competition, not just among the great *maisons*, but also among the Modernist or avant-garde artist-jewellers, the so-called 'bijoutiers-artistes', led by Jean Fouquet, Gérard Sandoz, Raymond Templier, Jean Després, Paul-Emile Brandt and Jean Dunand. These designers presented jewels of artistic

DESIGNERS

rather than intrinsic value, choosing materials purely for their decorative character and employing them in a pictorial and sculptural way, eschewing any superfluous decoration. Three of them in particular attracted a great deal of attention at the 1925 Exhibition: Jean Fouquet, Gérard Sandoz and Raymond Templier, all of whom were ardent followers of modern art and not content simply to exhibit their creations in the showcases of their well-respected and established fathers.

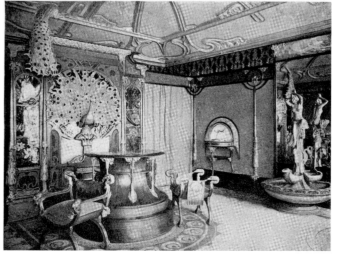

HAUTE JOAILLERIE IN FRANCE

CARTIER

Perhaps the best example of a great jewellery house embracing all the influences and eclecticism of the period was Cartier. For many this was the *maison* that reigned supreme in the field of personal accessories, with its amazing flair, inventive genius and ability to balance technical needs with aesthetic demands.

Alfred Cartier, son of the founder Louis-François, had four children: Louis, Pierre, Jacques and Suzanne, who all came into their own within the business in different ways in the Art Deco period. In 1898 the firm moved to 13 rue de la Paix, a well-chosen address next to the Ritz hotel and close to the great fashion house of Worth. The two families became officially linked by marriage when Louis married Charles Frederick Worth's granddaughter Andrée that same year, and his sister Suzanne later became the wife of Worth's grandson Jacques, all to the benefit of Cartier's enviable client list.

Louis, an inveterate traveller, was always inquisitive, constantly looking for inspiration from overseas and collecting and tracking down the finest gemstones and traditional crafts from other cultures to add to the firm's stock of *apprêts* (the term used to refer to fragments from disassembled jewels, watches and other objects, including original and ancient items from Persia, India, China, and Egypt). As company director he surrounded himself with a team of draughtsmen to whom he made his large collection of ornament books available, directing their studies yet never

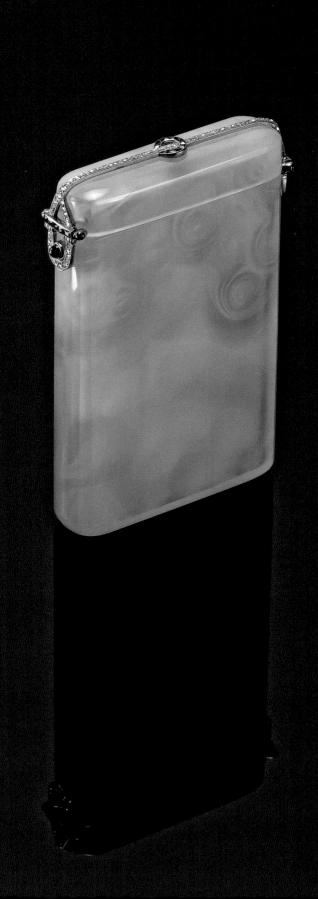

OPPOSITE Card case with a figured agate body, a rose-cut diamond and ruby strap to the top and diamond and ruby hinges. Cartier, Paris, c.1920. RIGHT Jacques Cartier and his wife on board the SS *Lafayette* in the 1920s.

stifling their individual style. In the Art Deco period it was head designer Charles Jacqueau, hired by Louis in 1909, who worked most closely with him.

During the heyday of the vanity case in the 1920s, Maison Cartier was entirely in tune with the various artistic and cultural themes of the day. In his reminiscences, James Gardner, a designer with the London firm from 1923, describes one occasion when Jacques Cartier (Louis's younger brother) perused his bookcase, took out a leather-bound volume on Chinese furniture and turned to the illustration of a black lacquered table, instructing Gardner to 'observe how the legs terminated'. This sort of research and attention to detail ran right through the Cartier offices of Paris, London and New York. Their use of gem materials was equally eclectic, with a great deal of carved jade and coral as well as carved precious stones being used in striking combinations: Louis Cartier constantly advised his team to 'infect the client with gemstone fever'. A high level of precision was applied to all production, no matter how small: Cartier even created an ingenious design for a key case for Consuelo Vanderbilt using exquisite enamelling. Although traditionally known for its remarkable use of colour, Cartier also produced more stark and striking jewels using contrasting black and white, the combination of diamonds with black enamel, lacquer or onyx proving a consistently popular option for stylish evening wear.

Highly creative, the Cartier siblings were also intuitive businessmen and always quick to adapt to any changes in market conditions. Louis Cartier and Charles Jacqueau introduced 'Department S' ('S' standing for silver), a more 'democratic' department stocking elegant gifts and a range of practical and functional consumer goods: smokers' requisites, desk sets, bags and vanity cases. A similar department was also established in New York. After the financial crisis of 1929–30, a clear shift could be seen in the turnover of these departments: sales of plain gold and silver cigarette lighters in the lower price bracket rose by 50 per cent, while the more expensive, exclusive creations, particularly vanity and cigarette cases in lacquer, jade and precious metals, fell by the same amount, replaced by more modest versions in simple black lacquer, perhaps embellished with a Chinese motif or initial. As always, Cartier stood ready to cater to changing tastes, altering their retail offerings to reflect new trends in customer consumption.

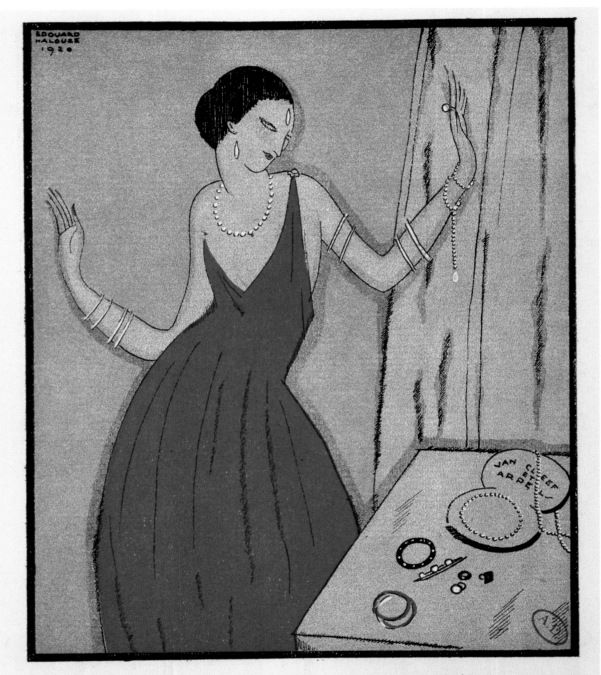

Van Cleef et Arpels

Joailliers

22, Place Vendome, 22
Paris

NICE VICHY DEAUVILLE

LEFT Advertisement for Van Cleef & Arpels from *La Gazette du Bon Ton*, 1920. RIGHT Princesse Jean-Louis de Faucigny-Lucinge, one of the period's great socialites, who owned the vanity case on the following pages, photographed by Cecil Beaton for *Vogue* in 1929.

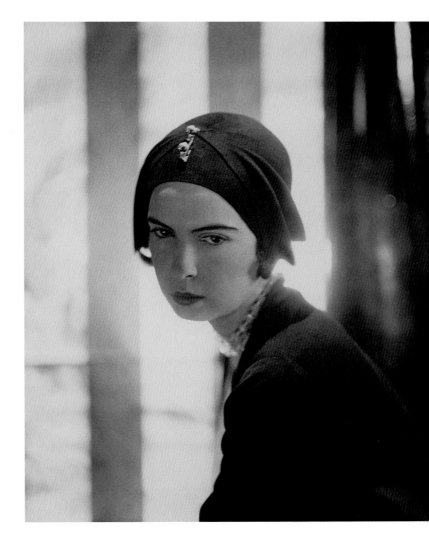

VAN CLEEF & ARPELS

Another family affair, this company was originally founded in 1906 by Alfred Van Cleef and Estelle Arpels, aided by Estelle's three brothers, Charles, Julian and Louis, who were themselves descended from several generations of lapidaries and diamond cutters from Amsterdam. Based on the Place Vendôme from its inception, the firm was a huge success with European aristocrats and wealthy Americans alike. During the 1920s it developed a name for dramatic new designs for jewels, including the fashionable long sautoirs and dangling earrings, and was also quick to design vanity cases to complement these contemporary styles.

In 1922 the brilliant designer René Sim Lacaze joined the company and soon formed a glittering partnership with Renée Puissant, Alfred and Estelle's daughter, who became the *maison's* artistic director following her husband's death in 1926. Although not trained as a draughtsman herself, Puissant relied on Lacaze to commit her flood of ideas to paper, adding her own detailed suggestions to his initial sketches. The partnership proved both fruitful and profitable.

While much of the house's artistic reputation was built on naturalism, the firm had always shown an affinity for abstract designs, and in the 1920s it became known for geometric boxes using calibré-cut precious stones set in long lines, squares or patterns inspired by Modernism. It understood the appeal of this sharp-edged, prismatic look, yet, like its competitors, it also created more ornate floral and exotic designs. Indeed, by the time of the 1925 Exhibition the firm's range of boxes and cases was breathtaking: a dramatic black enamel, jade, diamond and amethyst *nécessaire* with a three-tiered fountain motif on a column of jade, with 'cascades of water' created in diamonds, exemplified the level of expertise evident throughout the company's display. Many cases and boxes were inspired by the art of the Far East and Persia, using pink, green, lavender and blue enamels embellished with precious stones. Some had gold and polychromatic translucent enamel while others were more restrained yet highly sophisticated in their designs with lacquer in black, or black and red, and elegant edge decorations of geometrical motifs using small brilliant diamonds. A number of designs, such as a trompe-l'oeil book cover created using enamel and gold edging for the pages, were truly unique, ensuring the firm's continuing pre-eminence and popularity.

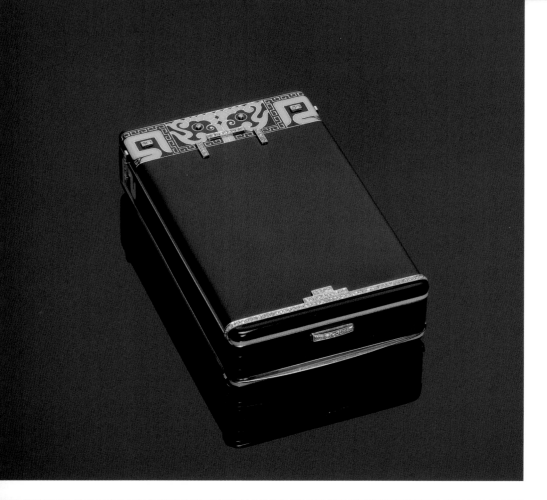

LEFT, BELOW and OPPOSITE Vanity case in black and yellow enamel, with a central mother-of-pearl panel inlaid with lapis lazuli and gold flowers. Van Cleef & Arpels, made by Alfred Langlois, c.1930.

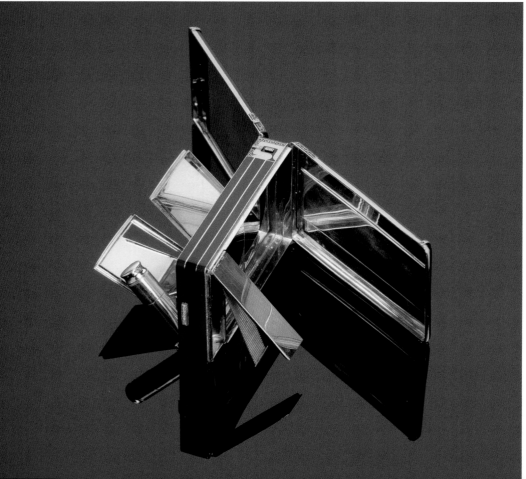

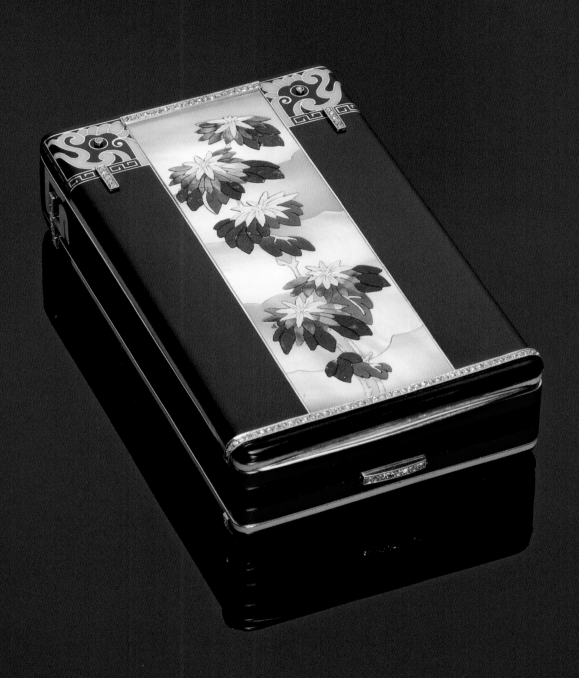

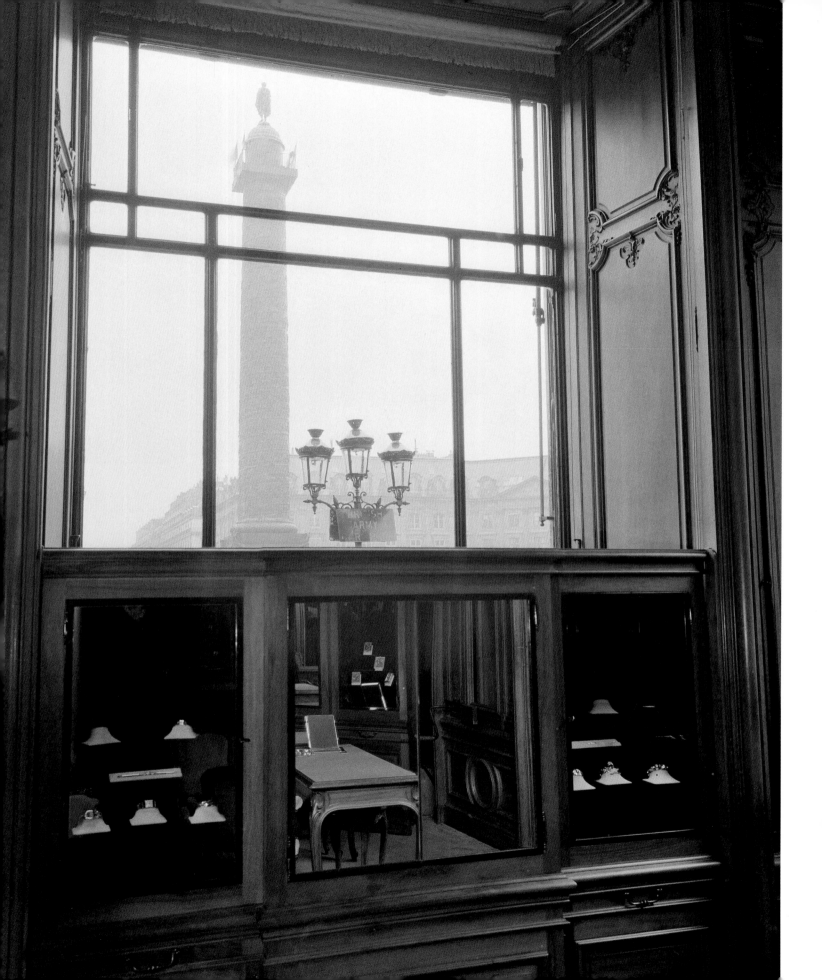

BOUCHERON

Frédéric Boucheron opened his first shop in Paris in 1858 in the Palais Royal. An expert in precious stones, he was also known as a creator of genius and an unrivalled jewellery technician who had learned his trade from apprenticeships with some of the greatest jewellers of his era. Despite starting on a small scale, when he branched out on his own success was quick to come, and Boucheron used the great international exhibitions of the late nineteenth and twentieth centuries to elevate his reputation. He was the first jeweller to set up shop in the Place Vendôme, in 1893, in the building where the celebrated Countess of Castiglione had lived. A true entrepreneur, he chose the location on account of the good natural light, which he used in innovative displays that stood jewels on velvet supports instead of laying them flat.

The extensive company archives tell the story of the evolution of the Boucheron style between 1920 and 1940, when Frédéric was joined by his son Louis. The designs for vanity cases are clearly in evidence among those for jewellery, decorative bowls, vases and clocks. The boxes reveal the full range of styles produced using mother-of-pearl panels and enamel. The firm had become well known in Russia after Frédéric opened a branch there in 1892. He counted Tsar Nicholas II and Tsarina Alexandra, and the Grand Dukes Vladimir and Michael amongst his loyal customers, and during this era the company became known as an enamelling specialist, building its knowledge and skills directly from local Russian enamelling masters of all genres. In Boucheron's hands even a simple cylindrical vanity case with striped black enamel on gold became a creation of sophistication and style.

OPPOSITE The Vendôme Column seen from inside the Boucheron shop in Paris, 1946. Photograph by René-Jacques, Bibliothèque Historique de la Ville de Paris. ABOVE Frédéric Boucheron, founder of the company.

FOLLOWING PAGES Cylinder form double-sided case with black enamel striped decoration and rose-cut diamond bands, makeup compartment on one side and cigarette compartment on the other, finger ring and chain. Boucheron, Paris, c.1923.

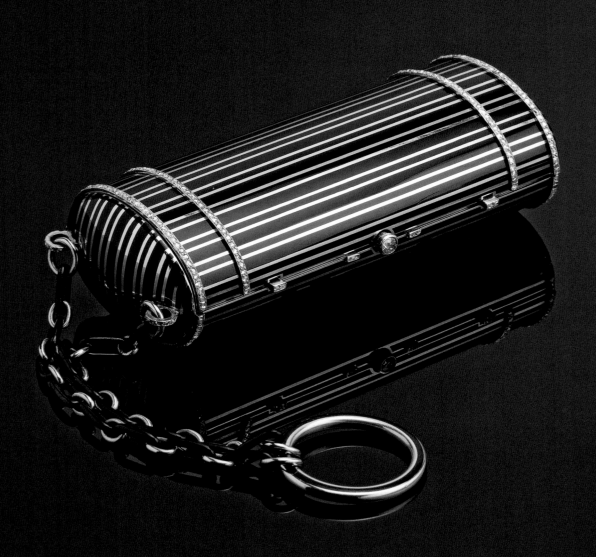

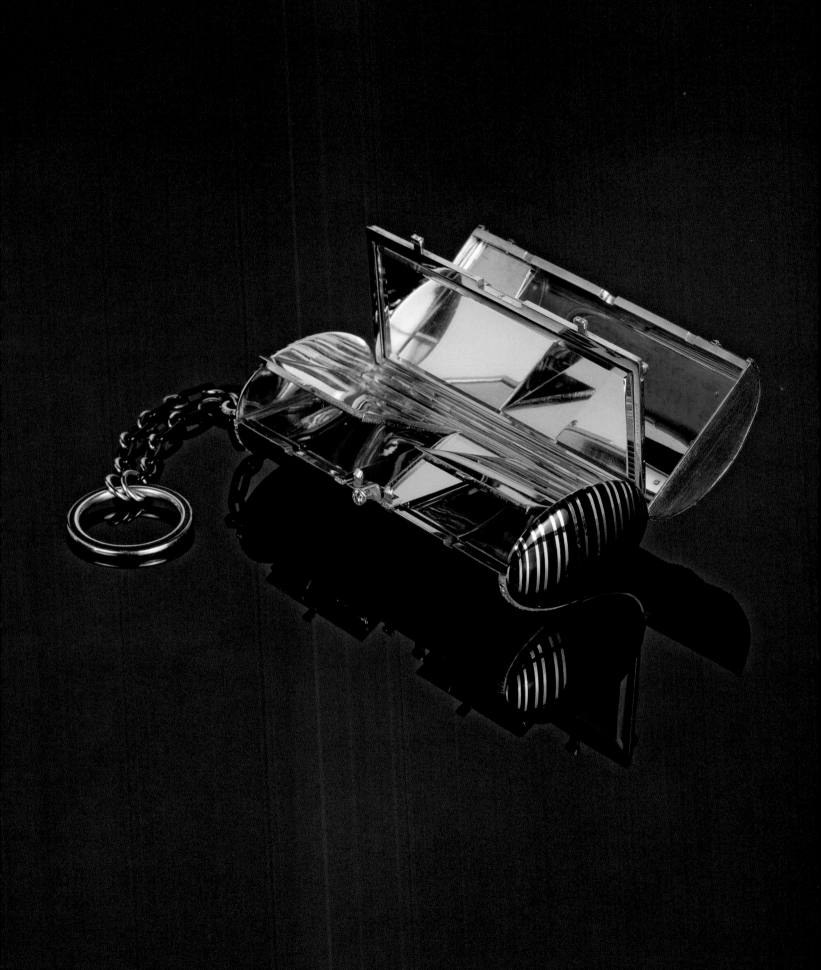

LACLOCHE FRÈRES

The brothers Leopold and Jules Lacloche, who were originally from Madrid, settled in Paris in about 1892. They were joined by their third brother, Fernand, together founding Maison Lacloche Frères in 1901. A second shop followed in 1912 on London's New Bond Street, which in 1920 bought up the remaining stock of the once great house of Fabergé after it was closed by the Bolsheviks. At the height of its fame the company also had branches in Aix-les-Bains, Barcelona, Biarritz, Buenos Aires, Cairo, Deauville, Nice, Madrid, Ostend and San Sebastián. Lacloche was a retail business that did not have its own design department, instead selecting and buying in its jewels after creative collaboration with outside designers and studios. In the early years of the 1920s it was closely associated with *nécessaires*, lipstick holders, powder compacts, cigarette cases and other personal accessories. Its reputation flourished after the 1925 Exhibition, where its products were highly praised.

The brothers liked works inspired by Chinese and Japanese art, and the fables of La Fontaine were also particular favourites. Almost any style was successfully delivered by this eclectic company, which might choose rock crystal to make the entire body of a delicate Japanese-inspired card case, or rich blue enamel to imitate lapis lazuli in an innovative inrō-style vanity with a matching enamelled chain and finger ring. As well as accessories, another speciality for which the firm became known were floral designs based on colourful Mughal jewels in the so-called 'tutti-frutti' style.

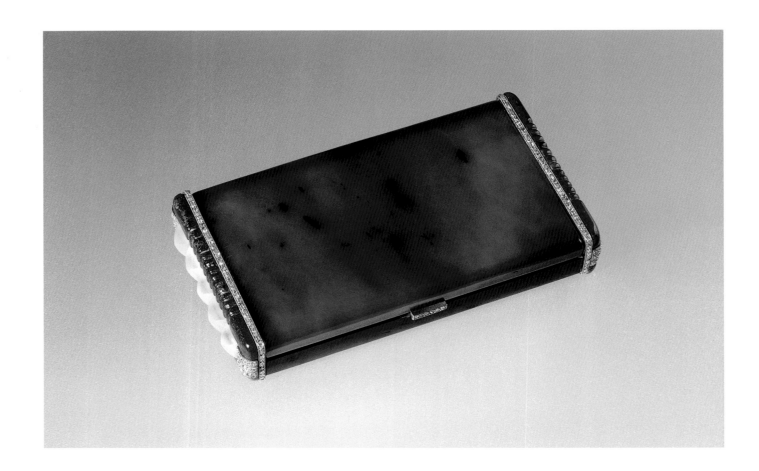

RENÉ BOIVIN

The house of René Boivin was actually run by René's widow, Jeanne, the elder sister of the designer Paul Poiret. Madame Boivin, as she insisted all her staff refer to her, was widowed in 1917, but as a highly skilled designer in her own right she continued to run her late husband's firm with enormous success, thanks to her creative flair and business acumen. She was joined by her own daughter Germaine, who started at the firm in 1938, Suzanne Belperron (née Vuillerme), who worked with the house from 1919 until 1932, and Juliette Moutard, who replaced Suzanne in 1932 and remained with the company until her retirement in 1970. Together, these women proved to be a collaborative tour de force, producing highly creative and strikingly avant-garde creations, including vanity cases using enamel and gemstones.

JANESICH

Leopoldo Janesich opened his first shop in Trieste, where he sold jewellery and silverware to an international clientele. His son Giovanni took over from him, becoming a skilled trader of gems and pearls and establishing the business in Paris. Other branches would follow in the fashionable resorts of Deauville, Monte Carlo and Vichy. Giovanni was joined by his son Alberto, also a gem expert and a well-connected Parisian socialite, who helped raise the profile of the company. Designs for vanity and cigarette cases were as diverse as the materials used in their creation: nephrite became the body of a chic and stylish case with minimal decoration except at its ends, while carved hardstones were used on an entire panel of flower motifs, offset with small diamonds. As success continued the client base widened, and in 1925 the House of Savoy awarded the company a royal warrant.

PREVIOUS PAGES LEFT The Lacloche Frères shop at 15 rue de la Paix, Paris. RIGHT The Lacloche Frères shop in New Bond Street. London Both illustrated in *The Savoyard*, c.1918. Private collection.

OPPOSITE Cigarette case with a body of nephrite, probably of Siberian origin, fluted lapis lazuli and rock crystal ends and rose-cut diamond borders. Janesich, Paris. English import mark for 1928. RIGHT Vanity case decorated in the Indo-Persian style with lilac and green enamel flowers and a blue enamel body. Ostertag, Paris, c.1925.

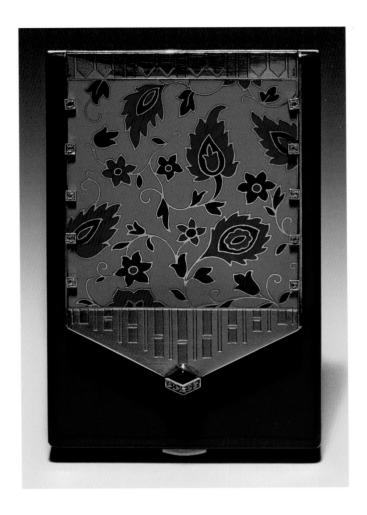

LINZELER-MARCHAK

Alexander Marchak, son of a famous Russian jeweller, launched a collaboration with René Linzeler in 1922, when they opened their shop together on rue de la Paix in Paris. Subsequently their names became linked with some of the greatest jewels in the Art Deco style, and gemstone carving, enamelling and inlay work were all incorporated into their designs for personal accessories. They were invited to join the 30 other exhibitors at the 1925 Exhibition, where they won a Grand Prix for their immaculate jewelled boxes. Despite this groundbreaking achievement, the partnership broke up shortly afterwards, though Marchak himself went on to win another Grand Prix at the Colonial Exhibition in 1931.

OSTERTAG

Arnold Ostertag founded his company in the 1920s and chose to locate it in the Place Vendôme, close to all the other important jewellery houses of the day. During the 1920s and 1930s the firm was especially known for jewellery and objets d'art which combined carved coloured stones in the 'tutti-frutti' style, but it also retailed high-quality decorative jewelled watches supplied by Audemars Piguet as well as clocks by the famous clockmaker George Verger. At the height of its fame in 1929, the house exhibited jewellery and objets d'art at Musée Galliera (Paris's fashion museum), and its wide selection of designs for vanity cases included enamelling in Indo-Persian styles and colours, and chinoiserie landscapes depicted in intricate mother-of-pearl marquetry.

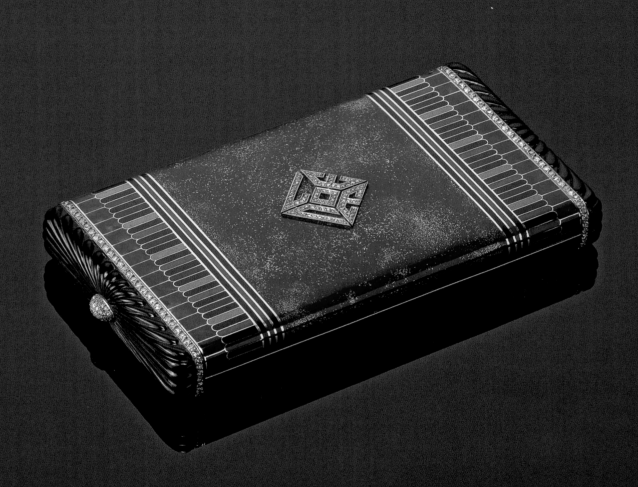

OPPOSITE Vanity case in simulated lapis enamel
with further enamel decoration, fluted onyx ends
and central diamond motif. Marzo, Paris, c.1925–30.

GHISO

The founder of this Buenos Aires jewellery house moved to Argentina from Italy in the 1890s and was soon joined in his business by his two sons. At the beginning of the century the sons travelled to Paris, where they established a French branch, with Oscar emerging to take over most of the everyday running of the business. Though output was small in comparison with other houses, the designs they created in Paris were hugely successful, smart and always stylish, and some of their vanity cases and boxes were shipped to Buenos Aires or sent for sale to the other branch in New York, as well as being retailed in Paris.

MARZO

Marzo was another of the celebrated French jewellery houses of the Art Deco period, known for its bold and innovative creations, some of which were included in the 1925 Exhibition. It was based at 4 rue de la Paix, Paris, in the same building as Alfred Cartier's office, and this was also the address of René Linzeler, the gold- and silversmith whose cutlery, candlesticks and other silverware, some of which was designed by Paul Iribe, were retailed by Cartier. Linzeler went into partnership with Marchak in 1922, while his second workshop was taken over by Cartier at the outbreak of the Second World War. For a small house, the range of production was extraordinary: colourfully enamelled cases of oriental inspiration were as successful as their simple but stunning designs in black and white.

OPPOSITE Cigarette case with figured agate body, rose diamond hinges and clasp, and diamond monogram. Black, Starr & Frost, New York, c.1920.

AMERICAN JEWELLERY HOUSES

CHARLTON & CO

John W. Charlton was involved with several jewellery firms before opening his own company in 1909 on Fifth Avenue, and when he took on additional partners he changed the name of the firm to Charlton & Co. The company kept abreast of all the latest French jewellery trends, matching European designs and manufacture with the help of their French-born designer Maurice Duvalet, who was able to reinterpret and adapt his designs to suit American tastes. Although Charlton retired in 1919, the business was well poised to take advantage of the prosperity of the 1920s, continuing his tradition of retailing fine jewellery as well as vanity cases of extraordinary virtuosity. Flower motifs were a signature of the firm, and their 'Rose Garden' series of powder boxes set with precious gems were the talk of the town when they were created, mirroring the contemporary gardening craze. Charlton's original treatment of flower motifs – on the ends of a case rather than its main body, for example – kept the company's production always looking up to date, and by the late 1920s the firm had expanded and opened branches in Palm Beach, Florida, and in Paris on the fashionable rue de la Paix.

BLACK, STARR & FROST

One of the oldest jewellery houses in America, Black, Starr & Frost is mentioned by name in the famous Marilyn Monroe song 'Diamonds Are a Girl's Best Friend'. The firm was founded as Marquand & Paulding in Savannah, Georgia, as early as 1810, and it grew quickly. By 1851 its status was such that it was invited to display at the Crystal Palace Exhibition in London. The firm changed its name to Black, Starr & Frost in 1876, and success continued. By the 1920s it was producing jewels and jewelled accessories in the Art Deco style, some of which were actually created in France and then retailed in the US. A particularly successful partnership with Vladimir Makowsky, the Russian master craftsman living in Paris, led to the production of cases using tinted mother-of-pearl as well as a variety of hardstones in beautifully detailed inlay designs. The resulting tablets often had a floral or oriental theme, but Black, Starr & Frost were not shy of using more unusual motifs, such as farmyard animals in domestic settings, and these miniature mosaics were often combined with a geometric border of enamel, producing a highly original result.

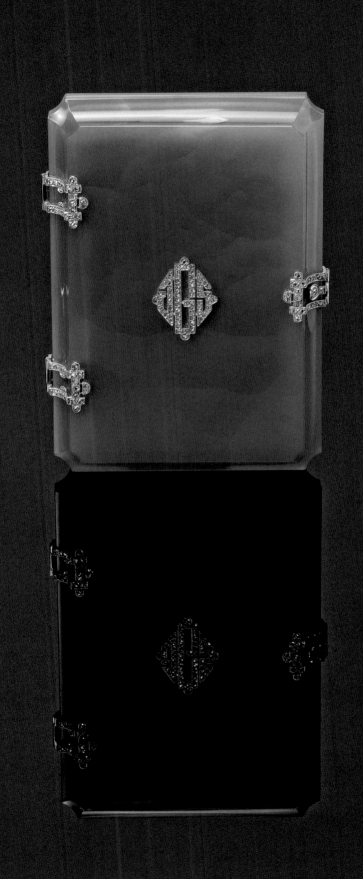

THE ARTIST-JEWELLERS

GÉRARD SANDOZ

Gérard Sandoz was the third generation of another successful jewellery family, and like several of his Modernist peer group he believed that 'a piece of jewellery must be simple, clear and be made without any unnecessary embellishments'. Young Gérard lived in an apartment in the same building as the family shop, yet unlike the stock in his father's main collection, his jewels and accessories were strikingly geometric and of distinctive machine-age design. Hugely talented, Gérard unveiled a range of his jewellery, along with powder compacts decorated with coloured enamel in Cubist-inspired designs, at the 1925 Exhibition. Though his jewellery, which was usually large in size, tended towards the abstract and geometric, for smaller objects like matchboxes and vanity cases he often favoured stylised figurative motifs – a boxer or a jazz musician, perhaps – created using *coquille d'oeuf* lacquer inlaid with broken eggshell. Though he loved using colour, he was in fact colour-blind, but this never held him back. He and his beautiful wife Juliette Vuillaume, whom he married at the age of 19, were dedicated party-goers and high-profile socialites who embraced the spirit and style of the time. Gérard's career as a jeweller may have spanned only a decade, but his output nonetheless remains significant within the realm of Art Deco jewellery.

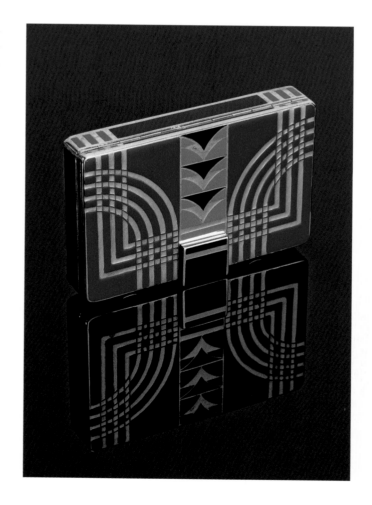

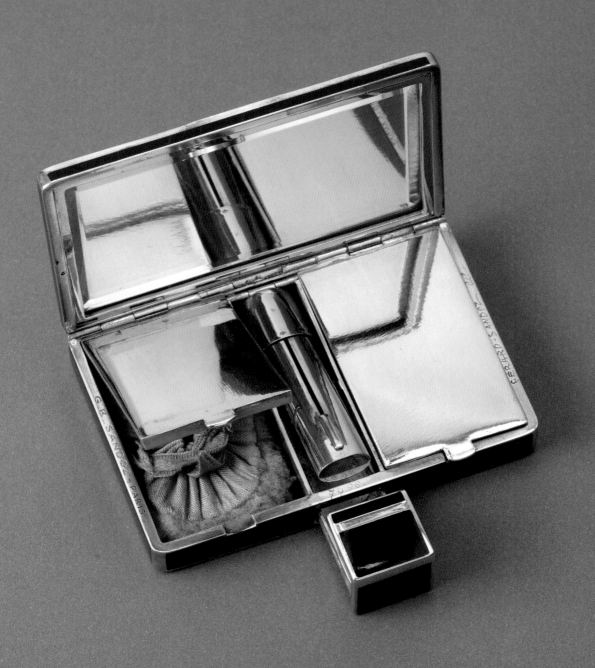

OPPOSITE Interior of Georges Fouquet's shop on the rue Royale, Paris (now reconstructed in the Musée Carnavalet, Paris), designed by Alphonse Mucha.

FOLLOWING PAGES An extremely rare Modernist vanity case in silver with black lacquer decoration, a silver gilt interior and a slide action lipstick holder. Jean Fouquet, c.1928–30.

PAUL-EMILE BRANDT

Born in Switzerland, Paul-Emile Brandt had a diploma in engineering and moved to Paris to work at renowned jewellery workshop Strauss Allard & Meyer, later gaining experience as a silversmith, engraver and enameller at Lacloche Frères and at Boucheron. He then set up on his own, and quickly moved away from the traditional approach to embrace more avant-garde designs. Cigarette cases and powder compacts provided him with the ideal surfaces on which to present his geometric forms, and he used lacquer and eggshell techniques as well as bold colours ranging from red and black to grey, mauve and dark blue – combinations almost reminiscent of Sonia Delaunay's compositions. He exhibited a range of these at the 1929 Salon d'Automne and also offered a selection of '*bijoux sport*', to be worn during the day with tailored suits or driving clothes. Multi-talented, Brandt expanded his business to include interior decoration, producing limited editions of furniture.

RAYMOND TEMPLIER

In 1919, the young Raymond Templier joined the family jewellery business, which had been founded by his grandfather, Charles Templier, in 1849. Raymond favoured strictly geometric designs inspired by Cubism, and the imagery of the machine age. 'As I walk in the streets I see ideas for jewellery everywhere, the wheels, the cars, the machinery of today', he told *Goldsmiths' Journal*. He used enamel, lacquer and semi-precious stones, seldom setting important gems in his creations unless a client specifically presented him with one to design a piece around.

In 1929, he was one of the founders of the UAM, the Union des Artistes Modernes, and he began a collaboration with designer Marcel Percheron. He would present his drawings to Percheron, who would then refine them, the two working successfully together for many years.

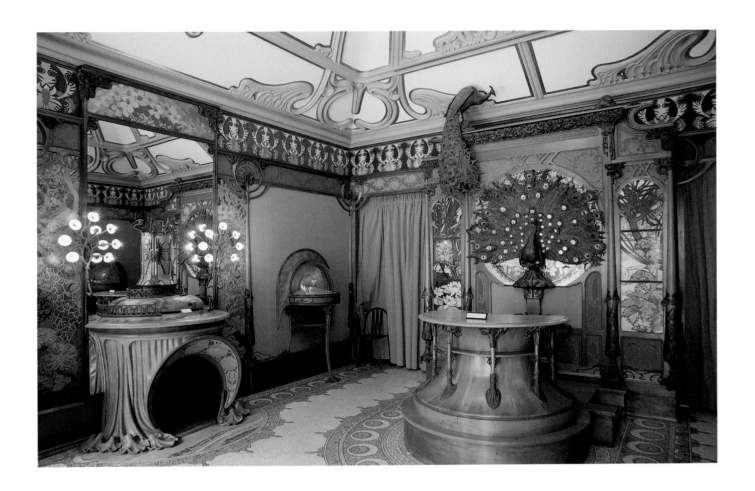

JEAN FOUQUET

The House of Fouquet included three generations of talented designers: Alphonse, the original founder of the firm, his son Georges and his grandson Jean. Georges was a true pioneer in the Art Nouveau period, even commissioning Alphonse Mucha to design the interior of his shop on the rue Royale as well as some flamboyant jewellery which he made for Sarah Bernhardt. The firm also commissioned jewellery from Eric Bagge, the noted architect and interior designer, painter André Leveille, and the premier poster artist of the day, Cassandre. Georges was a member of the selection committee for the 1925 Exhibition where his son, Jean, was first mentioned as a designer in his own right.

While Georges had triumphed in the Art Nouveau style, Jean quickly developed a taste for abstract composition, which he made his own, with simple forms and large flat surfaces sometimes decorated with semi-precious stones or lines of brilliant-cut gems. 'A piece of jewellery must be composed of masses clearly visible from a distance', he said, and his creations were the embodiment of Modernist design. Jean introduced novel combinations of materials that had rarely or never been used in jewellery before, including ebony and chrome-plated steel. Instead of platinum, he preferred grey gold, and rather than enamel, he favoured lacquer for the decoration of his pendants and signature cigarette cases, all of which would have been considered truly innovative and avant-garde at the time.

n 1929 Georges Fouquet defined what he believed to be the secret of success: 'It is necessary to interest the artist in his creative work by allowing him to follow his pieces through the various phases of their creation, so that he can explain in advance to the craftsmen in charge of the actual production the ideas behind his conception.'

The vast majority of *nécessaires* were made in Paris in the 1920s, when as many as 1,000 workshops were active in the city, manufacturing goods that were sold all over the world as well as in France. The work necessary to create boxes and cases of such finesse was extraordinary, and required the skill of many different specialists and craftspeople including goldsmiths, lapidaries, metal chasers and engravers, stone setters, lacquerers, guillocheurs and enamellers as well as the designers, with whom every project started. Each *maison* had a studio workshop to which specialist designers were attached. Many would not have any skills in the actual manufacturing process, the benefit of this being that their creativity remained

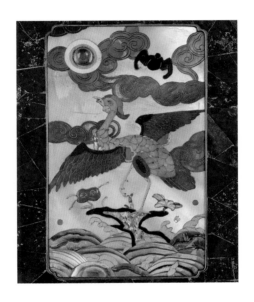

unconstrained when they did not have to consider technical limitations. Artists outside the house might be brought in only occasionally, making it easier to retain a coherence across the design repertoire of a large house such Cartier or Van Cleef & Arpels. Some of the smaller avant-garde jewellers just roughed out their ideas on paper, relying on an external workshop to take over the preparation of detailed sketches on whose precision the craftsman would rely.

Whether it was a vanity or cigarette case, a compact, lighter or lipstick case, each accessory was unique and never made on any scale. Unsurprisingly, given the complexity of the designs and decoration, a total of 800 hours might be required to make a vanity case. If it was a commission and created to order for a client, several sketches and watercolour designs would be drawn up and submitted for approval by the customer, after which the process of manufacture could begin, requiring a close collaboration between technicians, craftsmen and designers, during which the decorative conception

WORKSHOPS

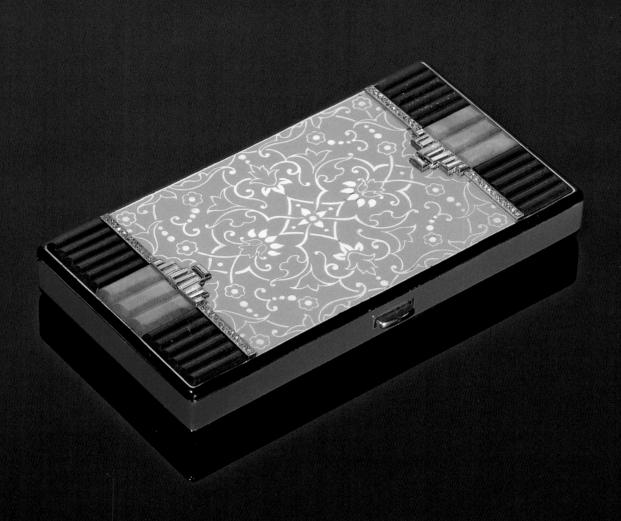

of a project would be adapted to the constraints of manufacture in the workshop. This was an age of glamour and innovation, and the subtle and constant exchange of creative ideas between jewellers, designers and craftsmen at every stage of production was the key to a successful outcome.

At the bigger houses each job was broken down into several different steps. At Van Cleef & Arpels, an order sheet and often a separate card would be made up for the design, specifying the number, type, size and cut of stones to be used, as well as the materials and specifications of the mounts. Most of these order cards remain in the company archives to this day. Thousands of design concept drawings for objects that were never made also exist, demonstrating the number of alternative ideas and options put forward for each design selection. Once the designs had been

prepared, accepted and costed, they were then passed on to the workshop to be executed. There was a strong tradition of handing down expertise from generation to generation within such workshops, as demonstrated by the number of second- or third-generation jewellers, with fathers and sons often working side-by-side at the bench. To an extent this is still maintained to this day.

Some of these craftsmen specifically made boxes and were known as *boîtiers*. The whole team of craftsmen would need to be supervised by the retailing *maison* to ensure that all production was in keeping with the overall aesthetic of the house. Some of Van Cleef & Arpel's most beautiful boxes were ordered from a box specialist named Alfred Langlois. He produced highly sophisticated enamel decoration in the Chinese taste and designs using Persian carpet motifs, as well as more abstract designs with

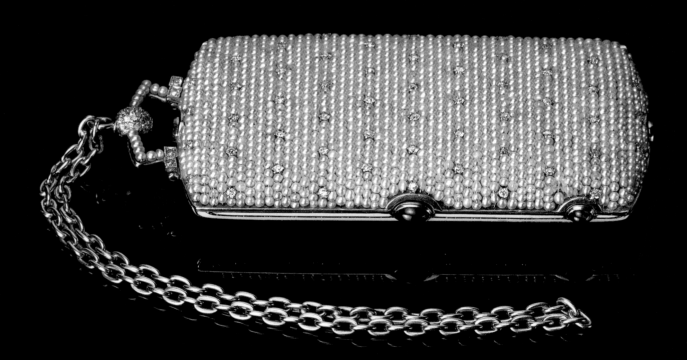

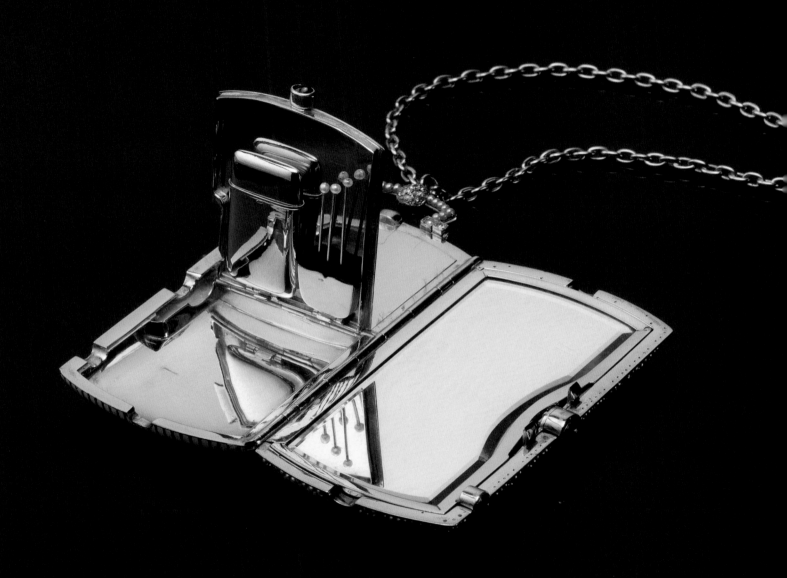

geometric shapes, predominantly in enamel. Initially Albert was master of his own independent workshop, but he soon expanded his repertoire from boxes to manufacturing many of the most detailed and exacting pieces of jewellery for Van Cleef & Arpels. By 1932 he worked exclusively for this great house.

At Cartier the extensive archives carefully record the workshop responsible for each piece and reveal that the Parisian workshops of Strauss Allard & Meyer, Lavabre, Holl, Picq, Charpentier, Harnichand, Andrey and Droguet all carried out work for the great house during this period. Lavabre, for instance, created engine-turned enamelled gold boxes for them and also executed some of Jacqueau's designs for geometric all-over enamel patterns, as well as work using *lac burgauté*. Two other important suppliers after the First World War were the Renault workshop (which worked primarily on gem-set pieces rather than goldwork or enamel) and the Bachaumont workshop, both of which were later taken over by Cartier. From the mid-1930s Cartier also took over the Linzeler workshop on rue d'Argenson. In 1919 Maurice Couet set up Cartier's clock workshop in rue Lafayette, which was also ideally suited to creating Cartier's fine vanity cases since its craftsmen offered a wide range of different skills. Working together under the same roof were 30 specialists, including enamellers, stone-setters, engravers and engine-turners. Cartier's London workshop, known as English Art Works, was established in 1922 in the Bond Street premises (where all employees were indeed English). During the 1930s some 60 skilled craftsmen were employed there. In New York, the business initially obtained its stock from Paris

and London, but by the 1920s a workshop had been established there too, American Art Works, situated on the fifth floor of the American headquarters, where up to 70 craftsmen were employed at the height of production.

Many of the other houses outsourced their jobs as necessary, and a variety of independent craftsmen worked for several different *maisons*. Sometimes two different workshops might even work on the same case. Interestingly, the 1925 Exhibition was the first occasion on which the names of the designers figured in all the showcases next to the name of the house – with the exception of Cartier, who exhibited away from the other jewellers, in the Haute Couture pavilion. The sheer diversity of cases made by a workshop such as Strauss Allard & Meyer illustrates the enormous range of skills covered by these craftsmen: lapidary work in a range of materials such as frosted rock crystal and amber, carving of figurines, such as a Buddha in lapis lazuli, enamelling of Indo-Persian inspiration, and even the inclusion of a diamond watch housed within a vanity case.

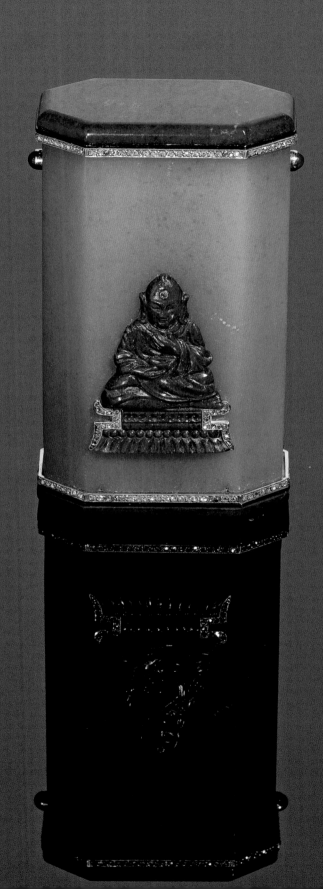

The New York Times.

Copyright, 1929, by The New York Times Company.

NEW YORK, WEDNESDAY, OCTOBER 30, 1929.

TWO CENTS in Greater New York | THREE CENTS Within 200 Miles | FOUR CENTS Elsewhere Except 7th and 8th Postal Zones

KAHN REFUSES POST IN SENATE CAMPAIGN; CALLS CHOICE UNWISE

He Writes to Moses to Withhold His Name for Treasurer Due to 'Divided Reception.'

WAS RELUCTANT, HE SAYS

Recalls He Told Senator of His Stand, but Yielded as a Duty to His Party.

HOLDS VIEWS CONFIRMED

Declares He Is a Wall St. Man but a Liberal in Politics—Friends See Him Put in False Light.

Otto H. Kahn in a letter to Senator George H. Moses of New Hampshire, chairman of the Republican Senatorial Campaign Committee, made public yesterday, declined the post of treasurer of that committee because of the "divided reception" which the announcement of his designation as treasurer had met.

Announcement of the selection of Mr. Kahn was made by Senator Moses at the dinner given last Thursday evening at the University Club here by Jeremiah Milbank for Claudius H. Huston, the new chairman of the Republican National Committee. Publication of this announcement, together with the report that speakers at the dinner attacked the members of the Progressive Republican group in the Senate, brought protests from some of these Senators against the selection of Mr. Kahn.

Mr. Kahn in his letter to Senator Moses declared that, while a Wall Street man, he was a liberal in politics. He said some of the interpretations placed on his designation were erroneous, but added that the way it had been received justified his earlier feeling that he was not the right man for the position. No formal action for the appointment of a treasurer of the Senatorial committee has yet been taken, and Mr. Kahn requested Senator Moses not to present his name to the committee.

Mr. Kahn's Letter.

Mr. Kahn's letter follows:

Oct. 28, 1929.

My dear Senator:

When you did me the honor to ask me to act as treasurer of the Republican Senatorial Campaign Committee I told you that I feared your kindly sentiment toward me, springing from a long friendship,

Newark Man, 4 Feet 10, Says He Was Smallest in A. E. F.

WASHINGTON, Oct. 29 (AP).—Nicholas Casale of Newark, N. J., wants to be known as the smallest man who went to France with the American Expeditionary Forces.

He has appealed to Representative Hartley of Kearny to establish that fact. Casale recently secured an affidavit from the Veterans' Bureau certifying that he was 4 feet 10 inches tall and weighed 106 pounds when he enlisted. The bureau has refused to declare him the "smallest man," saying it would require months for clerks to scan the record of every man who served with the A. E. F.

It was not explained how Casale secured enlistment when the minimum requirements are 5 feet and 110 pounds.

MISSING AIRLINER BROUGHT IN SAFELY

Pilot Lands Western Express Ship at Albuquerque After Being Forced Down.

WOULD NOT RISK STORM

Passengers Tell of Cold Night in Deserted Ranch House as Snow Swirled Round.

Special to The New York Times.

ALBUQUERQUE, N. M., Oct. 29.—Lost for more than twenty-four hours while marooned on a bleak New Mexico mesa, Western Air Express tri-motored liner 113 escaped today from the snow-swept stretch where it was forced down Monday and landed here with its crew of three and two passengers, chilled but safe.

Caught in a blinding swirl of snow Monday at 10:15 A. M., the plane was forced down near Rechado, seventy-five miles southeast of Gallup, N. M. The crew and passengers found refuge in an abandoned ranch house.

The passengers are Dr. A. W. Ward of San Francisco and W. E. Merz of Mount Vernon, N. Y. The crew includes James E. Doles, chief pilot, of Los Angeles; Allan C. Barrie, co-pilot, of Burbank, Cal., and R. L. Britton, steward, of Los Angeles.

Employes of the airport and pilots of two planes waiting for the weather to clear to resume the search for the 113 stood amazed as the big craft glided along the runway. They

STOCKS COLLAPSE IN 16,410,030-SHARE DAY BUT RALLY AT CLOSE CHEERS BROKERS BANKERS OPTIMISTIC, TO CONTINUE AID

LEADERS SEE FEAR WANING

Point to 'Lifting Spells' in Trading as Sign of Buying Activity.

GROUP MEETS TWICE IN DAY

But Resources Are Unable to Stem Selling Tide—Lamont Reassures Investors.

HOPE SEEN IN MARGIN CUTS

Banks Reduce Requirements to 25 Per Cent—Sentiment in Wall St. More Cheerful.

Resources of the banking group which was organized last Thursday to stabilize conditions in the stock market were utilized yesterday to break the force of the terrific flood of selling which accompanied the biggest day, from the point of view of volume, ever experienced on the New York Stock Exchange.

Despite the drastic decline, sentiment in Wall Street last night was more cheerful than it has been on any day since the torrent of selling got under way. Periodic "lifting spells" which developed between intervals of extreme weakness were cited by bankers at the close of the market, as testifying to the presence of investment buying. The public is in some measure regaining its senses and the unreasoning fear which had prompted the sacrifice of securities for any price they would bring is at length subsiding.

While even the tremendous buying power of the banking group was unable to turn the tide of selling in yesterday's market, the group did not relax its concern over the situation on the Exchange. Two meetings were held during the day, one at noon and one at 4:30 P. M., the latter lasting until 6:30 P. M.

Will Continue Support.

After the evening meeting Thomas W. Lamont of J. P. Morgan & Co. spoke to reporters.

240 Issues Lose $15,894,818,894 in Month; Slump in Full Exchange List Vastly Larger

The drastic effects of Wall Street's October bear market is shown by valuation tables prepared last night by THE NEW YORK TIMES, which place the decline in the market value of 240 representative issues on the New York Stock Exchange at $15,894,818,894 during the period from Oct. 1 to yesterday's closing. Since there are 1,279 issues listed on the New York Stock Exchange, the total depreciation for the month is estimated at between two and three times the loss for the 240 issues covered by THE TIMES table.

Among the losses of the various groups comprising the 240 stocks in THE TIMES valuation table were the following:

Group.	Number of Stocks.	Decline in Value.
Railroads	25	$1,128,686,488
Public utilities	29	5,135,734,327
Motors	15	1,689,840,902
Oils	22	1,332,617,778
Coppers	15	824,403,820
Chemicals	9	1,621,697,897

The official figures of the New York Stock Exchange showed that the total market value of its listed securities on Oct. 1 was $87,073,630,423. The decline in the 240 representative issues therefore cut more than one-sixth from the total value of the listed securities. Most of this loss was inflicted by the wholesale liquidation of the last week.

U. S. STEEL TO PAY $1 EXTRA DIVIDEND

American Can Votes the Same and Raises Annual Rate From $3 to $4.

BIG GAIN IN STEEL INCOME

Earnings for Nine Months Are $15.82 a Share, Against $8.17 a Year Ago.

Two leading industrial companies yesterday declared extra dividends of $1 a share on the common stock, as a result of their earnings through the Summer months. The companies were the United States Steel Corporation and the American Can Company, whose interests touch every section of the country. Their action caused the Wall Street district to accept the extra dividends as final proof of the prosperity of the country despite the breaks which

RESERVE BOARD FINDS ACTION UNNECESSARY

Six-Hour Session Brings No Change in the New York Rediscount Rate.

OFFICIALS ARE OPTIMISTIC

Mellon Also Attends Cabinet Meeting, but Declines to Discuss Developments.

Special to The New York Times.

WASHINGTON, Oct. 29.—The further decline in stock market prices today passed without expressed apprehension on the part of Federal officials. The situation was watched intently by the Federal Reserve Board, which held a continuous session from 10 A. M. until 4 P. M., with Secretary Mellon in attendance.

Secretary Mellon, as ex-officio chairman of the board, attended the early part of the meeting before go-

CLOSING RALLY VIGOROUS

Leading Issues Regain From 4 to 14 Points in 15 Minutes.

INVESTMENT TRUSTS BUY

Large Blocks Thrown on Market at Opening Start Third Break of Week.

BIG TRADERS HARDEST HIT

Bankers Believe Liquidation Now Has Run Its Course and Advise Purchases.

Stock prices virtually collapsed yesterday, swept downward with gigantic losses in the most disastrous trading day in the stock market's history. Billions of dollars in open market values were wiped out as prices crumbled under the pressure of liquidation of securities which had to be sold at any price.

There was an impressive rally just at the close, which brought many leading stocks back from 4 to 14 points from their lowest points of the day.

Trading on the New York Stock Exchange aggregated 16,410,030 shares; on the Curb, 7,096,300 shares were dealt in. Both totals far exceeded any previous day's dealings.

From every point of view, in the extent of losses sustained, in the turnover, in the number of traders wiped out, the day was the most disastrous in Wall Street's history. Hysteria swept the country as stocks went overboard for just what they would bring at forced sale.

Efforts to estimate yesterday's market losses in dollars are futile because of the vast number of securities quoted over the country and on out-of-town exchanges on which no calculations are possible. However, it was estimated that issues, on the New York Stock Exchange, lost between $8,000,000 and $9,000,000,000 yesterday. Added to that loss is to be reckoned

THE END OF THE LUXURY ERA

'A fashion', wrote the French philosopher La Bruyère, 'has scarcely destroyed another fashion, when it is abolished by an even newer one, which gives way in turn to the one that follows it, and that one will not be the last; such is our fickleness'. In the 1920s it seemed that artistic movements came and went as fast as the notion of innovation they glorified, but out of this maelstrom of ideas and energy Art Deco spread quickly and contagiously to become an all-consuming style, influencing every form of creativity.

Yet just as this free-wheeling decade approached its finale, the American stock market crashed on a catastrophic scale, and what had started as a boom ended with a monumental bust. The same soaring share prices that had made millionaires almost overnight now dealt a fatal blow, with Wall Street losing a third of its value in a matter of days. The great financial crisis would take a decade to recover from, and although the immediate effects rocked America, the repercussions soon reverberated around the world. People who had embraced modern urban life and the exuberant spirit of its popular culture were suddenly stopped dead in their tracks.

The crash of 1929 affected all levels of society, but proved particularly catastrophic to the luxury industries. From 1930 onwards, as the economic devastation deepened, clients stopped buying as many extravagant items, and firms stopped producing anything they thought might prove difficult to sell. All the major jewellery houses suffered, cutting back their staff or completely closing their doors. Art Deco's Grand Master Georges Fouquet ceased major production (although his son Jean went on working and exhibiting until he died in 1984, coincidentally the year in which the Musée des Arts Décoratifs, to which Georges Fouquet had donated his archives, paid tribute to the dynasty of three Fouquets with an exhibition). The Lacloche brothers closed their branches and then also the main shop in rue de la Paix, surviving only as a skeleton business run from the first floor above their old showroom. Ostertag held on until the onset of the Second World War, when they also succumbed, while Ghiso shut down both its French and American branches (the Buenos Aires branch remaining open until the 1960s). Even before the family company was dissolved in 1938, Gérard Sandoz had already left for pastures and passions new – the cinema – while in the US, the mighty Tiffany & Co scaled back both its staff and its operations to a minimum. It has been estimated that up to 90 per cent of the entire jewellery workforce lost their jobs during the Great Depression.

Coincidentally, just as the US economy collapsed, the great couture houses of Europe revealed their new romantic look, completely changing the contours of women's fashion and further impacting the world of Haute Joaillerie. The boyish *garçonne* style that had been so popular in the 1920s gave way to more gentle, womanly curves as softness replaced severity in the new couture designs of the 1930s: sharp lines dissolved into feminine folds and

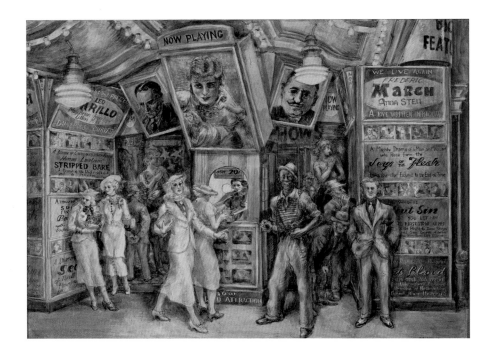

drapery as waists returned and bias-cut dresses revealed more feminine shapes again. The perennial pendulum of jewellery, swinging to and fro towards one style and back again, moved in tandem, bringing with it a return to ornament and to the figurative. The new 'mystery setting', patented by Van Cleef & Arpels in 1933, added to the sculptural feel of jewels as mosaics of stones – almost like carpets – now covered even curved surfaces, and smooth, rounded cabochons followed the voluptuous forms and silhouette of the 1930s woman.

Gradually but inevitably, aside from some stylised cigarette boxes and powder compacts, the production of *nécessaires* tailed off. After 1930, the increasing trend towards emphasising an accessory's function over its luxuriousness hastened the disappearance of bespoke vanity cases. In fact, by the outbreak of the Second World War it was becoming increasingly difficult for owners of vanity cases to find a supplier who still stocked loose and unbranded cosmetics: it was simply much easier to buy makeup from the larger cosmetics companies, who were now designing attractive semi-permanent packaging of their own. The vanity case began to give way to the purse, the handbag, the evening clutch, and a new invention for the 1930s, the minaudière. Charles Arpels is often credited with the initial idea for its creation. One day he received Mrs Florence Gould, a regular client who had

left home in a hurry and had thrown all her 'necessaries' into an empty steel tin of Lucky Stripe cigarettes. When she arrived with her makeshift bag, the mismatch between her stylish clothes and somewhat unsophisticated accessory inspired the idea for creating a customised jewelled version more befitting for a woman of elegance, and the minaudière was born.

Slightly larger than a vanity case and about the same size as a small book, it usually had straight edges and different compartments for storing the usual cosmetics, but now with some additions: a pill or candy holder, a lighter, theatre glasses, keys, tissues (Kleenex was introduced in 1924), business cards and possibly even a small clock. Often engraved with figures and emblems such as a ballerina, a signature Van Cleef motif, it might also be decorated with gems and lacquer, lined with velvet or silk, and have a black satin pouch as a protective holder.

Marketed by the firm as 'an exclusive creation to replace the handbag', it was registered by Alfred Van Cleef in 1933. The name 'minaudière' (literally 'coquettish woman') honoured his third wife Estelle, a charismatic socialite who could apparently simper and primp – or *minauder* – with more charm and spontaneity than anybody else. Alfred's home was even named 'La Minaudière' and the boxes quickly became synonymous with the beauty products sold by the cosmetics queens of the day (including Elizabeth Arden,

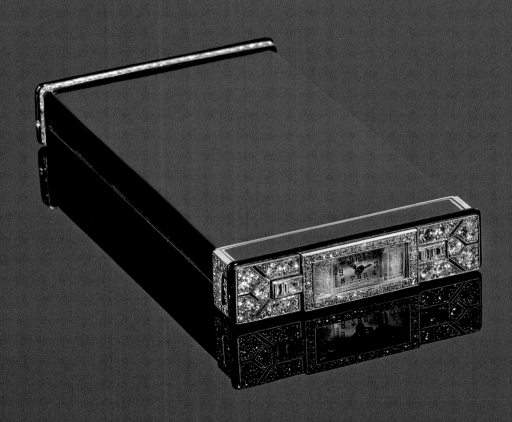

whose salon on the Place Vendôme was near Van Cleef's shop). The boxes and their gadgetry inside remained hugely popular for the next three decades, and even today their appeal endures. The firm has never allowed this iconic creation to disappear entirely from its production, and every year a small number of new minaudières are still made (the term strictly applying only to the production of this great French house).

In truth, the beginning of the end of the Art Deco style had actually started before the final years of the 1920s. As unlikely as it may have seemed at the time, the downward descent began almost immediately following the 1925 exhibition that marked its apotheosis. After this date decorative forms grew larger and more three-dimensional, and colour was toned down as the ebullience of Les Années Folles gradually faded. It had been rollercoaster of a ride that had blazed a trail of brilliance but then blew itself out. Yet even at the time, designers felt that its spirit would one day be revived. Georges Fouquet predicted the longevity of Art Deco in an article in *Le Figaro* in 1929, when he said: 'There can be no doubt that in a couple of hundred years, our jewellery will be sought after for collections and museums where it will have its own specially allotted place.' In reality this moment was to arrive much more quickly, and the 1966 exhibition held at the Musée des Arts Décoratifs entitled *Les Années 25: Art Déco/Bauhaus/Stijl/ Esprit Nouveau,* announced the resurgence of this style, as well as providing its name. The late 1960s saw the appearance of some significant collectors of Art Deco, including Yves Saint Laurent, Karl Lagerfeld and Andy Warhol, all of whom helped raise its profile. Three decades after its decline Art Deco came of age as an acknowledged art movement of the twentieth century, and so it has remained.

In the vanity case, Art Deco found arguably its most glorious form of artistic expression. The unrivalled workmanship and imagination that went into these tiny creations, to say nothing of the feats of ingenuity and engineering that were involved in their interior fitments, will never be recreated. Magnificently manufactured miniature marvels, each of these creations represents the embodiment of the style, glamour and sophistication that was the Jazz Age. Such glittering relics still have the power to evoke a golden era of supreme adornment, and stand as astonishing reminders of high times and great opulence. True icons of elegance, they materialised as if by magic, only to vanish again as quickly as they had appeared, evanescent in their luxury and sheer beauty.

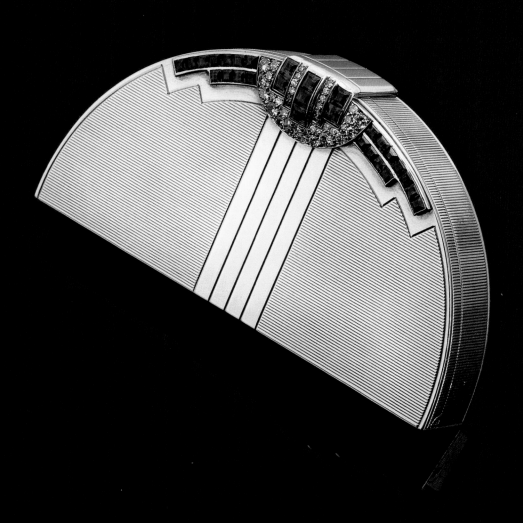

INDEX

Page numbers in *italics* refer to illustrations.

PICTURE CREDITS

All specially commissioned photographs of the cases and jewellery were taken by A.C. Cooper.

Key: Alamy = Alamy Stock Photo
Getty = Getty Images, London
BI = Bridgeman Images, London
ME = Mary Evans Picture Library, London

Page 1 Courtesy Cartier Archive/Photo © Nina Slavcheva; **8–9** Kashmira Bulsara; **10** World History Archive/Alamy; **14** Niday Picture Library/Alamy; **15** Photo © Granger/BI; **16l** © Illustrated London News Ltd/ME; **16–17** Culture Club/Getty; **17r** Musée de la Ville de Paris, Musée Carnavalet, Paris/BI; **18l** Bettmann/Getty; **18–19** JP Jazz Archive/Getty; **19t** John D. Kisch/Separate Cinema Archive / Getty; **19b** Hulton Archive/Getty; **20t** © Roger-Viollet/Topfoto; **20b** Private Collection; **20bl** Peter Edwards; **20br** Granger Historical Picture Archive/Alamy; **21** © Roger-Viollet/Topfoto; **22l** Granger Historical Picture Archive/Alamy; **22r** Everett Collection Historical/Alamy; **22–3** Chronicle/Alamy; **23t** Hulton Archive/Getty; **23b** Digital image, The Museum of Modern Art, New York/Art Resource/ Scala, Florence/© 2017 Calder Foundation, New York/DACS London; **24l** Everett Collection Inc./Alamy; **24r** Photo © Granger/ BI; **25** Everett Collection Inc./Alamy; **26l** ME/Retrograph Collection; **26r** ME/Retrograph Collection; **27l** Granger Historical Picture Archive/Alamy; **27tr** Private Collection/Photo © Christie's Images/BI; **27br** Victoria and Albert Museum, London/© ADAGP, Paris and DACS, London; **28l** © Pierre Jahan/Roger-Viollet/ Topfoto; **28r** ME; **29** Artepics/Alamy; **30l** Phillips/Getty; **30r** Topfoto Picturepoint; **31l** Getty; **31r** Heritage Images/Getty; **32l** GraphicaArtis/Getty; **32r** Popperfoto/Getty; **33t** Popperfoto/Getty; **33bl** © Illustrated London News Ltd/ME; **33br** past art/Alamy; **34** © Tate, London 2017; **36t** © Victoria and Albert Museum, London; **36b** George Wolfe Plank/Getty; **37** © Victoria and Albert Museum, London; **38** Private Collection/BI/ © Succession Picasso/DACS, London 2017; **39** Musée d'Art Moderne de la Ville de Paris/BI/© Succession Picasso/DACS, London 2017; **42** Private Collection/De Agostini Picture Library/Etude Tajan/BI; **42–3** Private Collection/The Stapleton Collection/BI; **44** Private Collection/Photo © Christie's Images/BI; **46** © Boris Lipnitzki/Roger-Viollet/Topfoto; **47** ME/INTERFOTO/Bildarchiv Hansmann; **48l** Granger Historical Picture Archive/Alamy; **48r** Private Collection/Archives Charmet / BI; **49tl** Collection Historical/Alamy; **49tr** Everett Collection Historical/Alamy; **49b** ME/Everett Collection Inc.; **50t** Henri Manuel/Photo © PVDE/BI; **50b** Private Collection/Photo © Christie's Images/BI; **51l and r** Private Collection/Archives Charmet/BI; **52t** Sasha/Getty; **52b** © Bibliothèque nationale de France, Paris; **53** Victoria & Albert Museum, London; **54** Private Collection/BI; **55l** © Fonds Delaunay Pracusa Artisticas SA; **55r** Private Collection/Photo © Bonhams, London, UK/ BI; **56l and r** Chronicle/Alamy; **57** William Bolin/Getty; **58l** © The Advertising Archives/BI; **58r** Getty; **59** Moviestore collection Ltd/Alamy; **60l** Archive Photos/Getty; **60r** Ruth Harriet Louise/Getty; **61l and r** George Hurrell /Getty; **62** Bettmann/Getty; **63t** Hulton Deutsch/Getty; **63b** H. Armstrong Roberts/ClassicStock/Getty; **64t** ME/Retrograph Collection; **64bl** Image Courtesy of The Advertising Archives; **64br** Lordprice Collection/Alamy; **65** Margaret Chute/Moviepix/Getty; **67** Getty; **68** Lipnitzki/Getty; **72** Everett Collection Inc./Alamy; **77** Photo: Getty/Condé Nast; **78** Photo © Ministère de la Culture–Médiathèque du Patrimoine, Dist. RMN-Grand Palais/image RMN-GP; **79** Science History Images/Alamy; **80** Roger Viollet/Topfoto; **80–1** © Léon et Lévy/Roger-Viollet/Topfoto; **82** Private Collection/Photo © Christie's Images/ BI; **83t** Photo © Ministry of Culture – Heritage Media Library, Dist.RMN-Grand Palais/image Médiathèque du Patrimoine; **83b** Photo 12/Alamy; **85t** Private Collection/The Stapleton Collection/BI; **85b** Private Collection/Photo © Christie's Images/BI; **90** Private Collection/Photo © Christie's Images/BI; **91** The Metropolitan Museum of Art, New York/Scala Archives; **92 and 93** Victoria and Albert Museum, London; **94** LOC/Alamy; **95** Private collection; **101t** Edward Steichen/Getty; **101b** General Photographic Agency/Hulton Archive/Getty; **102** George Hoyningen-Huene/Condé Nast via Getty; **120** Courtesy Van Cleef & Arpels; **152** Private Collection/ © Look and Learn/BI; **154** akg-images/Paul Almasy; **156l** Classicstock/Alamy; **156r** Victoria and Albert Museum, London; **157** Photo © Ministry of Culture –Heritage Media Library, Dist. RMN-Grand Palais/Nadar Workshop; **159** Bettmann/Getty; **160** akg-images/De Agostini Picture Library/G. Dagli Orti; **161** Cecil Beaton/Getty; **164** Roger-Viollet/Topfoto; **165** Courtesy of Boucheron, Paris; **168 and 169** Private Collection/ © Look and Learn/BI; **179** akg-images/viennaslide/© Harald A. Jahn; **182** akg-images/Paul Almasy; **185** Courtesy Van Cleef & Arpels; **190** Photo © Granger /BI; **192** Whitney Museum of American Art, New York/ © ARS, NY and DACS, London 2017.

FURTHER READING

V. Bouvet and G. Durozoi, *Paris Between the Wars: Art, Style and Glamour in the Crazy Years*, London 2010

F. Cailles, *René Boivin*, London 1994

R. Capstick-Dale, *Art Deco Collectibles, Fashionable Objets from the Jazz Age*, New York 2016

S. Coffin and S. Menkes, *Set in Style, The Jewelry of Van Cleef & Arpels*, London 2011

F. Cologni and P. Gries, *In Praise of Hands: The Art of Fine Jewelry at Van Cleef and Arpels*, Venice 2013

P. Corbett and W. Landrigan, *Jewelry by Suzanne Belperron*, New York 2016

A. Duncan, *Art Deco Complete: The Definitive Guide to the Decorative Arts of the 1920s and 1930s*, London 2009

M. Etherington-Smith, *Ultra Vanities: Minaudières, Nécessaires and Compacts*, London 2013

M. Gabardi, *Art Deco Jewellery 1920–1949*, Woodbridge 1989

V. Meylan, *Van Cleef & Arpels, Treasures and Legends*, Woodbridge 2015

V. Meylan, *Boucheron: The Secret Archives*, Woodbridge 2016

L. Mouillefarine and E. Possémé, *Art Deco Jewelry: Modernist Masterworks and their Makers*, London 2009

Musée des Arts Décoratifs, *Les Fouquet, bijoutiers et joailliers à Paris 1860–1960*, Paris 1993

H. Nadelhoffer, *Cartier*, (revd. edn.) London 2007

G. Néret, *Boucheron: Four Generations of a World-Renowned Jeweller*, 1988

C. Rainero et al, *Jeweled Splendors of the Art Deco Era: The Prince and Princess Sadruddin Aga Khan Collection*, New York 2017

S. Raulet, *Art Deco Jewelry*, (revd. edn.) New York 2002

S. Raulet, *Van Cleef & Arpels*, New York 1987

S. Raulet and O. Baroin, *Suzanne Belperron*, Paris 2011

J Rudoe (ed.), *Jewellery Studies* vol. 9 (2001) London 2001

J. Rudoe, *Cartier 1900–1939*, London 1997

ACKNOWLEDGEMENTS

This book is the result of the contributions and collaborative efforts of many different people from across all areas of the arts. We would like to thank them most sincerely for their expertise and joint cooperation in a project that is all the richer for their collective involvement and experience.

We want to express our special gratitude to Dr Jacques and Rosana Seguin; Martin Travis at Symbolic & Chase; Catherine Cariou, Heritage Director at Van Cleef & Arpels, Paris; Alain Cartier; Nina Slavcheva; and Richard Edgcumbe at the Victoria and Albert Museum. Our thanks also go to our production team: our editor Caroline Bugler; picture researcher Susannah Stone and our designer Gabriella Le Grazie. In addition, many thanks to Hugh Tempest-Radford and all at Unicorn Press; to John Bodkin and his team at Dawkins Colour and to Andy and Sharon at A.C. Cooper, whose wonderful photographs of the cases are used throughout the book.

To our friends and particularly our families we owe a huge debt of gratitude: to Noriko, for her indulgence in never mentioning 'The Vanity Project' and to Charles and Joey Hue-Williams for their unfailing enthusiasm and help. Your encouragement carried us through.

We would also like to thank Brian May, Roger Taylor and Jim Beach. We are particularly grateful to Roger for generously allowing us to use his lyrics for the title of the book.

And finally, of course, our greatest thanks go to Kashmira, without whom there would be no collection and no book. Her vision for this special collection and her unfailing support for the publication, from beginning to end, is the main reason it came into being, and why it has been such fun to work on. For all this, we are enormously grateful.

Sarah Hue-Williams and Peter Edwards
London, June 2017

First published 2017 by Unicorn Press
60 Bracondale, Norwich NR1 2BE

www.unicornpublishing.org

ISBN 978 1 910787 81 6

Editor Caroline Bugler
Design Gabriella Le Grazie
Picture Research Susannah Stone
Vanity cases photography Andy and Sharon at A.C. Cooper
Reprographics DawkinsColour, London
Printed in Belgium by Graphius, Gent

BELOW Cigarette case by Cartier, c.1925–8

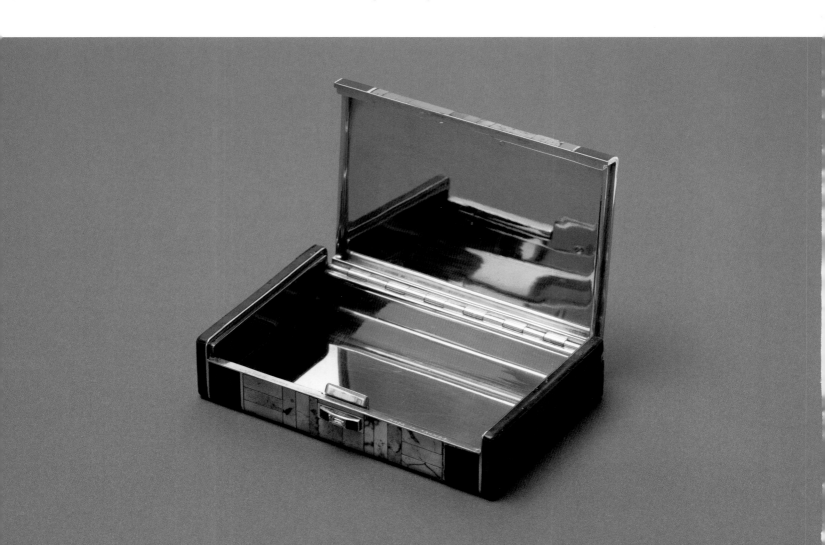

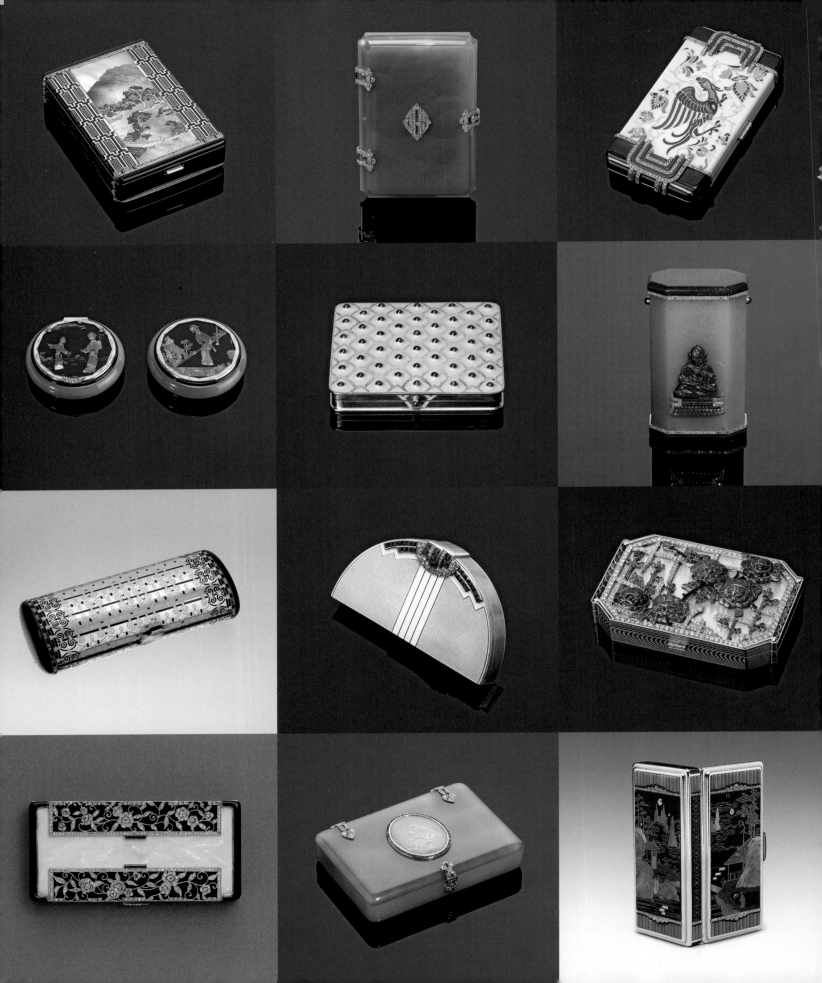